GLOUCESTER MASSACHUSETTS

ROCKPORT
PUBLISHERS

Clio Awards

**The 42nd Annual
Awards Competition**

© 2002 by Rockport Publishers, Inc.

First published in the United States of America by
Rockport Publishers, Inc.
33 Commercial Street
Gloucester, Massachusetts 01930-5089
Telephone: (978) 282-9590
Fax: (978) 283-2742
www.rockpub.com

ISBN 1-56496-855-3

10 9 8 7 6 5 4 3 2 1

Design and Cover Image: Hatmaker

Printed in China

Contents

Introduction

Clio is proud to present the winners of its 2001 worldwide competition.

Clio is the largest and most celebrated festival of its kind. For 42 years, we have sought to attract the best work from agencies and production houses all over the world. We have then submitted that work to a jury of leading professionals who have distinguished themselves in their fields, who represent the very best of craft, and who take the responsibility of judging very seriously.

Clio does not instruct the jury, other than to encourage it to award ideas rather than mere execution. Clio supports an honest, democratic, and non-political system of judging. Each piece is judged on its own merits. First, the jury votes a shortlist of the best work. From those finalists, the jury then determines which pieces, if any, are worthy of a statue. We present three statue levels: Gold, Silver, and Bronze. And occasionally, the judges honor a particular piece with a Grand Clio, our best of show.

To look at a Clio reel or to visit a Clio gallery is to see some of the world's most powerful ads. The winner's reel is sent to our representatives in 39 countries—and those representatives seek to screen the reel for interested groups. Part of our effort is to acknowledge greatness, part to instruct students of the craft, and part to celebrate one of the most interesting and influential art forms in modern culture.

Chairmen's Statements

TELEVISION & RADIO CHAIRMAN

At a time when dull advertising is so easy to ignore, fresh original thinking should be the norm rather than the exception—and the very best of this thinking should be celebrated, as it will be.

RON MATHER
National Creative Director
Campaign Palace
Sydney, Australia

PRINT & POSTER CHAIRMAN

I find writing print ads more satisfying than any other part of my job. But I fear that they are now often seen as the poor relations of their more glamorous cousins, TV ads. If that is so, it should not be so. Nothing stretches our imaginative, writing, and art directorial skills more than print. It is at the very core of our craft as creative people.

JAMES LOWTHER
Creative Director
M&C Saatchi
London, England

TECHNIQUE CHAIRMAN

Commercial craft awards salute those whose personal passion and creativity surpass everyday corporate clutter and compromise. A brave and relevant perspective humanizes the idea, dignifies the sell, and gives the work a soul.

BRUCE DOWAD
President and Director
Bruce Dowad Associates
Hollywood, California

INTERACTIVE CHAIRMAN

Sites that win awards are always questioned: Why did it win an award? Why is that so special? We need to have the courage of our convictions and reward the sites that serve the consumers, that add to their experience of the Internet, and that will give them the ability to tell others of their experiences. There isn't any point in awarding sites that are inaccessible to the masses. Our task is to highlight the here and now, the sites that work, the sites that delight and deliver. By setting the standards here, we are far more likely to get the industry thinking for the consumer, instead of for itself.

JAMES HILTON
President
AKQA
London, England

DESIGN CHAIRMAN

Many years ago, as a young designer, I visited Primo Angeli's office in San Francisco. In the reception area, there was a glass case chock full of statues and awards. One in particular caught my attention and sent pangs of envy through my entire body. I remember thinking, "That must be the Oscar for designers." It was the first time I had seen a gold Clio.

MICHAEL OSBORNE
President
Michael Osborne Design
San Francisco, California

2001 Clio Juries

EXECUTIVE JURY

Television & Radio

CHAIRMAN

RON MATHER
National Creative Director
The Campaign Palace
Sydney, Australia

OISTEIN BORGE
Creative Director
Leo Burnett A/S
Oslo, Norway

BERNARD BUREAU
Creative Director
Ogilvy & Mather
Paris, France

BHANU INKAWAT
Executive Creative Director
Leo Burnett Ltd.
Bangkok, Thailand

ANDRE KAMPER
Chief Creative Officer
Springer & Jacoby
Hamburg, Germany

YOSHIFUMI KAWAI
Manager, Creative Management Division
Dentsu Inc.
Tokyo, Japan

JASON LAWES
Creative Director
Lowe Lintas & Partners
London, England

SHEUNG YAN LO
Executive Creative Director
J. Walter Thompson/Bridge Advertising
Shanghai, China

CHRISTIANE MARADAI
Partner, Creative Director
Loducca
Sao Paulo, Brazil

CHUCK MCBRIDE
Creative Director
TBWA/Chiat/Day
San Francisco, California

JOHN MCCABE
Creative Director
Saatchi & Saatchi
Auckland, New Zealand

JOHAN NILSSON
Creative Director
Lowe Brindfors
Stockholm, Sweden

PETER VAN DEN ENGEL
Creative Director
D'Arcy Advertising
Amsterdam, Netherlands

FERNANDO VEGA OLMOS
General Creative
VegaOlmosPonce
Buenos Aires, Argentina

Print & Poster

CHAIRMAN
JAMES LOWTHER
Creative Director
M&C Saatchi
London, England

OLIVIER ALTMANN
Creative Director
BBDP & Fils
Boulogne-Billancourt, France

FRANK BODIN
Creative Director
Euro RSCG
Zurich, Switzerland

WARREN BROWN
Creative Director
Brown Melhuish Fishlock
Darlinghurst, Australia

CRAIG DAVIS
Executive Creative Director
Saatchi & Saatchi
Hong Kong, China

TIMO EVERI
Creative Director
Hasan & Partners
Helsinki, Finland

CARL JONES
Vice President, Creative Director
BBDO/Mexico
Mexico City, Mexico

BRIAN MCCARTHY
Director of Advertising Department
Academy of Art College
San Francisco, California

NEIL MCOSTRICH
Creative Director
Palmer Jarvis DDB
Toronto, Canada

BOB MOORE
Creative Director
Fallon
Minneapolis, Minnesota

ANNETTE MUUS
Creative Director
ADVANCE
Copenhagen, Denmark

FERNANDO VEGA OLMOS
General Creative
VegaOlmosPonce
Buenos Aires, Argentina

ADILSON XAVIER
Vice President/Creative Director
Giovanni FCB
Rio de Janeiro, Brazil

DAREK ZATORSKI
Creative Director
Leo Burnett
Warsaw, Poland

TECHNIQUE JURY

CHAIRMAN
BRUCE DOWAD
President and Director
Bruce Dowad Associates
Hollywood, California

Animation

SIMON BREWSTER
Visual Effects Designer
A52
Los Angeles, California

MORGANE FURIO
Inferno Artist
GMD
Sydney, Australia

PASI JOHANSSON
Inferno Artist
The Mill
London, England

ANDY MACDONALD
Creative Director/Visual Effects Supervisor
Post Logic
Santa Monica, California

STEVE SCOTT
Creative Director
525 STUDIOS
Santa Monica, California

DAVID SHIRK
Animation Supervisor
Quiet Man
New York, New York

STEFAN SONNENFELD
President/Chief Executive Officer
Company 3
Santa Monica, California

JERRY SPIVACK
Creative Director/Partner
Ring of Fire
West Hollywood, California

WILL VINTON
Chairman
Will Vinton Studios
Portland, Oregon

Direction

FREDRIK BOND
Director
Harry Nash
London, England

LESLIE DEKTOR
Director
Dektor Film
Hollywood, California

BRUCE DOWAD
Director
Bruce Dowad Associates
Hollywood, California

JEFF GORMAN
Director
JGF
Los Angeles, California

NOAM MURRO
Director/President
Biscuit Filmworks
Los Angeles, California

LOUIS NG
Director
The Film Factory
Hong Kong, China

DEWEY NICKS
Director
Epoch Films/Concrete & Clay
Beverly Hills, California

BRUCE PAYNTER
Director
Velocity Afrika
Johannesburg, South Africa

FREDERIC PLANCHON
Director
Première Heure
Paris, France
Academy Films, London

ROB SANDERS
Director
HLA
London, England

FLORIA SIGISMONDI
Director
Partners Film Company
Toronto, Canada

PEGGY SIROTA
Director
Mars Media
Venice, California

ROGIER VAN DER PLOEG
Director
Czar Films
Amsterdam, The Netherlands

Editing

ENRIQUE AGUIRRE
Chief Creative Officer
King Cut
Los Angeles, California

STEPHEN GANDOLFI
Editor
Cut & Run Limited
London, England

MICK GRIFFIN
Partner/Editor
Flashcut
Toronto, Canada

TOM MULDOON
President
Nomad Editing
Santa Monica, California

SUE SCHWEIKERT
Editor
Film Graphics
Sydney, Australia

KARL SODERSTEN
Editor
Karl Marks Films
Sydney, Australia

CRAIG WARNICK
President
mad.house
New York, New York

PAUL WATTS
Managing Director
The Quarry
London, England

ERIC ZUMBRUNNEN
Editor
Spot Welders
Venice, California

Music/Sound Design

JAVIER BLANCO
President/Composer
Taurus Music
Caracas, Venezuela

JOHNNIE BURN
Designer/Director
Wave Recording Studios
London, England

LYLE GREENFIELD
President/Creative Director
Bang Music + Sound Design
New York, New York

STEVE HAMPTON
Partner/Composer
Admusic
Santa Monica, California

PETER LAWLOR
Composer
Water Music Productions Ltd.
London, England

CLAUDE LETISSIER
Creative Director
Primal Scream
Santa Monica, California

RAMESH SATHIAH
Composer/Producer
Song Zu
Singapore

GARY WALKER
Engineer
750mph Ltd.
London, England

WALTER WERZOWA
President
Musikvergnuegen
Hollywood, California

INTERACTIVE JURY

CHAIRMAN
JAMES HILTON
Executive Creative Director
AKQA
London, England

MARC ADLER
Chairman
Macquarium Intelligent Communications
Atlanta, Georgia

DANIEL BIRCH
Design Director
Oyster Partners
London, England

TANIA BREBERINA
Creative Director
Photomation Design & Communication
Richmond, Australia

VICKY BROWNING
Publishing Director
Revolution
New York, New York

MARTIN CEDERGREN
Creative Director
Starlet Deluxe
Stockholm, Sweden

YURI DOKTER
Managing Director
Pulse Interactive
Amsterdam, Netherlands

KATE EVERETT-THORP
Chief Executive Officer
Lot21
San Francisco, California

LEE FELDMAN
Chief Creative Officer
Blast Radius
Vancouver, Canada

ANGELA FUNG
Creative Director, New Media
@radical.media, inc.
New York, New York

MANUEL FUNK
Chief Executive Officer
Fork Unstable Media
Hamburg, Germany

BOB GEBARA
Head of Creative
Zentropy Partners/Thunderhouse Brasil
São Paulo, Brazil

SETH GORDON
Internet Ethnographer
usabilityengineer.com
New York, New York

ARNE HABERMANN
Managing Director
Kabel New Media
Hamburg, Germany

GRAHAM KELLY
Regional Creative Director
OgilvyInteractive
Singapore

JAANA KOMULAINEN
Director of Planning
Grey Interactive Helsinki
Helsinki, Finland

MAYA KOPYTMAN
Creative Director, CCO/U.S.
IconMedialab
New York, New York

NICK KRULL
New Media Designer
OgilvyInteractive
Cape Town, South Africa

LAURA LANG
President
Digitas
Boston, Massachusetts

ANDREW LEITH
Creative Director
Deepend
London, England

SEBASTIAN MENDEZ
Creative Director
DoubleYou Remo
Madrid, Spain

GLENN MEYERS
President
Rare Medium
New York, New York

ANTHONY PAPPAS
Vice President, Creative Services
Proxicom
New York, New York

MARK PATRICOF
Chief Executive Officer
kpe
New York, New York

PJ PEREIRA
Creative Director
AgenciaClick
Sao Paulo, Brazil

JIMMY POON
Regional Interactive Marketing Director
Tribal DDB
Hong Kong, China

JOHN SCHMITZ
Chief Creative Officer
iXL
New York, New York

CINDY STEINBERG
Design Director
Razorfish
San Francisco, California

JOHAN TESCH
Creative Director
Tesch & Tesch
Stockholm, Sweden

STEEN TROMHOLT
Director of Communications
Valtech
Copenhagen, Denmark

DESIGN JURY

CHAIRMAN
MICHAEL OSBORNE
President
Michael Osborne Design
San Francisco, California

JOHN BLACKBURN
Executive Creative Director
Blackburn's Design Ltd.
London, England

LOUISE FILI
President
Louise Fili Ltd.
New York, New York

MARC GOBÉ
President/CEO/ECD
d/g* new york
New York, New York

HALEY JOHNSON
President
Haley Johnson Design
Minneapolis, Minnesota

STEVE SANDSTROM
Creative Director
Sandstrom Design
Portland, Oregon

MARY SCOTT
Director of Graphic Design
Academy of Art College
San Francisco, California

Best of Show

CATEGORY Media Promotion • **ADVERTISER/PRODUCT** Revista E'Poca • **TITLE** The Week • **ADVERTISING AGENCY** W/Brasil, São Paulo • **PRODUCTION COMPANY** Ad Studio, São Paulo • **EDITING COMPANY** Ad Studio, São Paulo • **MUSIC COMPANY** Ad Studio, São Paulo • **CREATIVE DIRECTOR** Washington Olivetto • **COPYWRITER** Alexandre Machado • **ART DIRECTOR** Jarbas Agnelli • **DIRECTOR** Jarbas Agnelli

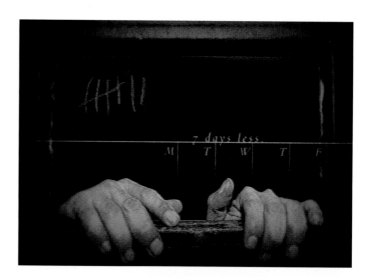

vo: To the prisoner…7 days less.
To the sick…7 days more.
To the happy…7 reasons.
To the sad…7 remedies.
To the rich…7 dinners.
To the poor…7 hungers.
To hope…7 new dawns.
To the sleepless…7 long nights.
To the lonely…7 chances.
To the absent…7 guilts.
To a dog…49 days.
To a fly…7 generations.
To business men…25% of the month.
To economists…0.019 of the year.
To the pessimist…7 risks.
To the optimist…7 opportunities.
To the earth…7 turns.
To the fisherman…7 returns.
To meet a deadline…too little.
To create a world…enough.
To someone with the flu…the cure.
To a rose in a jar…death.
To history…nothing.
To Epoca…everything.
super: Epoca.
Every week.

CATEGORY National Campaign • **ADVERTISER/PRODUCT** Volkswagen Beetle • **TITLE** Fun Fur • **TITLE** Snakes & Ladders • **TITLE** Desperate Dan •
ADVERTISING AGENCY BMP DDB, London • **ACCOUNT EXECUTIVE** Jon Busk • **CREATIVE DIRECTOR** Mike Hannett, Dave Buchanan •
COPYWRITER Adam Tucker • **ART DIRECTOR** Justin Tindall • **PHOTOGRAPHER** James Day • **TYPOGRAPHER** Kevin Clarke • **CLIENT**
SUPERVISOR Catherine Fordham • **ILLUSTRATOR (SNAKES & LADDERS)** Steve Dell

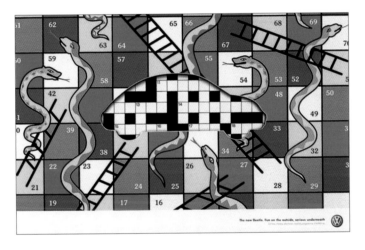

CATEGORY Hall of Fame • **ADVERTISER/PRODUCT** Jeep Grand Cherokee • **TITLE** Snow Covered • **ADVERTISING AGENCY** Bozell, Detroit • **PRODUCTION COMPANY** Plum Productions, Santa Monica • **EDITING COMPANY** Steve Wystrach, Los Angeles • **MUSIC COMPANY** Pilhofer Music, Minneapolis • **ANIMATION COMPANY** Digital Domain, Venice • **CREATIVE DIRECTOR** Gary Topolewski • **COPYWRITER** Gary Topolewski, Pete Pohl • **ART DIRECTOR** Andy Ozark • **DIRECTOR** Eric Saarinen • **PRODUCER** John Van Osdol • **VISUAL EFFECTS SUPERVISOR** Jay Riddle • **VISUAL EFFECTS PRODUCER** Teresa Chang

VISUAL: The camera follows the trail of a Jeep Grand Cherokee as it tunnels under the snow across a pristine winter land-scape. Upon reaching a nearly buried stop sign, taillights glow beneath the snow as the Jeep stops, signals, and turns. Not once is the vehicle shown.
SUPER: There's only one Jeep.
Jeep Eagle.

CATEGORY Hall of Fame • **ADVERTISER/PRODUCT** Nike • **TITLE** Good vs. Evil • **ADVERTISING AGENCY** Wieden & Kennedy Amsterdam, Amsterdam • **PRODUCTION COMPANY** Spots, London • **EDITING COMPANY** Spot Welders, Los Angeles • **MUSIC COMPANY** Admusic, Burbank • **ACCOUNT EXECUTIVE** Randy Browning, Matthew Warren, Dorothea Revhuhn • **CREATIVE DIRECTOR** Bob Moore, Michael Prieve • **COPYWRITER** Glenn Cole • **ART DIRECTOR** David "Jelly" Helm • **DIRECTOR** Tarsem • **PRODUCER** Simon Turtle • **AGENCY PRODUCER** Peter Cline • **CLIENT SUPERVISOR** Laurie Rechholtz, Rob Deflorio • **CINEMATOGRAPHER** Paul Laufer • **EDITOR** Robert Duffy • **MUSIC** Jim Bredouw • **SOUND DESIGN** Albert Ibotson • **PERFORMER/VOICE** Max Von Sydow

GOOD VS. EVIL

VISUAL: Ancient coliseum. Solar eclipse causes darkness. A hoofed foot steps onto the dirt of the field. Fire rises from the earth, creating boundary lines on the field.

VO: And on that day, a dark warrior rose to the earth…to destroy the beautiful day.

VISUAL: A human soccer team, comprised of international soccer players, steps onto the field. The crowd in the stadium is in a frenzy. Satan calls forth his team of players, who emerge from the fire.

PLAYER 1: Maybe they're friendly.

VISUAL: A human player is knocked down, almost spiked by a demon's razor-sharp cleat. The humans are bulldozed by the demons. A human player yells at a blind referee to call "Foul." A human player trips up one of the demons and steals the ball. The human team then performs a series of incredible moves to get the ball across the field, while defending themselves against the demons. Satan blocks the goalpost, revealing his full wingspan to block the net.

PLAYER 2: Au revoir.

VISUAL: Human player kicks soccer ball, which ignites into flames, and burns through Satan. A goal is scored and Satan explodes. The eclipse disappears, and the human players are left standing alone in the field.

SUPER: Just Do It.

CATEGORY Hall of Fame • **ADVERTISER/PRODUCT** McDonald's • **TITLE** Sign • **ADVERTISING AGENCY** Leo Burnett, Chicago • **PRODUCTION COMPANY** Steven Horn, Linda Horn, New York • **EDITING COMPANY** Avenue Edit, Chicago • **MUSIC COMPANY** Intuition Music, Chicago; Avenue Edit, Chicago • **ACCOUNT EXECUTIVE** Lisa Johnson • **GROUP CREATIVE DIRECTOR** Cheryl Berman • **CREATIVE DIRECTOR** Jonathan Moore, John Immesoete, Cheryl Berman • **COPYWRITER** Jonathan Rodgers • **ART DIRECTOR** Bob Shalleross, Jeff Abbott • **DIRECTOR** Steve Horn • **PRODUCER** Linda Horn, Steve Horn • **AGENCY PRODUCER** Chris Rossiter • **EDITOR** Terry Kaney • **MUSIC** Larry Pecerella

SYNOPSIS: A toddler swings back and forth on an indoor baby swing, which is positioned in front of a window. Swinging toward the window he smiles and laughs, while swinging away he frowns and cries. This is repeated several times: forward, happy; backward, sad. We then see through the eyes of the toddler: As he approaches the window, the familiar golden arches of the McDonald's sign appear and this causes him to smile; as he retreats, the sign disappears and this causes him to cry. We now know what makes the baby happy and what makes him sad.

SUPER: We love to see you smile.

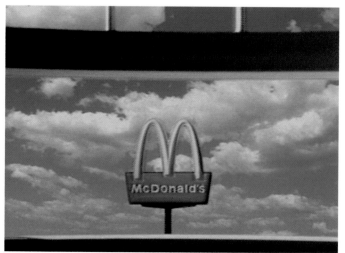

Advertiser of the Year

GUINNESS
Africa, England, Ireland, Malaysia, Singapore, United States

Production Company of the Year

GORGEOUS ENTERPRISES
London

Agency of the Year

BMP DDB
London

Agency Network of the Year

DDB WORLDWIDE

Television & Cinema

SILVER

CATEGORY Apparel/Fashion • ADVERTISER/PRODUCT Adidas Athletic Apparel • TITLE Adidas Makes You Better - Lomu • ADVERTISING AGENCY 180, Amsterdam • PRODUCTION COMPANY Harry Nash, London • ACCOUNT EXECUTIVE Chris Mendola, Lucie Tenney • CREATIVE DIRECTOR Larry Frey • COPYWRITER Lorenzo de Rita • ART DIRECTOR Dean Maryon • DIRECTOR Fredrik Bond • AGENCY PRODUCER Jackie Adler • PRODUCTION COMPANY PRODUCER Helen Williams • DIRECTOR OF PHOTOGRAPHY Carl Nilsson • STRATEGIC PLANNING Alex Melvin

VISUAL: A huge fish flops in a puddle of water in the middle of an intersection.

SUPER: Kiki Sq. 25m above sea level.

WOMAN 1: The poor fish, it just looked as though it was just screaming for water.

WOMAN 2: It was dying, it was lying there dying and nobody was helping it.

VISUAL: Jonah Lomu grabs the fish like a rugby ball and runs down the street.

WOMAN 1: Until a big man came along and just picked up the fish under his arms and he just shot off down the road.

VISUAL: Lomu jumps on a car as he weaves through a traffic jam.

WOMAN 2: And he jumped up on the bonnet of that car, and I thought he was going to come through the windscreen.

VISUAL: Lomu, seeing the fish's condition, looks around the street.

WOMAN 1: His muscles were bulging and he was just holding this fish just so tight.

VISUAL: Lomu runs through the spinning washers of a nearby car wash.

MAN 1: Of course it was Jonah Lomu. Veers through the car wash—Bang!

VISUAL: Lomu races toward the docks. He knocks into a van backing out of a garage, almost tipping the vehicle over.

MAN 1: By dingoes, he was moving.

VISUAL: Lomu makes a dive and hurls the fish into the water.

MAN 2: It was just on its last gasp and he just threw the fish in and it saved its life. Wearing Adidas makes you more caring about fish. And alligators and cats and elephants and even people.

SUPER: Adidas makes you better.

Adidas. Forever Sport.

www.adidas.com/bebetter

CATEGORY Apparel/Fashion • **ADVERTISER/PRODUCT** Aristoc Slimline System Tights • **TITLE** Subtitles • **ADVERTISING AGENCY** Miles Calcraft Briginshaw Duffy, London • **PRODUCTION COMPANY** Gorgeous Enterprises, London • **EDITING COMPANY** Sam Sneade, London • **SOUND DESIGN COMPANY** Jungle, London • **CREATIVE DIRECTOR** Paul Briginshaw, Malcolm Duffy • **COPYWRITER** Malcolm Duffy • **ART DIRECTOR** Paul Briginshaw • **DIRECTOR** Peter Thwaites • **PRODUCER** Paul Rothwell • **AGENCY PRODUCER** Fiona Marks • **EDITOR** Sam Sneade • **SOUND DESIGNER** James Saunders • **MUSIC** Nino Rota

SILVER

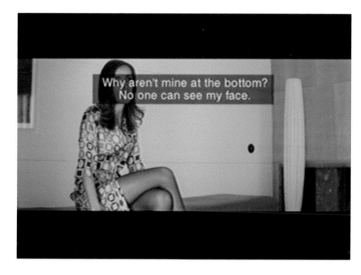

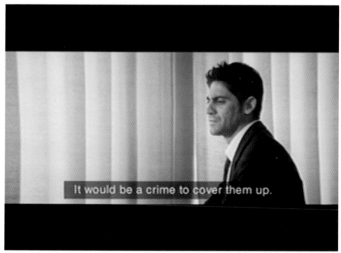

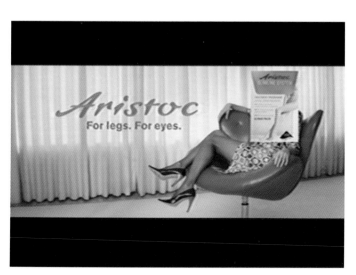

VISUAL: An attractive young woman walks into a room. A young man is sitting on a chair. The woman speaks Italian but the subtitles cover her head and shoulders so that her face can't be seen.

WOMAN: Paolo.

VISUAL: The man speaks. His subtitles are at the bottom of the screen.

MAN: Yes, my darling.

VISUAL: The woman speaks. The subtitles cover her face.

WOMAN: We need to talk.

VISUAL: The man speaks. The subtitles are at the bottom.

MAN: Ask me anything. We have no secrets.

VISUAL: As she speaks, subtitles appear at the top.

WOMAN: There's something wrong, Paulo.

VISUAL: As he speaks, the subtitles appear at the bottom.

MAN: Is it us?

VISUAL: The subtitles cover her face.

WOMAN: No, it's these stupid subtitles. Why aren't mine at the bottom? No one can see my face.

VISUAL: The man speaks. His subtitles are at the bottom of the screen.

MAN: That's because you're wearing Aristoc Slimline System tights, my darling. As you know, the compression knitting gently massages your skin for a slimmer looking bum and thighs. It would be a crime to cover them up.

VISUAL: A subtitle goes over the woman's face.

WOMAN: Oh.

VO: Aristoc Slimline System tights. For legs. For eyes.

VISUAL: The woman has her head down. She turns to face the camera. The Aristoc pack is placed right over her face.

SUPER: Aristoc. For legs. For eyes.

21

BRONZE

CATEGORY Apparel/Fashion • **ADVERTISER/PRODUCT** Nike • **TITLE** Elephant • **ADVERTISING AGENCY** Wieden & Kennedy, Portland • **PRODUCTION COMPANY** Propaganda Films, Hollywood • **ACCOUNT EXECUTIVE** Jessica Vacek, Whitney Merrifield-Palmer • **CREATIVE DIRECTOR** Jim Riswold, Hal Curtis • **COPYWRITER** Kash Sree • **ART DIRECTOR** Andy Fackrell • **DIRECTOR** Dante Ariola • **PRODUCER** Jennifer Webster • **EXECUTIVE PRODUCER** Colin Hickson • **AGENCY PRODUCER** Alicia Hamilton

VISUAL: A group of traveling circus performers stands around a prostrate elephant.
HUMAN CANNONBALL: She's stopped breathing. I think we've lost her.
VISUAL: The ringmaster kneels down next to the elephant.
RINGMASTER: Is there nothing we can do?
HUMAN CANNONBALL: I'm a human cannonball, not a doctor!
VISUAL: A group of bicyclers pass by the scene. Lance Armstrong stops his bike and strolls over to the fallen elephant. He kneels down, takes a deep breath and blows air into the elephant's mouth.
SUPER: Why sport?
VISUAL: The elephant, revived from Lance's breath, awakes and trumpets as it gets on its legs. Lance walks back to his bike.
SUPER: Healthy lungs.

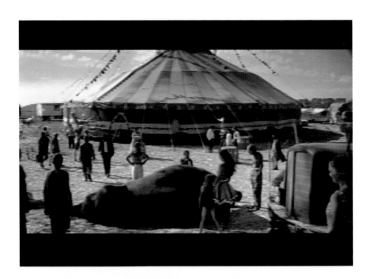

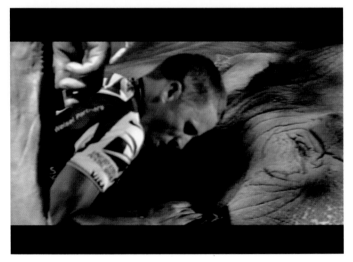

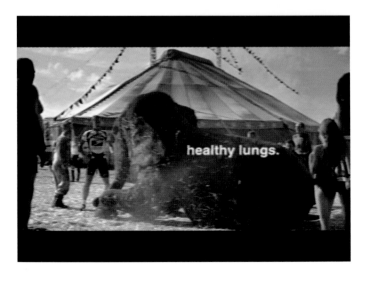

CATEGORY Apparel/Fashion • **ADVERTISER/PRODUCT** Levi's • **TITLE** Legs • **ADVERTISING AGENCY** Bartle Bogle Hegarty, London • **PRODUCTION COMPANY** Satellite, Los Angeles • **EDITING COMPANY** The Whitehouse, London • **CREATIVE DIRECTOR** Bruce Crouch, Adam Chiappe, Matthew Saunby • **COPYWRITER** Shawn Preston • **ART DIRECTOR** Adam Scholes • **DIRECTOR** Brian Beletic • **PRODUCER** Vince Landay • **AGENCY PRODUCER** Frances Royle

BRONZE

VISUAL: A factory with numerous jeans on two enormous conveyor belts. Two legs—one left, one right—on separate pairs of jeans are twisted together as if in love. Unfortunately, they are on separate conveyor belts. They are slowly pulled apart and forced to split up.

Cut to present day, when one leg is owned by a young man who is presently filling a large water jug at a public water machine on the sidewalk. The other leg belongs to a young woman who is jogging past the man waiting for his water. The two legs notice each other and, with much excitement, force their owners to come together. The surprised man is terrified that he has no control over his body as his pants leg is forcing him into traffic and across the street to its lost love. The young woman is also shocked that her jogging is interrupted by the rebellious leg of her jeans.

The jeans meet at the waist, thus introducing the owners in an extremely unusual manner. This joining of jeans becomes even more bizarre when the lovelorn legs begin to shed themselves from their owner. The man and woman protest as they desperately try to keep their pants on, but the jeans are just too eager to listen.

In the end the man and woman are sitting side by side on the curb in their underwear. Before them are the reunited legs, once again twisted together in love.

BRONZE

CATEGORY Apparel/Fashion • **ADVERTISER/PRODUCT** Reebok Hydro Move • **TITLE** The Blob • **ADVERTISING AGENCY** Lowe Lintas, London • **PRODUCTION COMPANY** Partizan, London • **EDITING COMPANY** Final Cut, London • **MUSIC COMPANY** John Murphy • **CREATIVE DIRECTOR** Charles Inge • **COPYWRITER** Brian Turner • **ART DIRECTOR** Mickey Tudor • **DIRECTOR** Traktor • **PRODUCER** Philippa Smith

VISUAL: A man is running down a suburban street wearing Reeboks when he glances behind him and sees a huge belly bounding along the road after him.

[**MUSIC:** Hard rock with singer repeatedly yelling, "Belly's going to get you!"]

VISUAL: The giant belly is in hot pursuit. The man vaults a fence, and the belly crashes straight through it. People clear out of the way of the giant belly as it follows the man into a shopping center. While the man is running up some stairs in the mall, belly takes the lift.

[**MUSIC:** Light muzak inside lift.]

VISUAL: The giant belly and a few people squashed against the walls of the lift are waiting to reach the top floor. The doors open just as the man runs past.

[**MUSIC:** Reverts back to hard rock.]

VISUAL: The belly pursues the man. It skids and overshoots a corner before adjusting itself and continuing the chase. Having given the belly the slip, the man slows down on a quiet street. Suddenly the belly appears on a motorcycle and chases the man up the ramps of a multi-story car garage to the roof. With nowhere left to run, the man vaults over the barrier and grabs on the edge of the building. The belly speeds straight through the barrier and plunges straight into the canal below.

SUPER: Lose the beer belly.

Reebok DMX. Whatever your goal.

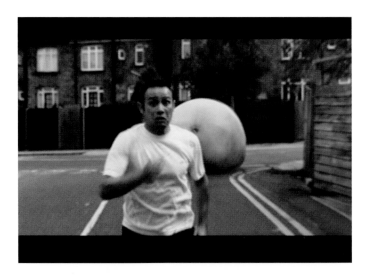

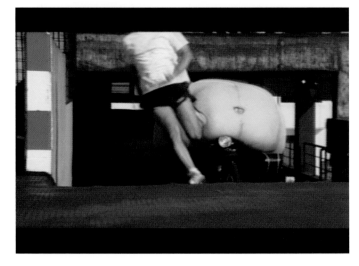

CATEGORY Apparel/Fashion • ADVERTISER/PRODUCT Nike • TITLE Gratitude • ADVERTISING AGENCY Giovanni , FCB, Rio de Janeiro •
PRODUCTION COMPANY Zero Filmes, São Paulo • EDITING COMPANY Zero Filmes, São Paulo • MUSIC COMPANY Play It Again, São Paulo •
ACCOUNT EXECUTIVE Marcelo Malachias, Luciana Leal • CREATIVE DIRECTOR Adilson Xavier, Cristina Amorim • COPYWRITER Rynaldo
Gondim, Fernando Campos, André Lima, Adilson Xavier • ART DIRECTOR Cláudio Gatão, Cristina Amorim, Fernando Barcellos, Carlos André
Eyer • DIRECTOR Sérgio Amon • PRODUCER Paulo Netto, Daniela Conde

BRONZE

VISUAL: Athletes Anonymous sign.
PATRICIA: My name is Patricia, and I haven't exercised for two months. I am here to thank all those who have supported me in my ordeal. My mother, my father, my brother Duda, my boyfriend, my close friends Ju and Paula.
VISUAL: Patricia is stretching her arms and upper body in various exercises while pointing out those who supported her. The crowd is dismayed by her actions. She begins to cry once she realizes that she is taking advantage of the situation to exercise. The group leader comes up and hugs Patricia.
PATRICIA: I'm sorry.
GROUP LEADER: It's hard, isn't it?
SUPER: Nike.

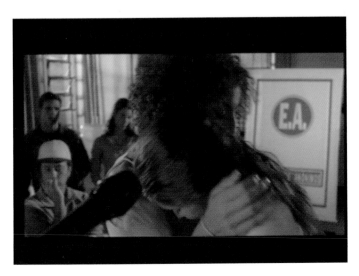

SILVER

CATEGORY Automotive • **ADVERTISER/PRODUCT** Volkswagen • **TITLE** Hands • **ADVERTISING AGENCY** Slogan DDB, Montevideo • **PRODUCTION COMPANY** Salado Films, Montevideo • **EDITING COMPANY** Rojo, Montevideo • **MUSIC COMPANY** Pregones, Montevideo • **SOUND DESIGN COMPANY** Pregones, Montevideo • **ACCOUNT EXECUTIVE** Vivian Birn • **CREATIVE DIRECTOR** Pedro Astol • **ART DIRECTOR** Julio Castillo • **DIRECTOR** Pablo Casacuberta • **PRODUCER** Fernando Astol, Adolfo Manzinalli

VISUAL: Hand with a tan line from a wedding band on ring finger.
SUPER: No wife.
VISUAL: Hand with fingernails bitten raw.
SUPER: No patience.
VISUAL: Hand missing a fingernail.
SUPER: No skill.
VISUAL: Hand missing a finger.
SUPER: No fear.
VISUAL: Hand with no palm lines.
SUPER: No history.
VISUAL: Soft hand of a baby.
SUPER: No experience.
VISUAL: Tattooed hand.
SUPER: No limits.
VISUAL: Hands dirty with oil.
SUPER: No Volkswagen.
Who else?

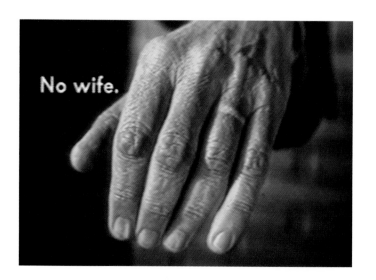

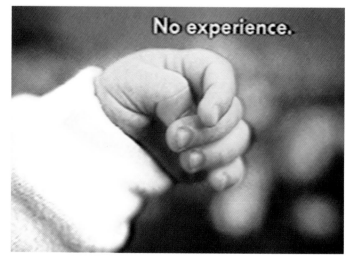

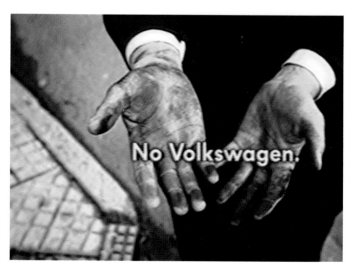

CATEGORY Automotive • **ADVERTISER/PRODUCT** Golf by Volkswagen • **TITLE** 4 Motion • **ADVERTISING AGENCY:** DDB Advertising, Paris • **PRODUCTION COMPANY** HLA, Paris • **ACCOUNT EXECUTIVE** Vincent Léorat • **COPYWRITER** Alexandre Hervé • **ART DIRECTOR** Samuel Kadz • **DIRECTOR** Rob Sanders

SILVER

VISUAL: A magician places his assistant in a box and cuts her into three sections in front of a large audience. However, from behind the scenes it is revealed that the assistant is actually a contortionist. Instead of being sliced into separate pieces, she has folded her body into only one section.

Two men are wrestling in a ring. One of the wrestlers falls to the floor after being knocked down by his opponent. On closer inspection, though, it seems that the two have been fighting without even touching one another. The match is rigged, and the crowd is none the wiser.

A woman is hanging from a ledge on the 40th floor of a building, screaming for help. Then the camera angle changes and it is shown that the woman is an actress in a movie. She in no danger because she is really lying horizontally on the floor of the set.

A Volkswagen Golf is the only car driving in a village paralyzed by snow.

SUPER: There's always a trick.

Golf 4 Motion.

Permanent four-wheel drive.

BRONZE

CATEGORY Automotive • **ADVERTISER/PRODUCT** Volvo V40 • **TITLE** Fly • **ADVERTISING AGENCY** Forsman & Bodenfors, Gothenburg • **PRODUCTION COMPANY** Traktor, Los Angeles • **COPYWRITER** Oscar Askelöf, Johan Olivero, Filip Nilsson • **DIRECTOR** Traktor • **PRODUCER** Traktor • **CLIENT** Volvo Cars Europe Market

VISUAL: A man is trying to swat a fly in his kitchen with a newspaper. After numerous misses, he slowly walks to the window where the fly is buzzing, raises the paper and lowers it slowly to get into position to kill it. However, before he kills the fly, he's distracted by the Volvo V40 driving by the house. As he watches the car as it passes, the fly buzzes away. When the car is gone, the man sees that the fly is no longer on the window. The man sighs and sets the newspaper on the kitchen table.
SUPER: The Volvo S40/V40 Phase II.
Designed to save lives.

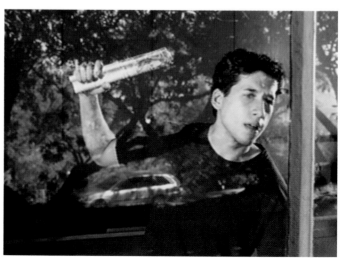

CATEGORY Automotive • **ADVERTISER/PRODUCT** Volkswagen • **TITLE** Lupo 3 Liters For 100 kms • **ADVERTISING AGENCY** DDB Advertising, Paris • **PRODUCTION COMPANY** Les Producers, Saint-Cloud • **ACCOUNT EXECUTIVE** Vincent Léorat • **CREATIVE DIRECTOR** Christian Vince • **COPYWRITER** Manoëlle Van der Vaeren • **ART DIRECTOR** Sébastien Vacherot • **DIRECTOR** Kasper Wedhendal • **PRODUCER** Jérémie Morichon

BRONZE

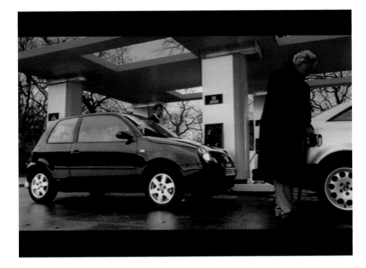

VISUAL: A man driving a Lupo pulls into a gas station and waits for an open pump. When the car in front of the Lupo is done using the gas pump, the Lupo driver immediately takes the pump handle away from the man who was using it. The Lupo driver turns the nozzle upside-down to pour out the few leftover drops of gas into his own tank. He then hands the pump back to the previous operator.

SUPER: Lupo. A few drops is enough.

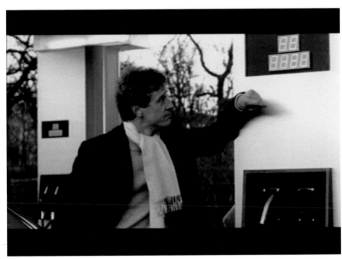

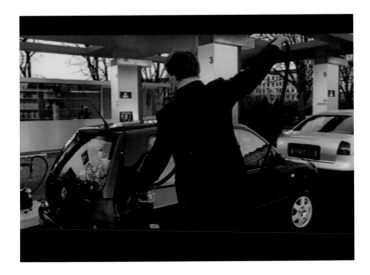

BRONZE

CATEGORY Automotive • **ADVERTISER/PRODUCT** Toyota Tacoma • **TITLE** Family Reunion • **ADVERTISING AGENCY** Saatchi & Saatchi, Torrance • **PRODUCTION COMPANY** Headquarters, Santa Monica • **EDITING COMPANY** Filmcore, Santa Monica • **CHIEF CREATIVE OFFICER** Steve Rabosky • **CREATIVE DIRECTOR** Matt Bogen, Stan Toyama • **COPYWRITER** Greg Collins • **ART DIRECTOR** Rohitash Rao • **DIRECTOR** Joe Public • **PRODUCER** Paul Ure • **EXECUTIVE PRODUCER** Tom Mooney, Alex Blum, Andrew Denyer • **AGENCY PRODUCER** Richard Bendetti

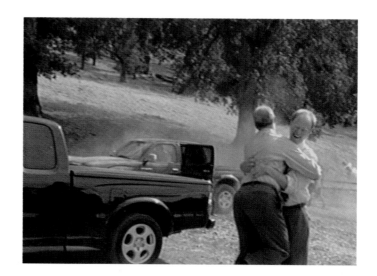

VISUAL: A family reunion. Everyone is greeting one another in a violent manner. Two men embrace. One of them knees the other in the groin.
MAN 1: Hey! Long time no see! What's up?
MAN 2: Hey there! Really missed you!
VISUAL: Two other men are arm wrestling over a flaming grill.
MAN 3: All right, who's your daddy now?
VISUAL: A man hugs a woman getting out of her car. They pound each other on the back.
WOMAN 1: Hey! Good to see you!
MAN 4: Hey! Haven't seen you in a long time!
VISUAL: Two women greet by pulling each other's hair. A grandma pinches her grandson's face before headbutting him.
GRANDMA: Such a big boy!
VISUAL: The camera zooms out to show the family reunion is one big, friendly rumble.
VO: Think you're tough enough to drive a Tacoma? Join the club. The new restyled Tacoma trucks are here.
SUPER: Tacoma Tough Club.
Toyota.

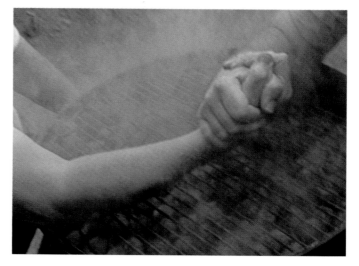

CATEGORY Automotive • **ADVERTISER/PRODUCT** Fiat • **TITLE** Radar • **ADVERTISING AGENCY** Leo Burnett Publicidade Ltda, São Paulo •
PRODUCTION COMPANY Zohar Cinema, São Paulo • **EDITING COMPANY** Casablanca Finish House, São Paulo • **MUSIC COMPANY** MCR, São
Paulo • **ACCOUNT EXECUTIVE** Denise Millan • **CREATIVE DIRECTOR** José Henrique Borghi • **COPYWRITER** Renato Simões • **ART DIRECTOR**
André Nassar, Bruno Prósperi • **DIRECTOR** Márcia Ramalho • **PRODUCER** Iracema Nogueira

BRONZE

VISUAL: A tree near a deserted road at nightfall.
[SFX: Car approaching at high speed.]
VISUAL: Car speeds down the road, past the tree. Several
seconds after the car has left the scene, a radar flash
stationed in the tree finally goes off.
SUPER: Marea Turbo.
Come see it up close at a Fiat dealer.

BRONZE

CATEGORY Automotive • **ADVERTISER/PRODUCT** Mercedes-Benz SLK • **TITLE** Summertime • **ADVERTISING AGENCY** Springer & Jacoby, Hamburg • **PRODUCTION COMPANY** Cobblestone Pictures, Hamburg • **MUSIC COMPANY** Per Paton, Ulf Knutsen • **CREATIVE DIRECTOR** Alexander Schill, Axel Thomsen • **COPYWRITER** Alexander Weber • **ART DIRECTOR** Bastian Kuhn • **DIRECTOR** Ron Eichhorn • **GRAPHIC ARTIST** Annette Steffens • **AGENCY PRODUCER** Natascha Teidler

NOTE: This commercial was aired on the weekend when clocks were scheduled to switch to summertime.
VISUAL: An SLK is outside with its roof closed. The roof opens and the car becomes a cabriolet.
SUPER: Don't forget to switch to summertime.
The SLK. A roadster for 365 days a year.
Mercedes-Benz
The future of the automobile.

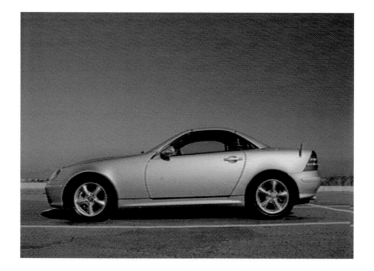

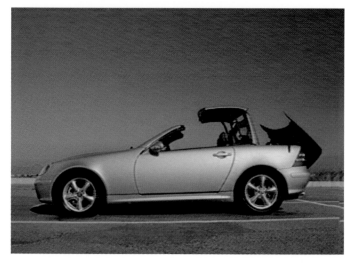

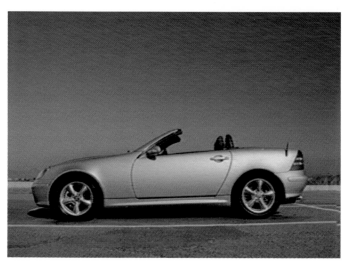

CATEGORY Automotive • **ADVERTISER/PRODUCT** BMW • **TITLE** Landspeed • **ADVERTISING AGENCY** TBWA Hunt Lascaris, Johannesburg •

PRODUCTION COMPANY Egg Productions, Johannesburg • **EDITING COMPANY** Cutaways, Johannesburg • **SOUND DESIGN COMPANY**

Cutaways, Johannesburg; Sterling Sound, Johannesburg • **CREATIVE DIRECTOR** Tony Granger • **COPYWRITER** Clare McNally • **ART DIRECTOR**

Jan Jacobs • **DIRECTOR** Kim Geldenhuys • **PRODUCER** Helena Woodfine

BRONZE

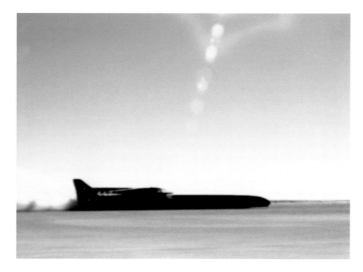

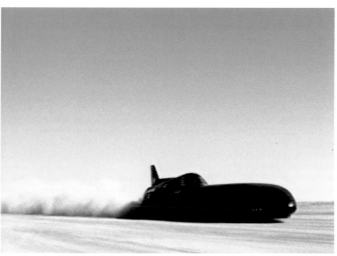

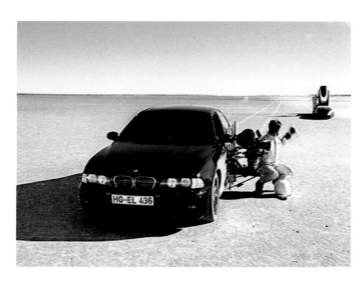

VISUAL: A black object shimmers on the horizon in a desert.
[SFX: Jet engines accelerating.]
VISUAL: The object is a jet-propelled vehicle of the kind used to break landspeed records. After a quick overview of the vehicle, it slows down and eventually grinds to a halt.
[SFX: Jet engines die down and come to a stop.]
VISUAL: The driver of the car filming the jet-propelled vehicle walks into frame. He peers into the camera, checking to make sure that it was functioning properly. When the camera zooms out, it is shown that the vehicle that kept pace with the jet-car was a BMW.
SUPER: The BMW M5. Fastest saloon car on the planet.

BRONZE

CATEGORY Automotive • **ADVERTISER/PRODUCT** Audi A4 • **TITLE** Dreams • **ADVERTISING AGENCY** Tandem Campmany Guasch DDB, Barcelona • **PRODUCTION COMPANY** Piramide • **CREATIVE DIRECTOR** Alberto Astorga, Dani Ilario • **COPYWRITER** Alberto Astorga • **ART DIRECTOR** Dani Ilario, Fernando Codina • **PRODUCER** Vicky Moñino

VISUAL: A concrete mixer with a plastic cover on it. The air moves the cover to show the machine's steering wheel.
SUPER: The steering wheel.
VISUAL: A guy steps on a trash can pedal and throws away a paper. His foot steps off the pedal.
SUPER: The pedal.
VISUAL: A hand pulls the metal lever on a slot machine.
SUPER: The gear stick.
VISUAL: The wheels of a supermarket cart.
SUPER: The wheels.
VISUAL: A hand mirror on a bed.
SUPER: The rear-view mirror.
VISUAL: A red construction light.
SUPER: The indicator.
VISUAL: A person steps on a bathroom scale. The pointer goes to 55 kilos.
SUPER: The kilometre gauge.
VISUAL: A key hanging in a door lock.
SUPER: The keys.
VISUAL: A lawnmower's engine in the rain.
SUPER: The engine.
VISUAL: A window being cleaned by window wipers.
SUPER: The windscreen wiper.
VISUAL: Two empty seats in a waiting room.
SUPER: The seats.
VISUAL: Two pool lights blink on and off.
SUPER: The headlights.
And what if things dreamed of a better life?
Audi A4.

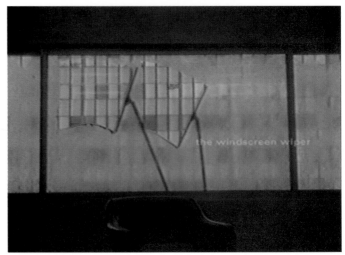

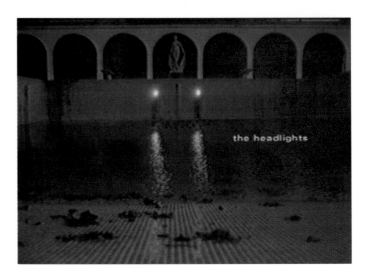

CATEGORY Automotive • ADVERTISER/PRODUCT Fiat Punto • TITLE Crash Test • ADVERTISING AGENCY Leo Burnett, Paris • PRODUCTION COMPANY 1/33, Suresness • MUSIC COMPANY Attention O'Chiens, Levallois • ACCOUNT EXECUTIVE Valérie Planchez, Stéphanie Alencar • CREATIVE DIRECTOR Christophe Coffre, Nicolas Taubes • COPYWRITER Christophe Coffre • ART DIRECTOR Nicolas Taubes • DIRECTOR Neil Harris • PRODUCER Catherine Guiol

BRONZE

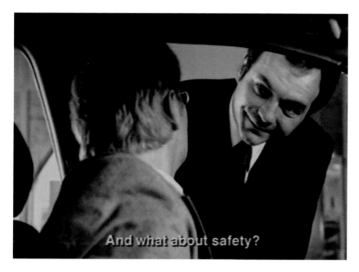

VISUAL: A customer inspects a Fiat Punto in a car dealership showroom. He gets into the driver's seat.
CUSTOMER: And what about safety?
VISUAL: Dealer pushes the customer into the passenger seat. The dealer gets behind the wheel, starts the car, and crashes it into the wall of the dealership.
CUSTOMER: I'll take it!
VO: According to the Euro NCap tests, Fiat Punto is the safest car in its category.
VISUAL: Customer happily drives away in the damaged car.
VO: Fiat Punto. Astonishing, isn't it?

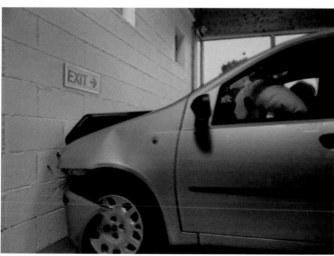

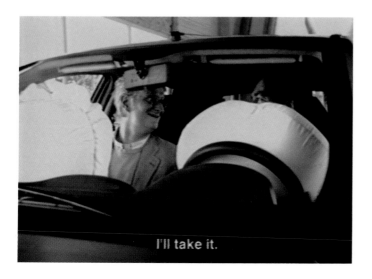

SILVER

CATEGORY Banking/Financial • ADVERTISER/PRODUCT E*TRADE • TITLE Monkey • ADVERTISING AGENCY Goodby, Silverstein & Partners, San Francisco • PRODUCTION COMPANY Hungry Man • EDITING COMPANY Mackenzie Cutler, Inc. • MUSIC COMPANY Asche & Spencer • CREATIVE DIRECTOR David Gray, Gerry Graf, Rich Silverstein • COPYWRITER Gerry Graf • ART DIRECTOR Dave Gray • DIRECTOR Bryan Buckley • PRODUCER Tod Puckett

VISUAL: Two guys sit in a house garage. A monkey wearing an "E*TRADE" t-shirt approaches them. The monkey turns on a boom-box stereo.

[MUSIC: La-coo-ka-ra-cha-cha-cha!]

VISUAL: As the music plays, the two guys clap along. The monkey taps his foot and waves his arms. The three do this until the music stops.

SUPER: Well, we just wasted 2 million bucks.
What are you doing with your money?

VISUAL: The two guys and the monkey smile.

SUPER: E*TRADE

VO: It's time for E*TRADE, the number one place to invest online.

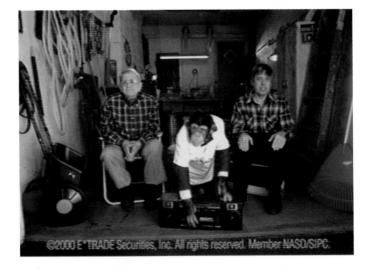

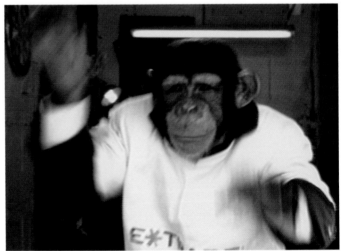

BRONZE

CATEGORY Banking/Financial • **ADVERTISER/PRODUCT** Electronic Data Systems • **TITLE** Cat Herders • **ADVERTISING AGENCY** Fallon, Minneapolis • **PRODUCTION COMPANY** Hungry Man, New York & Los Angeles • **EDITING COMPANY** FilmCore, Santa Monica • **MUSIC COMPANY** Asche & Spencer, Minneapolis • **SOUND DESIGN COMPANY** Framework Sound, Burbank • **ANIMATION COMPANY** Sight Effects, Los Angeles • **ACCOUNT EXECUTIVE** David Sigel • **CREATIVE DIRECTOR** David Lubars • **COPYWRITER** Greg Hahn • **ART DIRECTOR** Dean Hanson • **DIRECTOR** John O'Hagan • **PRODUCER** Marty Wetherall, Judy Brink

VISUAL: A young cowboy holds a photograph.
COWBOY 1: This man right here is my great-grandfather. He was the first cat herder in our family.
[**SFX:** Epic western music.]
VISUAL: Men on horses herd thousands of cats across a vast Montana plain.
COWBOY 2: Herdin' cats, don't let anybody tell you it's easy.
[**SFX:** Meows.]
COWBOY 3: Anybody can herd cattle. Holding together 10,000 half-wild short hairs, well that's another thing altogether.
COWBOY 4: Being a cat herder is probably about the toughest thing I think I've ever done.
VISUAL: A cowboy rolls up a ball of yarn in the back of a wagon. Two cowboys try to get cats out of a tree. Another two cowboys show their wounds to the camera. One of them points at his face.
COWBOY 5: I got this one this mornin' right here. And if you look at his face…
COWBOY 6: It ain't…
COWBOY 5: …it's just ripped to shreds, you know.
VISUAL: The herd crosses a small stream. A cowboy carries two cats across.
COWBOY VO: You see the movies, ya, ya hear the stories…it's… I'm livin' a dream. Not everyone can do what we do.
VISUAL: A cowboy removes cat hair from the sling on his arm. Another cowboy sneezes while he's herding.
COWBOY 7: I wouldn't do nothin' else.
VISUAL: The cowboys and their herds head for the old-fashioned western town in the distance.
COWBOY VO: It ain't an easy job, but when you bring a herd into town and you ain't lost a one of 'em, ain't a feelin' like it in the world.
SUPER: In a sense, this is what we do. We bring together information, ideas, and technologies and make them go where you want.
VO: EDS. Managing the complexities of e-business.
SUPER: EDS solved.
EDS.com

BRONZE

CATEGORY Banking/Financial • **ADVERTISER/PRODUCT** Westpac Banking Corporation - Olympics • **TITLE** Nev Hackett • **ADVERTISING AGENCY** The Campaign Palace, Sydney • **PRODUCTION COMPANY** Film Graphics, Sydney • **EDITING COMPANY** Frame Set & Match, Sydney • **MUSIC COMPANY** Arizona, Sydney • **SOUND DESIGN COMPANY** Jon Marsh Studios, Sydney • **ANIMATION COMPANY** na, na • **ACCOUNT EXECUTIVE** Phil Deer • **CREATIVE DIRECTOR** Ron Mather • **COPYWRITER** Mick Hunter • **ART DIRECTOR** Ian Morton • **DIRECTOR** Graeme Burfoot • **PRODUCER** Jude Lengel

VISUAL: An elderly man swims gracelessly in a pool. The man stops at the end of the pool. He's out of breath.
SUPER: Nev Hackett, Grant's Dad.
NEV HACKETT: I don't know how he does it.
VISUAL: An elderly woman runs toward a long jump pit. Without making much of a jump, she lands on her bottom.
SUPER: Sue Murphy, Adrian's Mum.
SUE MURPHY: How does he get that far?
VISUAL: A woman trying to mount a beam. She winds up hanging upside down on it.
SUPER: Anne Skinner, Lisa's Mum.
ANNE SKINNER: How on earth does she get up on this thing?
VISUAL: An old man in the water, trying to stop balls from getting into a waterpolo net.
SUPER: Barry Weekes, Liz's Dad.
BARRY WEEKES: I can't believe she can do this.
VISUAL: Four elderly people in a small rowing boat, trying to stay afloat.
SUPER: The Parents of the Oarsome Foursome.
WOMAN IN FRONT: I don't know how they do it.
SUPER: Since 1997, Westpac has provided financial support to the Australian Olympic Team.
That's not how they do it. But it does help.
Australia. We're with you.
Westpac/AOC.

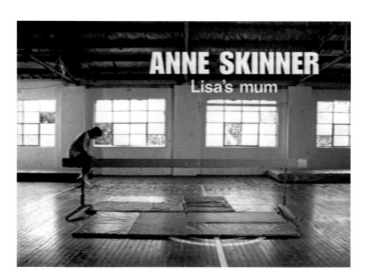

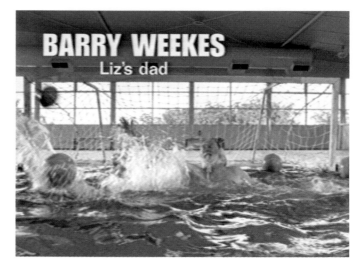

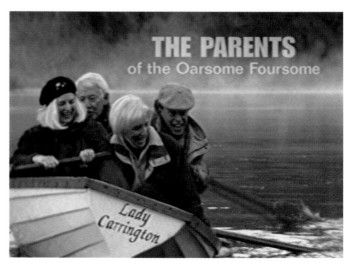

CATEGORY Beverages/Alcoholic • ADVERTISER/PRODUCT Budweiser • TITLE What Are You Doing? • ADVERTISING AGENCY Goodby, Silverstein & Partners, San Francisco • PRODUCTION COMPANY Headquarters, Santa Monica • EDITING COMPANY Bob & Sheila's Edit World, San Francisco • SOUND DESIGN COMPANY Ripe Sound • CREATIVE DIRECTOR Jeffrey Goodby, Rich Silverstein • COPYWRITER Ian Kalman • ART DIRECTOR Stefan Copiz • DIRECTOR Lloyd Stein • PRODUCER Cindy Epps • ASSISTANT PRODUCER Jennie Lindstrom

GOLD

VISUAL: Brett, a preppy guy, is sitting on his living room couch. He's watching television when the phone rings.
VISUAL: Brett picks up the phone.
BRETT: This is Brett.
VISUAL: Ian is watching television at his place.
IAN: What are you doing?
BRETT: What are you doing?
IAN: Just watching the market recap, drinking an import.
BRETT: That is correct. That is correct.
VISUAL: Another preppy guy, Chad, enters Brett's living room.
CHAD: What are you doing?
BRETT: What are you doing?
IAN: Hey Brett, who's that?
BRETT: Hey Chad, pick up the cordless.
VISUAL: Chad picks up the cordless phone off the wall.
CHAD: Chad here.
IAN: What are you doing?
CHAD: What are you doing?
BRETT: What are you doing?
CHAD: Whaaaaaa……
IAN: Whaaaaaa……
BRETT: Whaaaaaa……
VISUAL: The camera shows Brett is actually on television. These preppy guys are actually a spoof of the original "Whassup!" commercial. Two of the original "Whassup!" guys are watching the spoof. They both look at each other in disbelief.
SUPER: Budweiser.
True.

SILVER

CATEGORY Beverages/Alcoholic • **ADVERTISER/PRODUCT** Stella Artois • **TITLE** Hero's Return • **ADVERTISING AGENCY** Lowe Lintas, London • **PRODUCTION COMPANY** Gorgeous Enterprises, London • **EDITING COMPANY** The Quarry, London • **MUSIC COMPANY** Air Edel, London • **SOUND DESIGN COMPANY** 750 MPH, London • **ACCOUNT EXECUTIVE** Harriet Bell, Jeremy Bowles • **CREATIVE DIRECTOR** Charles Inge • **COPYWRITER** Paul Silburn • **ART DIRECTOR** Vince Squibb • **DIRECTOR** Frank Budgen • **LIGHTING/CAMERAMAN** Ivan Bird • **EDITOR** Paul Watts • **SOUND DESIGNER** Nigel Crowly • **MUSIC** Anne Dudley • **PRODUCER** Paul Rothwell • **AGENCY PRODUCER** Sarah Hallatt

VISUAL: The villagers rejoice at the return of two soldiers from war. Amidst the revelry, one of the men is reunited with his father, the owner of the local bar. The viewer is presented with flashbacks as the son tells his father how his comrade saved his life. Proclaiming the young man a hero, the father calls for a celebration.

However, instead of wine, the son asks for a Stella Artois. After a moment's hesitation, the father succumbs and pours his son a pint. Then as the father goes to give the hero a glass of wine, he too demands a Stella.

Distressed, though unable to refuse the man who saved his son's life, the father proceeds to pour a second pint. But, alas, nothing but froth sputters out. Apologetically declaring the Stella "off," he once again reaches for the bottle of wine. Only when we look behind the bar do we see that the father has placed his foot on the hose that supplies the precious brew. The father toasts the somber wine-sipping hero while his son gleefully knocks back his beer.

SUPER: Stella Artois. Reassuringly expensive.

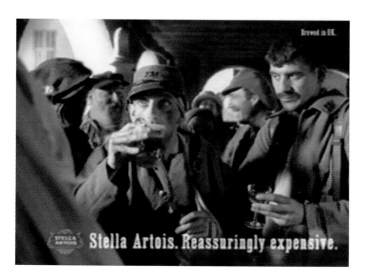

CATEGORY Beverages/Alcoholic • **ADVERTISER/PRODUCT** Budweiser • **TITLE** Come Home • **ADVERTISING AGENCY** DDB Chicago, Chicago • **PRODUCTION COMPANY** Industrial Light + Magic, San Rafael • **EDITING COMPANY** Industrial Light + Magic, San Rafael • **MUSIC COMPANY** Elias Associates, Santa Monica • **ANIMATION COMPANY** Industrial Light + Magic, San Rafael • **CHIEF CREATIVE OFFICER** Bob Scarpelli • **GROUP CREATIVE DIRECTOR** Don Pogany • **CREATIVE DIRECTOR** Craig Feigen, Adam Glickman • **COPYWRITER** Craig Feigen • **ART DIRECTOR** Adam Glickman • **DIRECTOR** Rick Schulze • **PRODUCER** Marcie Malooly • **EDITOR** Nick Seuser • **PRODUCTION DESIGNER** Randy Gaul • **AGENCY PRODUCER** Gregg Popp

SILVER

VISUAL: A house where a party is taking place.

VISUAL: A dog pushes open the screen door and walks down the front steps. He heads to a nearby field and comes to a stop. Suddenly, a blinding tractor beam shoots down from an alien spaceship in the sky and sucks the dog in the air. The alien spaceship zips away from Earth. It leaves the galaxy and makes its way to deep space, heading toward its mother planet.

The dog walks down a ramp inside a large futuristic landing dock. Two sliding doors open as he enters a dimly lit chamber. The dog is at the end of a platform in a huge high-tech coliseum; he stands before a small, strange looking alien with a crown—the Emperor—who gazes down at him from a small balcony. Thousands of other aliens sit in the stands, intensely curious about the odd creature in their midst.

A small mechanical apparatus flies in, takes hold of the dog's head and lifts it off, revealing an alien, identical to all the others, underneath. The rest of the dog costume falls away and the alien stands on his feet.

The Emperor speaks to him in an alien language. The words are subtitled.

EMPEROR SUPER: What have you learned on Earth?

RETURNING ALIEN: WHASSUP!!!

EMPEROR: WHASSUP???

ALIEN 1: WHASSUP!!!

ALIEN2: WHASSUP!!!

ALIEN 3: AHHHHHH!!!

EMPEROR: AHHHHHH!!!

RETURNING ALIEN: AHHHHHH!!!

COUNCIL MEETING: WHASSUP!!! WHASSUP!!! WHASSUP!!!

VISUAL: A satellite station on Earth. A technician listening for alien frequencies sits up in his chair.

TECHNICIAN: Oh man, we are not alone.

SUPER: Budweiser.

True.

www.budweiser.com

BRONZE

CATEGORY Beverages/Alcoholic • ADVERTISER/PRODUCT Budweiser • TITLE Whassup Language Tape • ADVERTISING AGENCY DDB Chicago, Chicago • PRODUCTION COMPANY Morton Jankel Zander, Santa Monica • EDITING COMPANY Lookinglass, Chicago & Santa Monica • MUSIC COMPANY Admusic, Santa Monica • GROUP CREATIVE DIRECTOR Don Pogany • COPYWRITER Vinny Warren • ART DIRECTOR Glen Jameson • DIRECTOR Craig Gillespie • AGENCY PRODUCER Kent Kwiatt

VISUAL: Two French guys in an apartment. One is on the couch on the phone. The other one walks in from the kitchen, arms spread.

FRENCH GUY 1: CA VAAAAAA?

FRENCH GUY 2: CA VAAAAAA?

VISUAL: Two Japanese guys in an apartment. One is on the couch on the phone. The other one walks in from the kitchen, arms spread.

JAPANESE GUY1: KONEECHEEWAAAA!

JAPANESE GUY 2: KONEECHEEWAAAA!

VISUAL: Two Scot guys in an apartment. One is on the couch on the phone. The other one walks in from the kitchen, arms spread.

SCOT 1: HOOSABOOTYEEEE!

SCOT 2: HOOSABOOTYEEEE!

VISUAL: A man sitting on a desk. A list of ways to say Whassup! in different languages scrolls down the screen as he speaks.

PRESENTER: Now you can learn how to say Whassup! In 36 different languages. Just visit Budweiser.com and learn useful phrases like, Was ist loos! or Que Pasa! Instantly bond with your fellow man the world over.

FRENCH GUY 1: Yo, telephone!

VISUAL: French Guy 2 picks up the telephone.

FRENCH GUY 2: 'allo!

JAPANESE GUY 1: CA VAAAAAAA!

FRENCH GUY 2: HOOSABOOTYE!

SCOTTISH GUY 1: KONEECHEEWA!!!

SUPER: Budweiser.

True.

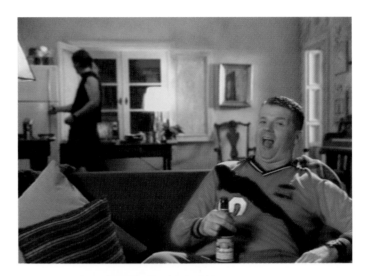

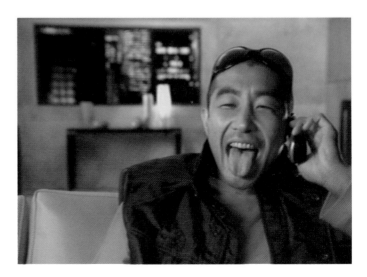

CATEGORY Beverages/Alcoholic • **ADVERTISER/PRODUCT** Budweiser • **TITLE** Whassup Girlfriend • **ADVERTISING AGENCY** DDB Chicago, Chicago • **PRODUCTION COMPANY** C&C Storm Films, New York • **EDITING COMPANY** Lookinglass, Santa Monica • **GROUP CREATIVE DIRECTOR** Don Pogany • **COPYWRITER** Vinny Warren • **ART DIRECTOR** Chuck Taylor, Justin Reardon • **DIRECTOR** Charles Stone III • **AGENCY PRODUCER** Kent Kwaitt • **EDITOR** Livio Sanchez

BRONZE

VISUAL: Dookie and his girlfriend are watching ice-skating on TV.
[**SFX:** Phone ringing.]
VISUAL: Dookie picks up cordless phone.
[**SFX:** Skates on ice, applause.]
DOOKIE: Hello.
VISUAL: Dookie's buddy is calling on a cell phone from the bar where the rest of the Whassup! gang is hanging out.
BUDDY: WHASSUP!
VISUAL: Dookie is more low-key because he's with his girlfriend.
DOOKIE: Whassup!
ALL: WHASSSSSUUUUUUUUUUUUUUUUUUUP!!!!!!
DOOKIE: Yo, what y'all doin'?
BUDDY: Watchin' the game, havin' a Bud...What's up with you?
VISUAL: Dookie turns away from his girlfriend so she won't hear what he's saying.
DOOKIE: I'm...uh...Watchin' the game. And...uh...havin' a Bud.
VISUAL: The girlfriend grips Dookie's arm. It's an exciting moment—for her anyway.
TV COMMENTARY: Triple Axel! Triple Toe Loop!
[**SFX:** Skating noises, applause.]
GIRLFRIEND: Oh, Oh, Oh!
VISUAL: Dookie's buddy is puzzled by the sounds from Dookie's phone.
BUDDY: What game you watchin'?
DOOKIE: Uuuuuuuh…
SUPER: Budweiser.
True.

CATEGORY Beverages/Alcoholic • **ADVERTISER/PRODUCT** Budweiser • **TITLE** Whassup Wasabi • **ADVERTISING AGENCY** DDB Chicago, Chicago • **PRODUCTION COMPANY** C & C Storm Films, New York • **EDITING COMPANY** Lookinglass, Santa Monica • **GROUP CREATIVE DIRECTOR** Don Pogany • **COPYWRITER** Vinny Warren • **ART DIRECTOR** Chuck Taylor, Justin Reardon • **DIRECTOR** Charles Stone III • **AGENCY PRODUCER** Kent Kwiatt

VISUAL: Dookie and his girlfriend are chatting in a Japanese sushi restaurant as they wait for their food. The waiter arrives promptly with the dishes.
WAITER: Here you are sushi…and wasabi.
DOOKIE: Wasabi?
WAITER: Yes, wasabi.
DOOKIE: WASABI! WASABI!
SUSHI CHEF: Wasabi!
DOOKIE: WASABI!
SUSHI CHEF 2: Wasabi!
SUSHI CHEF 3: Wasabi!
DOOKIE: WASABI!
SUSHI CHEF 1: Waaaa…
SUSHI CHEF 2: …saaaa…
SUSHI CHEF 3: …beee!
WAITER: Yes, wasabi.
VISUAL: Dookie's girlfriend kicks him under the table to make him stop the insanity. Dookie stops screaming Wasabi! and gives his girlfriend a penitent look.
SUPER: Budweiser.
True.

CATEGORY Confections/Snacks • **ADVERTISER/PRODUCT** Fizzels • **TITLE** Dwarves • **ADVERTISING AGENCY** Agulla & Baccetti, Buenos Aires • **PRODUCTION COMPANY** U, Buenos Aires • **EDITING COMPANY** Videocolor, Buenos Aires • **MUSIC COMPANY** Musica Aplicada, Buenos Aires • **SOUND DESIGN COMPANY** La Casa Post Sound, Buenos Aires • **ACCOUNT EXECUTIVE** Rafael Barbeito • **CREATIVE DIRECTOR** Sebastian Wilhely • **COPYWRITER** Miximiusuo Itleoff • **ART DIRECTOR** Facundo Goldaracena • **DIRECTOR** Sebastian Alfie • **PRODUCER** Jimmy Ayerza

BRONZE

VISUAL: Garden gnomes in the backyard of a house are spotted through binoculars.

VOICE ON WALKIE-TALKIE: Attention! I can see them. They've got five hostages. Go, go, go!

VISUAL: Five dwarves dressed in full camouflage appear from behind the bushes and run through the yard. As the dwarves rush forth to abduct the garden gnomes, the door to the house opens and an old lady stomps out with a broom. Knowing the enemy is coming, the dwarves head for the fence with the gnomes in tow.

One dwarf stays behind to seize the last garden gnome. When he snatches the statue, the old lady hits him with the broom. The dwarf tries to escape the blows, but he can't make it over the fence in time.

DWARF 1: Brian! Brian!

VISUAL: Brian hands the gnome to his comrades before the lady comes upon him and knocks him down. The others try to help.

BRIAN: Go on, guys. Go!

VISUAL: The dwarves take the statue and run away back to their headquarters.

They are at their hideout, surrounded by all the garden gnomes they rescued. Each dwarf takes a Fizzel candy and raises it in the air.

DWARVES: To the victory! To the victory!

DWARF 1: No! To Brian!

DWARVES: To Brian!

VO: New Fizzels Candy. The miniature soft drink.

SILVER

CATEGORY Corporate/Institutional • **ADVERTISER/PRODUCT** IBM • **TITLE** Recording Session • **ADVERTISING AGENCY** Ogilvy & Mather, New York • **PRODUCTION COMPANY** PYTKA, Los Angeles • **EDITING COMPANY** Go Robot, New York • **MUSIC COMPANY** Ear to Ear Audio, Los Angeles • **ACCOUNT EXECUTIVE** Scott Leonard • **EXECUTIVE CREATIVE DIRECTOR** Steve Hayden • **CREATIVE DIRECTOR** Susan Westre, Chris Wall • **COPYWRITER** Tom Bagot • **ART DIRECTOR** Susan Westre • **DIRECTOR** Joe Pytka • **EDITOR** Dave Bradley • **COMPOSER** Brian Banks • **EXECUTIVE PRODUCER** Lee Weiss

PRODUCER: Stay on the line, take six.

TALENT: Please stay on the line.

PRODUCER: Cut.

TALENT: Please stay on the line.

PRODUCER: Take 31.

TALENT: Please stay on the line.

PRODUCER: No. Could you add a smile to "please" please?

TALENT: A smile?

PRODUCER: Yes. These people have been waiting a long time. Have a little sympathy.

TALENT: Please stay on the line.

PRODUCER: It doesn't sound sincere. Um… do "your business."

TALENT: Your business is important to us. Your business is important to us.

PRODUCER: (mumbles) Put a beat in between "business" and "is."

TALENT: Your business is important to us.

PRODUCER: We need more empathy!

VO: There's an easier way to treat people better.

PRODUCER: Am I alone in this?

VO: e-customer service from IBM

SUPER: e-customer service

SUPER: IBM
Solutions for a small planet
www.ibm.com

TALENT: We care.

CATEGORY Corporate/Institutional • **ADVERTISER/PRODUCT** Barclay's • **TITLE** Player • **ADVERTISING AGENCY** Leagas Delaney, London • **PRODUCTION COMPANY** RSA, London • **EDITING COMPANY** The Mill, London • **ACCOUNT EXECUTIVE** Tim Delaney • **CREATIVE DIRECTOR** Olly Watson • **DIRECTOR** Tony Scott • **PRODUCER** Adrian Harrison

SILVER

ANTHONY HOPKINS: What is this about "big?"
You know seeing the big picture, having the big idea, clinching the big deal. Nobody wants to clinch the little deal. Who wants to do that? You'd be a little deal clincher. A small shot. When you go and get a burger, you want a Big Mac. You go to the fun fair, you ride the Big Dipper. You turn on the TV, you see Big Bird. Are you afraid of the Big Bad Wolf?
When I was growing up, I wanted to be the big man. I never wanted to be the little man. Even the little man wanted to be the big man.
When you go to America, you want to go to the Big Apple, not this Little Apple. When I get up in the morning, I want a big breakfast. I want my girlfriend to say, "Good morning, Big Boy" to which I'll reply, "I've got a big day today. Big meeting with a big cheese from a big studio, it's the big time for the big bucks." And she'll turn to me rolling her big blue eyes and say, "Big head."
I'll retort, "What's the big deal?" and give her a big kiss and I'll get into my big car and set off into the big wide world. She'll give me a big wave, close the door of our big house, look in the mirror and ask herself, "Does my bum look big in this?"
SUPER: Because we're big, we've become the largest online bank in the U.K.
We arrange more syndicated loans in Europe than anyone. You can access your money from over 450,000 places worldwide.
ANTHONY HOPKINS: And in my big meeting, I'll turn to one of the big hitters, and I'll say, "I love this movie, it's gonna be big. There's only small problem…my fee…I'd like it to be… erm…what's the word?…"
SUPER: A big world needs a big bank.
Barclays.
www.barclays.com

BRONZE

CATEGORY Corporate/Institutional • **ADVERTISER/PRODUCT** Die Welt (Newspaper) • **TITLE** Wheelchair • **ADVERTISING AGENCY** Springer & Jacoby Werbung GmbH & Co. KG, Hamburg • **PRODUCTION COMPANY** Cobblestone Pictures GmbH, Hamburg • **MUSIC COMPANY** Blunck und Will, Hamburg • **CREATIVE DIRECTOR** Alexander Schill, Axel Thomsen • **COPYWRITER** Alexander Weber • **ART DIRECTOR** Bastian Kuhn • **DIRECTOR** Sebastian Grousset • **PRODUCER** Jenny Krug

VISUAL: A man in a wheelchair negotiates a giant trade fair complex without problems until he suddenly gets stuck in a grill. Unexpectedly he gets up out of the wheelchair and takes notes.
SUPER: Uwe Grahl, architect.
The world belongs to those with a new way of thinking.
Die Welt.de

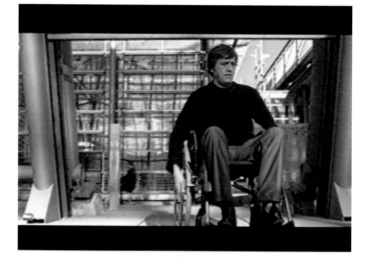

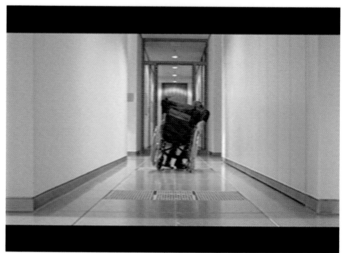

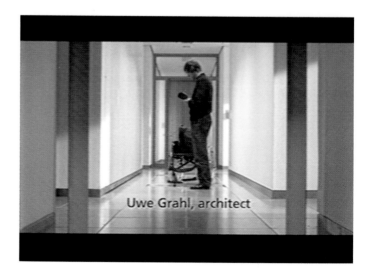

CATEGORY Corporate/Institutional • ADVERTISER/PRODUCT Amnesty International • TITLE Billboard • ADVERTISING AGENCY Lowe Lintas & Partners, Copenhagen • PRODUCTION COMPANY Parafilm, Copenhagen • MUSIC COMPANY Marie Frank Fet. Brother Brown, Copenhagen • CREATIVE DIRECTOR Hans Henrik Langevad • COPYWRITER Kim Juul • ART DIRECTOR Søren Møller Rasmussen • DIRECTOR Kim Juul • PRODUCER Niels Kau Andreasen

BRONZE

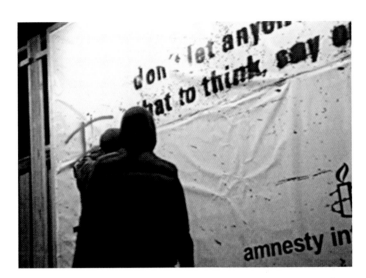

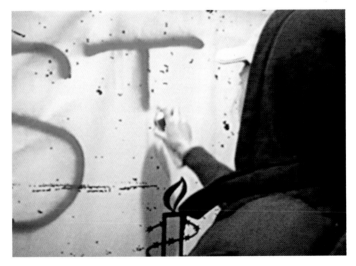

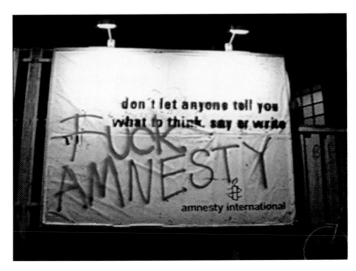

SIGN: Don't let anyone else tell you what to think, say, or write…
VISUAL: Two young people walk by the billboard. One stops to graffiti the sign.
GRAFFITI: Fuck Amnesty.
SUPER: Freedom of speech is a human right…
Amnesty International.

BRONZE

CATEGORY Cosmetics/Perfumes • **ADVERTISER/PRODUCT** Axe • **TITLE** Sugar • **ADVERTISING AGENCY** VegaOlmosPonce, Buenos Aires • **PRODUCTION COMPANY** Peluca Filmes, Buenos Aires • **EDITING COMPANY** Videocolor, Buenos Aires • **SOUND DESIGN COMPANY** Inaudito, Buenos Aires • **ACCOUNT EXECUTIVE** Martin Montoya • **CREATIVE DIRECTOR** Hernán Ponce • **COPYWRITER** Pablo Minces • **ART DIRECTOR** Norberto Vatrano • **DIRECTOR** Peluca • **PRODUCER** Horacio Ciancia, Selva Dinelli

VISUAL: The hallway of a typical flat building. The doors in the hall are closed. Suddenly, one of the doors opens. A girl in a nightdress comes out of the flat while passionately kissing a man. As he is already satisfied, he pushes the girl out of his apartment and closes the door in her face. She is left in the hallway, holding a cup of sugar. She turns to the large window in the hall and dumps out the sugar. Then she enters her own flat next door.
SUPER: The Axe Effect.

CATEGORY Dot Com Advertising • ADVERTISER/PRODUCT FusionOne • TITLE Diner • ADVERTISING AGENCY Black Rocket, San Francisco • PRODUCTION COMPANY Tool of North America, Santa Monica • EDITING COMPANY Phoenix Editorial, San Francisco • MUSIC COMPANY Earwax, San Francisco • SOUND DESIGN COMPANY Earwax, San Francisco • ANIMATION COMPANY Razorfish, Los Angeles • ACCOUNT EXECUTIVE Suzanne Reeves • CREATIVE DIRECTOR Bob Kerstetter, Steve Stone • COPYWRITER Dave Loew • ART DIRECTOR Steve Stone • DIRECTOR Bob Kerstetter • PRODUCER Stacey Higgins

BRONZE

VISUAL: Lunchtime at a greasy-spoon diner. A man sits down at the counter. A waitress comes up and pours coffee on the table. The patron wonders what's going on as the waitress places a cup and saucer in the puddle of coffee.
The cook comes over with a slab of meat loaf on a spatula, slaps it on the table and ladles gravy on it.
COOK: How ya doin'?
VISUAL: The cook sets a plate on top of the meatloaf. The waitress returns and pulls out her order pad.
WAITRESS: OK, hon, what can I get you today?
SUPER: Sync is everything.
VO: Sync is everything.
SUPER: FusionOne.
VO: FusionOne.

CATEGORY Dot Com Advertising • **ADVERTISER/PRODUCT** Recol.es (Internet Site for Professionals) • **TITLE** Anyone In The Room? • **ADVERTISING AGENCY** Vitruvio/Leo Burnett, Madrid • **PRODUCTION COMPANY** Stange Fruit, Madrid • **EDITING COMPANY** Dalton, Molinare, Madrid, Madrid • **MUSIC COMPANY** Jingle Box, Madrid • **ACCOUNT EXECUTIVE** Isabel Gistau • **EXECUTIVE CREATIVE DIRECTOR** Javier Olvariz • **CREATIVE DIRECTOR** Rafa Antón • **COPYWRITER** Santiago Romero • **ART DIRECTOR** Carlos Miniño • **DIRECTOR** Fernando García • **PRODUCER** David de la Flor

BRONZE

VISUAL: A seaside restaurant where a couple is eating dinner. A waiter pours them some wine.

WAITER: How's everything here?

WIFE: Very nice. Thank you.

VISUAL: The husband starts coughing.

WIFE: Are you all right, honey?

VISUAL: The husband drops to the floor.

WAITER: Is he all right? Is there a doctor in the house?

DOCTOR: Out of the way, I'm a doctor.

VISUAL: The doctor checks the husband's vital signs.

DOCTOR: We've got to get him to a hospital urgently.

VISUAL: The waiter notices a hydroplane on the shore of the beach.

WAITER: We need a pilot. Is there a pilot in the restaurant?

VISUAL: A man in the back of the restaurant raises his hand. Another man at a nearby table steps forth.

PILOT: I'm a pilot. What's the problem?

DOCTOR: We have to get this man out of here.

WIFE: But we don't have our passports!

WAITER: Is there a lawyer or diplomat in the room?

VISUAL: A throng of men and women rush over to help the couple.

SUPER: Ever seen so many professionals together?

www.recol.es. The only Internet platform for professionals. Recol.

CATEGORY Dot Com Advertising • **ADVERTISER/PRODUCT** All Business.com • **TITLE** Pet Store • **ADVERTISING AGENCY** Butler Shine & Stern, Sausalito • **PRODUCTION COMPANY** Stiefel & Co., Santa Monica • **EDITING COMPANY** Rock Paper Scissors, Los Angleles • **CREATIVE DIRECTOR** Mike Shine, John Butler • **COPYWRITER** Sean Austin • **ART DIRECTOR** Jerome Marucci • **DIRECTOR** Noam Murro • **PRODUCER** Rita Ribera

BRONZE

VISUAL: A man is walking by a pet store when something in the window catches his eye. He stops to stare intently at the small puppy in the display cage at the window. The man seems interested in the puppy. He taps on the window to get the attention of the store clerk. He motions for her to come to the window and gestures for her to pick up the puppy. The clerk smiles and holds the puppy up for the man to see. However, the man keeps his gaze locked on the place where the puppy was sitting. The woman stops smiling when she realizes what is really catching the man's interest. It's the business section of the newspaper that the puppy was sitting on. The man is totally absorbed by the article he's reading.
SUPER: We're very, very dedicated to business.
AllBusiness.com
Solutions for small business.

SILVER

CATEGORY Entertainment Promotion • **ADVERTISER/PRODUCT** Game Show Network • **TITLE** Botulism • **ADVERTISING AGENCY** TBWA/Chiat/Day, San Francisco • **PRODUCTION COMPANY** The Director's Bureau, Hollywood • **EDITING COMPANY** Plank, Santa Monica • **SOUND DESIGN COMPANY** Eleven, Santa Monica • **ACCOUNT EXECUTIVE** Shawn Bavanesco, Robin Blankfort • **EXECUTIVE CREATIVE DIRECTOR** Chuck McBride • **ASSOCIATE CREATIVE DIRECTOR** Rob Smiley • **COPYWRITER** Jeremy Postaer • **ART DIRECTOR** Tia Lustig • **DIRECTOR** Roman Coppola • **SENIOR PRODUCER** Betsy Beale • **EDITOR** David Herman • **SVP, MARKETING (GAME SHOW NETWORK)** Dena Kaplan • **VP, ON-AIR PROMOTIONS (GAME SHOW NETWORK)** Ken Warun

VISUAL: An elderly man lying on a hospital bed.
ELDERLY MAN: Botulism.
VISUAL: Clerk at a market.
CLERK: Botulism.
VISUAL: Little girl in her pajamas sitting in the living room. A couple is sitting on the couch in the background.
LITTLE GIRL 1: Botulism.
VISUAL: Two soldiers hanging out on their bunk beds.
SOLDIER 1: Botulism.
SOLDIER 2: Botulism.
VISUAL: Baker in the kitchen making cookies.
BAKER: Botulism.
VISUAL: Cocktail waitress holding a tray of drinks.
WAITRESS: Botulism.
VISUAL: A group of employees sitting in a lounge having coffee.
EMPLOYEES: Botulism.
VISUAL: Clerk at the market.
CLERK: Botulism.
VISUAL: Elderly man lying on the hospital bed.
ELDERLY MAN: Botulism.
VISUAL: Group of employees sitting in a lounge having coffee.
EMPLOYEES: Botulism.
VISUAL: Two little girls in matching bathing suits.
LITTLE GIRL 2: Botulism.
LITTLE GIRL 3: Botulism.
VISUAL: Little girl in living room. The couple behind her is making out.
LITTLE GIRL 1: Botulism!
VISUAL: Cocktail waitress holding tray of drinks.
WAITRESS: Botulism!
VISUAL: Clerk at market. A robber is behind him, stealing money out of the register.
CLERK: Botulism!
VISUAL: Baker rolling cookie dough in bakery.
BAKER: Botulism!
VISUAL: Woman in a Laundromat.
WOMAN: Botulism!
VISUAL: A couple on a couch eating burger and fries. The guy throws a French fry at the screen.
GUY ON COUCH: Botulism!
VISUAL: Cocktail waitress holding tray of drinks.
WAITRESS: Botulism!
VISUAL: Clerk at market. The robber is watching the screen, his hand still in the register drawer.
CLERK: Botulism!
ROBBER: Botulism!
VISUAL: Elderly couple sitting in front of the television.
ELDERLY COUPLE: Botulism!
VISUAL: Game show on TV. Contestant is thinking of an answer.
CONTESTANT: Salmonella.
[**SFX:** Buzzer going off.]
SUPER: You Know You Know; Gameshow Network
[**SFX:** Chime. Clapping and cheering.]

CATEGORY Entertainment Promotion • ADVERTISER/PRODUCT Los Angeles Dodgers • TITLE Giant Loser • ADVERTISING AGENCY
WONGDOODY, Los Angeles • PRODUCTION COMPANY The A+R Group, Los Angeles • EDITING COMPANY Cosmo Street, Santa Monica •
ACCOUNT EXECUTIVE Steve Koch • CREATIVE DIRECTOR Tracy Wong • COPYWRITER Matt McCain • ART DIRECTOR Michael Ivan Boychuk •
DIRECTOR David Frankham • PRODUCER Brian O'Rourke

SILVER

VISUAL: Hidden camera footage of an L.A. Dodgers fan in full Dodger regalia walking onto a crowded city bus and taking a seat.
SUPER: Bus Route 9
Hidden Camera.
VISUAL: The fan tries to persuade a stranger across the aisle to put on a San Francisco Giants baseball cap.
FAN: Excuse me. Can you just put this on for a second? Could I just get you to put it on? I'm sorry, sir, it'll just take a second. No harm, no foul. I'd really appreciate it.
VISUAL: The fan reaches over and puts the Giants cap onto the reluctant stranger's head. The fan begins heckling the man in the Giants cap.
FAN: What are you, a Giant loser?! You're like the Giant bums?! The Giant no-chance-you're-ever-getting-past-Blue?! Yeah, that's what I thought! Yeah, wear that hat proudly! Cause I'm a Giant Loser! I like to cheer on people that don't win! That's me, look at me everybody! I like people who don't win games! That's me!
VISUAL: The fan reaches over and politely takes the Giants cap off the stranger's head and sits back down.
FAN: Thank you. Thank you.
SUPER: You have to be there.
Dodgers Tickets: 1-800-6-DODGER
FAN (VO): Anybody wanna try the hat on?

BRONZE

CATEGORY Entertainment Promotion • **ADVERTISER/PRODUCT** The 4th Thai Short Film and Video Festival • **TITLE** James Bond • **ADVERTISING AGENCY** Leo Burnett Ltd., Bangkok • **PRODUCTION COMPANY** Silhouette, Bangkok • **EDITING COMPANY** Cutting Edge, Bangkok • **SOUND DESIGN COMPANY** Cutting Edge, Bangkok • **CREATIVE DIRECTOR** Vilailak Udomsrianan • **COPYWRITER** Rakkhana Poonsawatkitikoon • **ART DIRECTOR** Seree Simasathian, Badin Limapornvanich • **DIRECTOR** Praipot Chunlawong • **PRODUCER** Sompetch Nuntasinlapachai • **MEDIA DIRECTOR** Withaya Tangtanaporn

[MUSIC: James Bond Theme]
VISUAL: The classic title sequence of a James Bond film.
James Bond strolls into the scene.
[SFX.: Gun shot.]
VISUAL: Bond is suddenly shot down. Blood floods the frame.
[SFX: Ambulance sirens.]
SUPER: The end.
The 4th Thai Short Film Fesitval
August 11-17, 2000 at Major Cineplex.
Thai Film Foundation.

CATEGORY Entertainment Promotion • **ADVERTISER/PRODUCT** De Lotto - Jackpot • **TITLE** Speed Bump • **ADVERTISING AGENCY** Result DDB, Amstelveen • **PRODUCTION COMPANY** Hazazah, Amsterdam • **SOUND DESIGN COMPANY** John Bake Sound, Amsterdam • **ACCOUNT EXECUTIVE** Sjef Wolters, Nelly de Wit • **CREATIVE DIRECTOR** Michael Jansen • **COPYWRITER** Dylan de Backer • **ART DIRECTOR** Joris Kuijpers • **DIRECTOR** Yani • **PRODUCER** Susanne Huisman

BRONZE

VISUAL: A Lamborghini screeches to a halt at a speed bump. A woman gets out of the passenger side of the vehicle and struggles to pull out the groceries in the car. When she has removed enough weight from the car, only then is the Lamborghini able to drive over the speed bump. Once the car is over the bump, the woman gets back inside with her groceries, and the Lamborghini takes off.
VO: Know what you're getting into.
Lotto. The biggest risk of becoming a millionaire.
SUPER: Lotto. The biggest risk of becoming a millionaire.

BRONZE

CATEGORY Entertainment Promotion • ADVERTISER/PRODUCT San Francisco Jazz Festival • TITLE Low Riders • ADVERTISING AGENCY Butler, Shine & Stern, Sausalito • PRODUCTION COMPANY Kaboom, San Francisco • EDITING COMPANY FilmCore, San Francisco • MUSIC COMPANY San Francisco Jazz Festival, San Francisco • ASSOCIATE CREATIVE DIRECTOR Ryan Ebner • CREATIVE DIRECTOR John Butler, Mike Shine • COPYWRITER Ryan Ebner • ART DIRECTOR Stephen Goldblatt • DIRECTOR Brandon Dickenson • PRODUCER Stephanie Bunting

VISUAL: Three tough-looking, urban youth driving a lowered Impala convertible.
[MUSIC: Blue Note jazz.]
VISUAL: The lowriders are nodding along with the music, enjoying the ride. Suddenly, the guy in the passenger seat points up ahead.
GUY 1: Yo! Pedestrian!
VISUAL: The driver quickly changes the radio station.
[MUSIC: Heavy gangsta rap.]
VISUAL: The Impala pulls up to the stoplight next to the pedestrian. The low riders are nodding their head along with music, looking tough. The pedestrian, a white guy, looks a bit nervous because of the attitude coming from the Impala. The light turns green, and the car drives away. The guy in the backseat turns around to give the signal.
GUY 2: Clear!
VISUAL: The driver calmly changes the booming gangsta rap back over to the Blue Note jazz.
[MUSIC: Blue Note jazz.]
VISUAL: The three continue to enjoy the ride.
SUPER: It's that time of year again.
The San Francisco Jazz Festival.

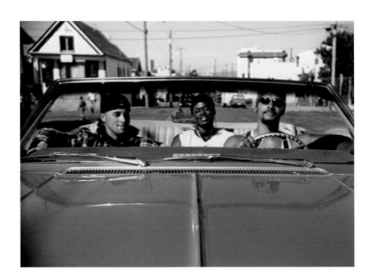

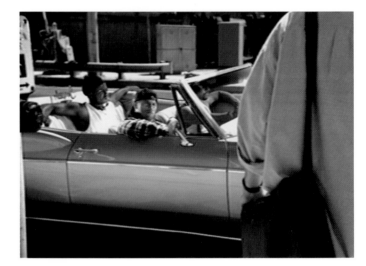

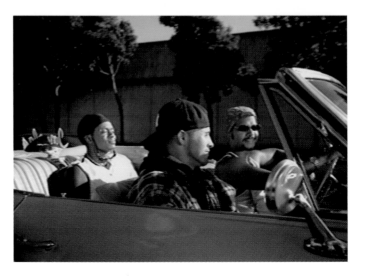

CATEGORY Foods • **ADVERTISER/PRODUCT** John West • **TITLE** Bear • **ADVERTISING AGENCY** Leo Burnett, London • **PRODUCTION COMPANY** Spectre, London • **EDITING COMPANY** Cut & Run, London • **SOUND DESIGN COMPANY** Jungle • **CREATIVE DIRECTOR** Mark Tutssel, Nick Bell • **COPYWRITER** Paul Silburn • **ART DIRECTOR** Paul Silburn • **DIRECTOR** Daniel Kleinman • **PRODUCER** David Botterell • **EDITOR** Steve Gandolphi • **AGENCY PRODUCER** Charlie Gatsy

GOLD

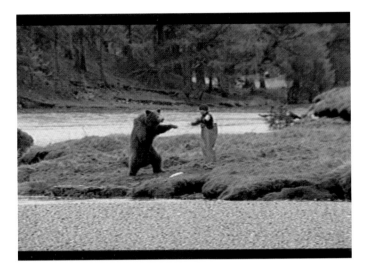

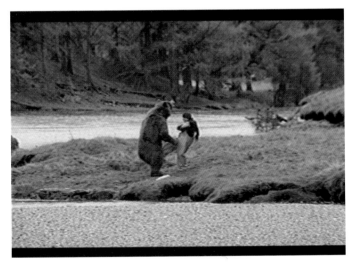

VISUAL: Bears are hunting for fish at a river mouth.
VO: At the river mouth the bears catch only the tastiest, most tender salmon.
VISUAL: A bear catches a huge salmon. A fisherman rushes out of the woods.
VO: Which is exactly what we at John West want.
VISUAL: A rumble ensues between the bear and the fisherman. Despite demonstrating some Wu Tang moves, the grizzly is finally distracted by the fisherman and floored by a well-aimed boot to the gonads. The fisherman steals the fish and runs back into the woods.
VO: John West endures the worst to bring you the best.

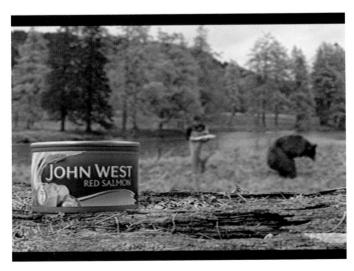

SILVER

CATEGORY Foods • **ADVERTISER/PRODUCT** Belette Soft Spread • **TITLE** Passport • **ADVERTISING AGENCY** Paltemaa Huttunen Santala TBWA, Helsinki • **PRODUCTION COMPANY** Moland Film Company, Copenhagen • **EDITING COMPANY** Destiny, Copenhagen • **SOUND DESIGN COMPANY** Ministi, Copenhagen • **ACCOUNT EXECUTIVE** Katja Haverinen • **COPYWRITER** Jusa Valtonen • **ART DIRECTOR** Juha Larsson • **DIRECTOR** Stefan Treschow • **PRODUCER** Roger Kormind • **MARKETING MANAGER** Jussi Hirvelä • **PRODUCT MANAGER** Marjo Lehtinen

VISUAL: A slender man hands his passport to a female passport officer at the airport. Instead of handing it back right away, she looks at the document suspiciously; there is a photo of a fat man in the passport.
The slender man feels uncomfortable with this suspicion until he realizes what is bothering the officer. The man blows up his cheeks to show a resemblance to the passport photo. The officer gives the passport back to the man with a sigh.
SUPER: Belette tub.
Very light soft spread.

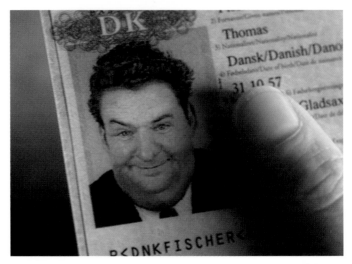

CATEGORY Health Care Services • **ADVERTISER/PRODUCT** Bun-en System • **TITLE** Smoking Defector • **ADVERTISING AGENCY** Dentsu Inc., Tokyo • **PRODUCTION COMPANY** Tohokushinsha Film Corporation, Tokyo • **CREATIVE DIRECTOR** Masaaki Tsuruho • **COPYWRITER** Yoichiro Abe • **DIRECTOR** Shinya Nakajima • **PRODUCER** Satoshi Matsumoto • **ADVERTISER** Midori Anzen

BRONZE

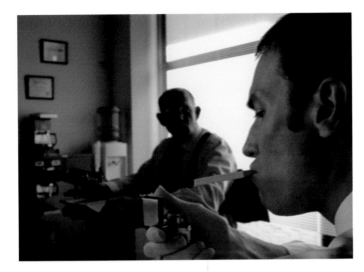

VISUAL: A smoker is about to light a cigarette in the office.
MAN 1: No smoking.
WOMAN: If you want to smoke so badly, go to Japan!
VISUAL: The smoker returns home, tired of being scolded for his habit. He sits down on his couch and turns on the TV.
TV NEWS: In Japan today boatloads of refugees continue to arrive from all over the world. No-smoking campaigns back home have driven them into leaving their countries in search of Bun-en culture.
VISUAL: Footage on TV shows refugees arriving to the shores of Japan in inflatable rafts.
TV NEWS: The Bun-en system of Japan helps smokers and nonsmokers achieve a spirit of unity.
VISUAL: Two smokers are standing with a nonsmoker around the Bun-en machine, which sucks in the smoke from the cigarettes. The smoker watching TV is inspired by this news.
SMOKER: Japan.
VISUAL: The smoker, scruffy with beard after spending weeks on a raft, is ecstatic when he sees the Japanese shore in the distance.
SMOKER: Japan! Japan!
VISUAL: Several officials are waiting for the refugees to arrive. They help the smoker get out of the boat, where he is instantly surrounded by women offering cigarettes, tea, and fresh clothes.
SMOKER: Bun-en!
VISUAL: The smoker is standing around the Bun-en system with a cigarette in his hand and a smile on his face.
SUPER: We're clearing the air.
http://www.midori-bunen.com.

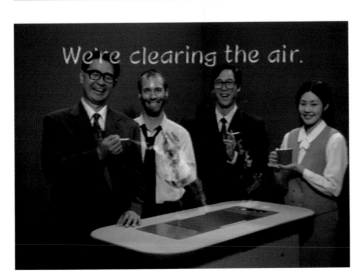

BRONZE

CATEGORY Home Products • **ADVERTISER/PRODUCT** Clorox - PineSol • **TITLE** Bad Aim • **ADVERTISING AGENCY** Palmer Jarvis DDB, Toronto • **PRODUCTION COMPANY** Jolly Roger, Toronto • **EDITING COMPANY** Stealing Time, Toronto • **SOUND DESIGN COMPANY** Lonesome Pine, Toronto • **ACCOUNT EXECUTIVE** Melanie Johnston, Danielle Zima • **CREATIVE DIRECTOR** Neil McOstrich, David Chiavegato, Rich Pryce-Jones • **COPYWRITER** Ben Weinberg • **ART DIRECTOR** Shelly Weinreb, Marketa Krivy • **DIRECTOR** Wayne Craig • **PRODUCER** Andrew Schulze, Peter Davis • **EDITOR** Mark Hajek

VISUAL: A little boy, while using the washroom, is distracted by his mother's voice. Turning to respond, he misses the toilet while he pees. Oblivious to his error, he runs off to enjoy the day.
SUPER: Pine-Sol cleans the dirt you know about. And the dirt you don't.

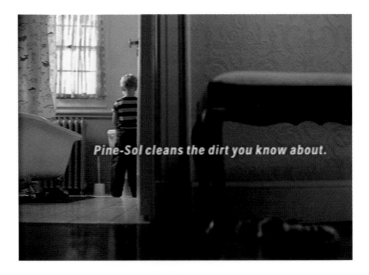

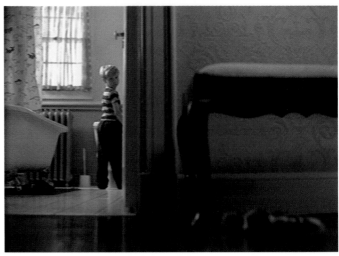

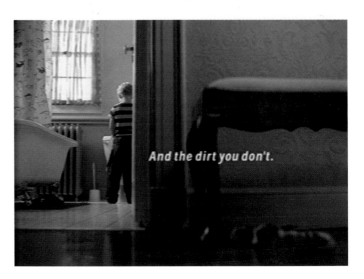

CATEGORY Media Promotion • **ADVERTISER/PRODUCT** Revista E'Poca • **TITLE** The Week • **ADVERTISING AGENCY** W/Brasil, São Paulo •
PRODUCTION COMPANY Ad Studio, São Paulo • **EDITING COMPANY** Ad Studio, São Paulo • **MUSIC COMPANY** Ad Studio, São Paulo •
CREATIVE DIRECTOR Washington Olivetto • **COPYWRITER** Alexandre Machado • **ART DIRECTOR** Jarbas Agnelli • **DIRECTOR** Jarbas Agnelli

GOLD

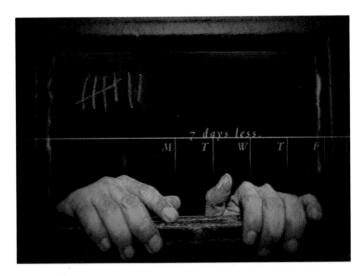

VO: To the prisoner…7 days less.
To the sick…7 days more.
To the happy…7 reasons.
To the sad…7 remedies.
To the rich…7 dinners.
To the poor…7 hungers.
To hope…7 new dawns.
To the sleepless…7 long nights.
To the lonely…7 chances.
To the absent…7 guilts.
To a dog…49 days.
To a fly…7 generations.
To business men…25% of the month.
To economists…0.019 of the year.
To the pessimist…7 risks.
To the optimist…7 opportunities.
To the earth…7 turns.
To the fisherman…7 returns.
To meet a deadline…too little.
To create a world…enough.
To someone with the flu…the cure.
To a rose in a jar…death.
To history…nothing.
To Epoca…everything.
SUPER: Epoca.
Every week.

SILVER

CATEGORY Media Promotion • **ADVERTISER/PRODUCT** Mercado • **TITLE** Crosswalk • **ADVERTISING AGENCY** CraveroLanis EURO RSCG, Buenos Aires • **PRODUCTION COMPANY** Andon Cine, Buenos Aires • **ACCOUNT EXECUTIVE** Elizabeth Ares • **GENERAL CREATIVE DIRECTOR** Juan Cravero, Dario Lanis • **CREATIVE DIRECTOR** Esteban Pigni • **COPYWRITER** Guillermo Castañeda, Esteban Pigni • **ART DIRECTOR** Mercedes Tiagonce, Sebastian Garin • **DIRECTOR** Ruben Andon • **PRODUCER** Carlos Volpe • **CLIENT SUPERVISOR** Monica Moccia

VISUAL: A blind man walks down the street with his cane. He stops at the curb of a busy intersection. The blind man stands next to a man with sunglasses.

MAN WITH SUNGLASSES: Crossing?

BLIND MAN: Yes.

VISUAL: The man wearing sunglasses takes the blind man's arm to help cross. When the camera zooms out, it is shown that the man with sunglasses is also blind. The two head right into the busy intersection, unaware of the dangerous situation they have put themselves into.

SUPER: Even worse than not being informed is believing that you are.

Mercado. Business Magazine.

CATEGORY Media Promotion • **ADVERTISER/PRODUCT** Dagbladet (Newspaper) • **TITLE** Strong Opinions • **ADVERTISING AGENCY** JBR McCann, Oslo • **PRODUCTION COMPANY** EPA, Stockholm • **ACCOUNT EXECUTIVE** Trond Sando • **CREATIVE DIRECTOR** Paal Tarjei Aasheim • **COPYWRITER** Bjornar Buxrud, Paau Tarjei • **ART DIRECTOR** Jannicke Ostrie, Joachim Haug • **DIRECTOR** Calle Astrand, Chris Von Reis • **PRODUCER** Johan Persson • **ACCOUNT MANAGER** Anita N. Dahl • **AGENCY PRODUCER** Tonje Ostbye

BRONZE

VISUAL: A politician visits a convalescent home followed by a full press corps. He is obviously there for the publicity. The elderly people are lined up on exhibition, and the politician is extremely friendly. He is shaking wrinkled hands and patting old shoulders while the photographers document his friendliness. But when walking down the corridor with only his aides, it is obvious that he is disgusted with being at the nursing home. He's constantly wiping his hands on a handkerchief, and his face is pinched from the smell.

The politician approaches a blind woman in a wheelchair. He allows her to "see" his face with her hands, but suddenly she starts pinching him. The politician is doing his best to get away from the woman without resorting to anger. After he struggles out of her grip, she gives him a hard slap across the face. The press is there to document it all. The upset politician hurries off. The elderly woman, who can really see, picks up the Dagbladet newspaper with a triumphant smile and starts to read.

SUPER: Dagbladet. Strong opinions.

BRONZE

CATEGORY Media Promotion • **ADVERTISER/PRODUCT** ESPN • **TITLE** Swimming Pool • **ADVERTISING AGENCY** Ground Zero, Marina Del Rey • **PRODUCTION COMPANY** Headquarters, Santa Monica • **EDITING COMPANY** Imago, Venice • **ACCOUNT EXECUTIVE** Patricia Phelan • **CREATIVE DIRECTOR** Court Crandall • **COPYWRITER** Kristina Slade • **ART DIRECTOR** Patrick Harris • **DIRECTOR** seanmullens • **PRODUCER** JJ Morris • **EXECUTIVE PRODUCER** Alex Blum, Tom Mooney, Andrew Denyer

VISUAL: A group of elderly women are doing water aerobics in a community pool. They toss an exercise ball from one person to the next. Alongside the pool, the instructors are giving instructions and shouting encouragement. The instructors, according to their t-shirts, are each designated by a certain month: April, May, June, July, August, and September.

APRIL: Nice work here. This is great stuff, ladies. That's great! All we can ask is that you give it your best try!

AUGUST: You guys are fantastic! No, super-fantastic!

JULY: Super-fantastic!

VISUAL: Suddenly, a man wearing a t-shirt labelled "OCTOBER" pops out from underwater with a furious yell. He gets in the face of one of the players.

OCTOBER: Not. Good. Enough! Not good enough, Jean. It's do or die time! What do you want out of this, Jean? Do you want a championship or do you want a fourth grade intramural game? 'Cause that's what you're giving me now!

SUPER: October is different.

OCTOBER VO: You're not giving me pro, you're giving me fourth grade, and if I want fourth grade, I'll hire a bunch of fourth graders!

SUPER: Major League Baseball Playoffs on ESPN.

CATEGORY Public Service • **ADVERTISER/PRODUCT** Companion Animal Placement • **TITLE** Park • **ADVERTISING AGENCY** Suburban Advertising, New York • **PRODUCTION COMPANY** Compass Films, New York • **EDITING COMPANY** 89 Greene Editorial, New York • **CREATIVE DIRECTOR** Eric Aronin • **COPYWRITER** Eric Aronin • **ART DIRECTOR** Dave Laden, Eric Aronin • **DIRECTOR** Kenan Moran • **PRODUCER** Karen Renaudin • **EXECUTIVE PRODUCER** Lise Ostbirk, Kathrin Lausch • **LINE PRODUCER** Karen Renaudin • **EDITOR** Jordan Green • **MUSIC** Erik Satie • **CASTING** Liz Lewis Casting • **DIRECTOR OF PHOTOGRAPHY** Sean O'De • **ON-LINE** Invisible Dog • **POST PRODUCTION** 89 Greene Editorial, New York • **CLIENT** Companion Animal Placement

GOLD

VISUAL: A young man with a cute little dog sits down next to a kind, elderly woman. When the woman is looking away, the young man rummages through her purse. He steals her money and tosses her medication away. Without judgment, the dog licks his face with undying affection.
SUPER: That's the great thing about pets. They really don't care. Adopt today.
Companion Animal Placement.
www.rescue-a-pet.com.

SILVER

CATEGORY: Public Service • **ADVERTISER/PRODUCT:** Florida Department of Health • **TITLE:** Secrets • **ADVERTISING AGENCY:** Crispin Porter + Bogusky, Miami • **PRODUCTION COMPANY:** Villains, Los Angeles • **EDITING COMPANY:** FilmCore, Santa Monica • **MUSIC COMPANY:** One Callery Productions, Los Angeles • **SOUND DESIGN COMPANY** Mit Out Sound, San Francisco • **ANIMATION COMPANY** Imaginary Forces, Los Angeles • **ACCOUNT EXECUTIVE** Barbara Karalis, Claudia Contreras • **CREATIVE DIRECTOR** Alex Bogusky • **COPYWRITER** Tom Adams, Tim Roper • **ART DIRECTOR** Dave Clemans, Paul Keister • **DIRECTOR** Phil Joanou • **PRODUCER** Jane Reardon, Terry Stavoe, Sara Lopez

NOTE: This commercial quickly skips to various sequences because of its movie preview format.

SUPER: EVIL EMPIRE PICTURES

DAD: Honey, I'm home…

VO: There's not a more "perfect" neighbor, than…

NEIGHBOR (to investigator): Mike Howard? He's a decent fellow. Minds his own business…

JENN (at school): Hi.

BRAD (to Jenn): Hi.

VO: But even for the "perfect" father of the "perfect" family… Certain questions remain.

INVESTIGATIVE REPORTER (shouting thru crowd): Why won't you return my phone call?

NEIGHBOR: So…what do you do for a living there, Howard?

TEEN FRIEND: Do you have any clue what your Dad does for a living, Jenn?

SNITCH: What do they hope to gain from these kids?

DAD (to teens in his TV room): Hi.

VISUAL: Teens look suspiciously at Dad.

INVESTIGATIVE REPORTER: What is the connection between a 51-year-old "executive" and a bunch of…teenagers?

VO: And the closer you get to the answer . . .

TEEN BOY (to Brad): There's something about Jenn's dad…

VO: The more you'll realize…that "perfect"…is way too good to be true.

TOP EXECUTIVE: We've got to gain the trust of these young people. Our survival depends on it.

DAD (to Jenn): I know you're getting information all the time on a lot of things.

PROTESTOR: You killed my father! Murderer!

DAD (to Jenn): I trust you to make up your own mind.

TOP EXECUTIVE (continues his directive to associates): We must study their be-havior patterns, their clothes, their music, the jargon they speak…

DAD (observing teenagers): They're our only source of replacement.

VISUAL: Snitch confides to reporter in darkened parking garage.

SNITCH: They've built a monster. Now they have to find a way to feed it.

VO: Evil Empire Pictures invites you to explore a world…

INVESTIGATIVE REPORTER: They take in over three thousand kids a day.

FELLOW EXECUTIVE (to Howard): What is this "doomsday scenario?"

INVESTIGATIVE REPORTER (continued): A third of them never come out.

VO: …where Father of the Year…

BRAD (to Jenn): People are dying. And your dad has something to do with it!

VISUAL: Jenn slaps Brad.

VO: And Employee of the Month…could be committing the crime of the Century.

DAD (reassuringly): I've never lied to you, Jenn.

JENN (crying): No, you just failed to mention a few million things!

BRAD (to Jenn): Sooner or later, you're gonna have to choose sides.

DAD (crazed at Jenn): I am just…trying…to do…my job!

SUPER: SECRETS OF A TOBACCO EXECUTIVE

DAD (delivering commencement speech): I'm a big believer in the youth of America. You are our future.

SUPER: ANOTHER TRUTH PRODUCTION

CATEGORY Public Service • **ADVERTISER/PRODUCT** Associazione Italiana Parkinsonian • **TITLE** Associazione Italiana Parkinsonian • **ADVERTISING AGENCY** McCann Erickson, Milan • **PRODUCTION COMPANY** Film Master SRL, Milan • **EDITING COMPANY** Antonio DiPeppo, Milan • **MUSIC COMPANY** Madasky, Milan • **CREATIVE DIRECTOR** Stefano Campora • **COPYWRITER** Stefano Campora • **ART DIRECTOR** Federico Pepe • **DIRECTOR** Ago Panini • **EXECUTIVE PRODUCER** Alessio Gramazio

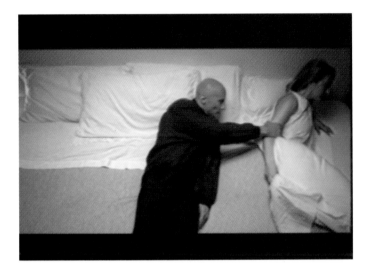

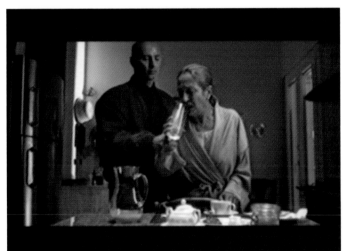

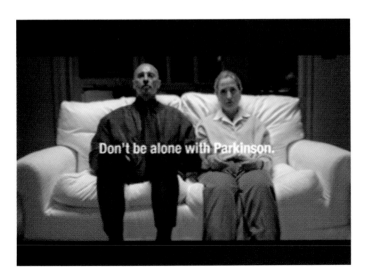

VISUAL: A woman wakes up in the morning. A man in a green jacket lies next to her. He grips her arm, preventing her from getting out of bed.

The woman pours herself a glass of water. Before she can drink, the same man grabs her hand, stopping the glass from reaching her lips.

The woman takes a teakettle off the stove and sets it on a tray. As she carries the tray, the man knocks it out of her hands. The man wraps his arms around the woman so she can't put on her overcoat.

SUPER: Living with Parkinson isn't easy.

VISUAL: The woman, frustrated beyond all belief, hits the man. He silently takes the abuse.

SUPER: With us it will be easier.

VISUAL: The woman sits on the couch with the man in the green jacket. He grabs her wrist and shakes it to make her hand twitch.

SUPER: Don't be alone with Parkinson.

Italian Parkinsonian Association.

BRONZE

CATEGORY Public Service • **ADVERTISER/PRODUCT** AA Alcoholics Anonymous • **TITLE** Police Control • **ADVERTISING AGENCY** McCann-Erickson, Zürich • **PRODUCTION COMPANY** Pumpkin Film, Zürich • **CREATIVE DIRECTOR** Claude Catsky • **COPYWRITER** Claude Catsky • **ART DIRECTOR** Claude Catsky • **DIRECTOR** Guntmar Lasning • **PRODUCER** Sonja Brand, Roger Neuburger

VISUAL: A drunken man gets in his car and drives home. Along the way, he's swerving his vehicle because his vision is going out of focus. Unfortunately for him, he is stopped at a police checkpoint before he can make it home. The driver, cursing his situation, pulls over and rolls down his window. When the officer approaches, the driver tries to explain himself to the policeman, but he only winds up mumbling his excuse.

The officer replies to this drunken behavior by mumbling, too. It seems the policeman has been drinking, too!

SUPER: Alcoholism. It can happen to anyone.

We can help. Call 0848 848 846.

Alcoholics Anonymous.

CATEGORY Public Service • **ADVERTISER/PRODUCT** American Legacy Foundation • **TITLE** Memorial - Revised • **ADVERTISING AGENCY** ARNOLD Worldwide, Boston • **PRODUCTION COMPANY** Redtree Productions • **EDITING COMPANY** Mad River Post • **MUSIC COMPANY** Elias Music • **SOUND DESIGN COMPANY** Blast/Soundtrack • **ACCOUNT EXECUTIVE** Sue Richmond, Rick Abruzzese • **CHIEF CREATIVE DIRECTOR** Ron Lawner • **GROUP CREATIVE DIRECTOR** Pete Favat, Alex Bogusky • **CREATIVE DIRECTOR** Pete Favat, Alex Bogusky • **COPYWRITER** Annie Finnegan • **ART DIRECTOR** Robert Hamilton • **DIRECTOR** Christian Hoagland • **EXECUTIVE PRODUCER** RJ Casy, Maria Sheehan • **PRODUCER** Keith Dezen • **EDITOR** Tom Scherma, Gala Verdugo • **COMPOSER** Alex Lasarenko • **ARRANGER** Fritz Doddy • **SOUND DESIGNER** Joe O'Connell, Mike Secher • **LINE DIRECTOR** Jeff Trenner • **COLORING** Nice Shoes • **COLORIST** Lez Rudge

BRONZE

SUPER: Washington, D.C.
TIM: My fellow Americans! As you know, Washington is full of memorials to people who've died. Well, today we're building a new one that's kind of important.
VISUAL: Teenagers rake the Memorial grounds and prepare to build it.
TIM: The Tobacco Memorial.
VISUAL: Teenagers empty body bags out of huge trucks. They carry the bags into a corner of the lot. Spectators are curiously watching the construction of the memorial.
TIM: 1,200 loyal customers dead every day.
VISUAL: Teenagers are dragging even more body bags out of the trucks. There is now a big pile of body bags in the lot.
SUPER: Sponsored by truth.
TIM: And the cigarette companies just keep cranking 'em out.
VISUAL: Tim is talking to a couple on the street.
WOMAN: What are those?
TIM: Oh, they're mothers, fathers, sisters, brothers, friends…ya know…
VISUAL: Bags are thrown on a conveyer belt and dropped onto the huge pile. Tim is on top of one of the trucks, pointing at the headstone being set in front of the memorial.
TIM: This is so everyone in America can see what Big Tobacco is really up to.
VISUAL: Truth banner drops down the side of adjacent building. There is an aerial shot of the pile of body bags.
TIM VO: If anyone finds this offensive, so do we.
SUPER: thetruth.com

BRONZE

CATEGORY Public Service • **ADVERTISER/PRODUCT** SWR - Television Station • **TITLE** Amok 2 • **ADVERTISING AGENCY** Ogilvy & Mather, Frankfurt • **PRODUCTION COMPANY** Das Werk, Frankfurt • **EDITING COMPANY** Christoph Matthies • **MUSIC COMPANY** Sinus AV Studio/Lars Kellner • **ANIMATION COMPANY** David Volkavicius • **ACCOUNT EXECUTIVE** Delle Krause • **COPYWRITER** Johannes Krempl • **ART DIRECTOR** Alexander Heil • **PRODUCER** Julia Franzke • **COMPUTER ANIMATION/ILLUSTRATION** David Volkavicius

VISUAL: The opening sequence for the "Amok II" video game appears. The anonymous player of the game selects a firearm and enters the Columbine High gallery. Footage of the Columbine High shooting is shown and a rifle target appears on the screen. The player aims at the people in the footage and fires.
SUPER: Do not underestimate the power of video games. A recommendation of SWR Television.

CATEGORY Public Service • ADVERTISER/PRODUCT Molson Take Care • TITLE Wheelchair • ADVERTISING AGENCY TAXI Advertising & Design, Toronto • PRODUCTION COMPANY Avion, Toronto • EDITING COMPANY Chris Parkins, Toronto • MUSIC COMPANY Great Big Music, Toronto • ACCOUNT EXECUTIVE Gary McGuire • CREATIVE DIRECTOR Zak Mroueh, Paul Lavoie • COPYWRITER Zak Mroueh • ART DIRECTOR Paul Lavoie • DIRECTOR Paul Lavoie, Zak Mroueh • PRODUCER Louise Blouin

BRONZE

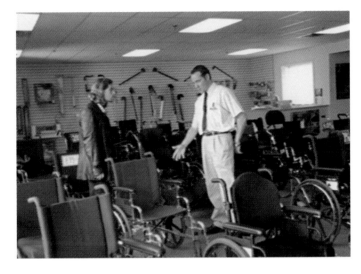

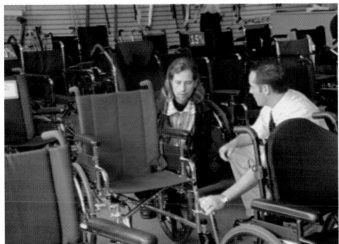

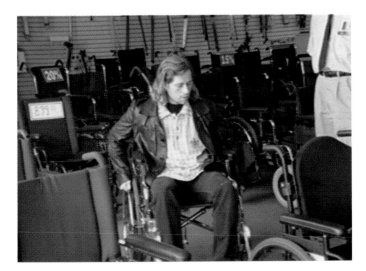

VISUAL: Wheelchair showroom. A salesman is explaining the benefits of a particular model to a young, able-bodied man.

SALESMAN: So, this is the lightest wheelchair in its category. As you can see, it has a very small wheelbase, thus giving you very, very sharp turns. Jump in. Give it a try.

VISUAL: The young man sits in the chair, tests its turning capabilities.

SALESMAN: And also, being titanium, you get a lifetime warranty on that frame.

VISUAL: The young man is deciding whether or not to buy.

SALESMAN: So, when is this big party of yours happening?

YOUNG MAN: Tomorrow. I'm probably going to get totally hammered…drive home.

SUPER: If you're going to drink and drive, plan ahead.
Molson.
Don't drink and drive.

CATEGORY Public Service • **ADVERTISER/PRODUCT** Childrens' Rights Campaign • **TITLE** Invisible Children • **ADVERTISING AGENCY** Contrapunto, Madrid • **PRODUCTION COMPANY** Piramide, Madrid • **EDITING COMPANY** Mad Pix, Madrid • **SOUND DESIGN COMPANY** Classic & New • **CREATIVE DIRECTOR** Antonio Montero • **COPYWRITER** Juan Silva • **ART DIRECTOR** Duarte Pinheiro • **DIRECTOR** Luis Alonso • **PRODUCER** Mamen F. Puyot

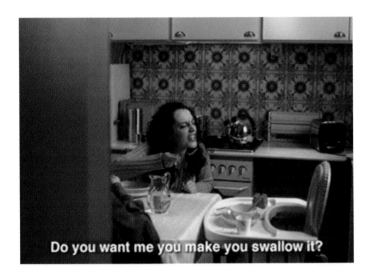

VISUAL: Husband and wife are eating soup at the table. Between them is an empty child's seat with a bowl of soup on it. The mother starts yelling at the empty seat.

MOTHER: Do you want me to make you swallow it? What's wrong with you? Can't you hear me? Are you deaf as well as stupid?

VISUAL: A father watching TV is annoyed by the sound of a toy car. Irritated, he gets up and approaches an empty corner of the room. He begins thumping the air as if someone was there.

FATHER: When I say be quiet, I mean be quiet!

VISUAL: A mother unlocks a door and turns on the light in the empty closet.

MOTHER: Calmer now, are you? Because if not, you'll stay here another whole day. I'm in no hurry.

VISUAL: The mother locks the door again.
In the final scene, a father enters a room and gets into an unoccupied bed. As he gets under the sheets of the small child's bed, he begins stroking the empty space next to him.

FATHER: Show me how much you love Daddy.

VO: There are some situations a child should never have to go through, not even to make this commercial.

SUPER: Council of Andalusia. Campaign for Children's Rights.

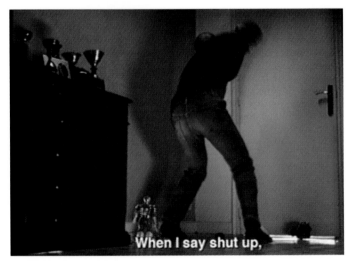

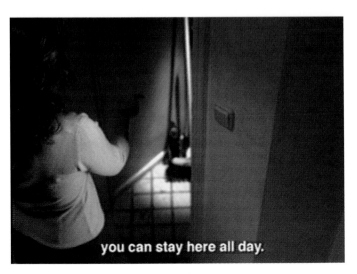

CATEGORY Recreational Items • **ADVERTISER/PRODUCT** Scrabble • **TITLE** Syphilis • **PRODUCTION COMPANY** Odeon Productions • **CREATIVE DIRECTOR** Andy Greenaway • **COPYWRITER** Eugene Cheous • **ART DIRECTOR** Andyt Greenaway • **DIRECTOR** Sng Tong Beng • **PRODUCER** Samuel Kho

BRONZE

VISUAL: A young woman is looking down motionlessly and concentrating hard at some unknown task at hand. Finally, there is a breakthrough and she smiles in her triumph.
WOMAN: I've got syphilis.
SUPER: Syphilis.
Scrabble.
The world's favorite word game.

BRONZE

CATEGORY Retail Food • **ADVERTISER/PRODUCT** Weetabix • **TITLE** Black Beauty • **ADVERTISING AGENCY** Lowe Lintas, London • **PRODUCTION COMPANY** Rose Hackney Barber, London • **EDITING COMPANY** Willcox & Willcox, London • **ACCOUNT EXECUTIVE** Viki Winch • **CREATIVE DIRECTOR** Charles Inge • **COPYWRITER** Brian Turner, Micky Tudor, Andy Amadeo, Mick Mahoney • **ART DIRECTOR** Micky Tudor, Brian Turner, Andy Amadeo, Mick Mahoney • **DIRECTOR** Graham Rose • **PRODUCER** Sarah Hallatt, Steven Worley

VISUAL: A series of beautiful shots of a black horse running free through the English countryside.
[**MUSIC:** Theme to Black Beauty.]
VISUAL: The horse races through the woods, splashes along the beach and gallops through cornfields before rearing on its hind legs with joy.
When it returns to the stables, its skin unzips and two men pop out of the horse.
MAN 1: Good run, Bob. Same time tomorrow?
MAN 2: Yeah, lovely.
SUPER: WEETABIX

CATEGORY Retail Food • ADVERTISER/PRODUCT Church's Chicken • TITLE Old Man • ADVERTISING AGENCY Cliff Freeman and Partners, New York • PRODUCTION COMPANY Omaha Pictures, New York • EDITING COMPANY The Whitehouse • CREATIVE DIRECTOR Cliff Freeman • COPYWRITER Adam Chasnow • ART DIRECTOR Taras Wayner • DIRECTOR Paul Gay • PRODUCER Liz Graves

BRONZE

VISUAL: A family is sitting around the table in the dining room to eat lunch. There is an empty seat at the table.
SON: Grandpa! Lunchtime!
FATHER: C'mon, Pop!
VISUAL: Grandpa shuffles into the kitchen. He is completely naked. The rest of the family is shocked.
FATHER: Aw geez, Dad.
MOM: He is not sitting down to eat at this table!
VISUAL: The father waves the old man away.
FATHER: Go…just go…
MOM: Why'd he do that?
SUPER: Maybe it's your cooking.
VISUAL: Grandpa walks out of the room, celebrating to himself.
VO: Try Church's Chicken. It's what made from scratch should taste like.
SUPER: Church's.
What made from scratch should taste like.

CATEGORY Retail Food • **ADVERTISER/PRODUCT** Cooker Restaurant • **TITLE** Wine And Ribs • **ADVERTISING AGENCY** Crispin Porter + Bogusky, Miami • **PRODUCTION COMPANY** Oil Factory • **CREATIVE DIRECTOR** Alex Bogusky • **COPYWRITER** Bill Wright • **ART DIRECTOR** Andrew Keller • **DIRECTOR** Steven Tsuchida • **PRODUCER** Mark Castro, David Rolfe

VISUAL: A man sits by himself at the Cooker Bar. As he casually scans the restaurant, his eyes lock on a woman sitting with a girlfriend. The man grabs the waiter and tells him something while pointing to the woman.

The waiter delivers a complimentary glass of wine to the woman. The woman is impressed, and she toasts the man from across the restaurant.

The man is still by himself at the bar when the waiter delivers a complimentary rack of ribs. The man is surprised and looks at the woman. She's eating ribs of her own, and her hands, face, and shirt are covered in BBQ sauce. She "toasts" the man at the bar with a rib bone.

SUPER: Tuesday is Rib Night.
Cooker Bar and Grille.

CATEGORY Toiletries/Pharmaceuticals • **ADVERTISER/PRODUCT** Ansellsa / Manio • **TITLE** The Fingerprint • **ADVERTISING AGENCY** BDDP & Fils, Boulogne Billancourt • **PRODUCTION COMPANY** La Pac, Paris • **EDITING COMPANY** Editors, Paris • **MUSIC COMPANY** Amaganset, Paris • **CREATIVE DIRECTOR** Olivier Altmann • **COPYWRITER** Bruno Delhomme • **ART DIRECTOR** Daniell Bellon • **DIRECTOR** Franck Vroegrop • **AGENCY PRODUCER** Christine Bouffort

VISUAL: A hand grabs a condom package. It takes out the condom and slips it onto its index finger.
The index covered by latex heads toward an inkpad. The finger presses down on the pad. The index moves to a piece of white paper. The finger presses down on the sheet. When the index finger pulls away, it leaves behind a perfect fingerprint on the paper.

BRONZE

CATEGORY Toiletries/Pharmaceuticals • **ADVERTISER/PRODUCT** Libero Diapers • **TITLE** Silly Walk • **ADVERTISING AGENCY** Forsman & Bodenfors, Gothenburg • **PRODUCTION COMPANY** Silverscreen, Stockholm • **COPYWRITER** Jonas Enghage • **ART DIRECTOR** Kim Cramer • **DIRECTOR** Jorn Haagen • **PRODUCER** Ciro Sammarco • **MUSIC COMPOSER** Micke Sundin • **CLIENT** SCA Hygiene Products

VISUAL: In a quiet library, a woman is wandering along the bookshelves. When she turns a corner, it is apparent that she is walking in an odd manner, her legs wide apart.
Next, in a park, an old man and his dog encounter a group of joggers, all of them awkwardly running with their legs wide apart.
Finally, in a train station, commuters pour out of the trains, all of them walking in the same silly manner.
SUPER: Would you like to walk like this?
Neither would your kid.
VISUAL: A child is walking comfortable.
SUPER: Up & Go. Made for walking.

CATEGORY Travel/Tourism • ADVERTISER/PRODUCT Avista Language School • TITLE The Goldfish • ADVERTISING AGENCY Lowe Brindfors, Stockholm • PRODUCTION COMPANY Forsberg & Co., Stockholm • CREATIVE DIRECTOR Johan Nilsson • COPYWRITER Olle Sjöden, Björn Ståhl • ART DIRECTOR Mick Born, Patrik Forsberg • DIRECTOR Patrik Forsberg

VISUAL: A cat sneaks through a window into a house and walks up to the goldfish swimming in a bowl on the table. The goldfish looks increasingly worried as the cat comes nearer. When the cat puts his head into the bowl, the goldfish barks loudly and the cat runs off.
SUPER: Learn another language.
Avista Language School.

SILVER

CATEGORY Utilities • **ADVERTISER/PRODUCT** Telefonica • **TITLE** Angels • **ADVERTISING AGENCY** DM9 DDB, São Paulo • **PRODUCTION COMPANY** Video Filmes, São Paulo • **EDITING COMPANY** Casablanca, São Paulo • **MUSIC COMPANY** Supersonica, São Paulo • **ACCOUNT EXECUTIVE** Maristela Pati Correa • **CREATIVE DIRECTOR** Camila Franco, Erh Ray, Sergio Valente • **COPYWRITER** Jader Rossetto • **ART DIRECTOR** Pedro Cappeletti • **DIRECTOR** Carlos Manga Junior • **PRODUCER** Jose Augusto Machado, Daniela Andrade

VISUAL: An overview of two conjoined telephone booths.
SUPER: In Brazil, telephone booths look like this.
VISUAL: A young girl looks at a man standing in between the phone booths. The booths behind him look like wings.
A boy walks down the street. He sees the shadow of an angel on the wall. It's coming from a woman standing at the phone booths.
A girl sees a man with wings from her car.
A boy playing soccer with his friends chases after the ball. A man in front of the phone booths picks up the ball. The boy smiles at him.
SUPER: In December, every time you make a long distance call you help a child with cancer. Be an angel this Christmas. Telefonica.

CATEGORY Regional Campaign • ADVERTISER/PRODUCT Fox Sports • TITLE India • TITLE China • TITLE Turkey • ADVERTISING AGENCY Cliff Freeman and Partners, New York • PRODUCTION COMPANY Cape Direct, Capetown; Partizan • EDITING COMPANY Mackenzie Cutler, New York • ANIMATION COMPANY Quiet Man, New York • ACCOUNT EXECUTIVE Cathy Goldman • CREATIVE DIRECTOR Eric Silver • COPYWRITER Dan Morales • ART DIRECTOR Rossana Bardales, Taras Wayner • DIRECTOR Traktor

GOLD

VISUAL: A host of a sports news show in Bombay is seated next to a large man. The two banter back and forth in Hindi before cutting to the sports footage. On the footage, two blindfolded men chase each other with clubs in front of a large crowd of people cheering wildly. The Indian commentator does the play-by-play as the two men take wild swings at each other.

Suddenly, one of the competitors loses his bearings and starts pounding a gentleman in the crowd. The fans go wild as others try to stop the blindfolded man from clubbing the spectator even more.

SUPER: Sports news from the only region you care about. Yours.

SUPER: 11PM Regional Sports Report. Fox Sports Net.

VISUAL: A Chinese sports news announcer in the studio introducing a segment. The sports footage appears on the screen.

Two Chinese lumberjacks axe a large tree while Chinese spectators wait in anticipation.

A Chinese athlete chalks his taped hands and stretches his arms. The anchorman does the play-by-play as the athlete readies himself.

The tree begins to fall. The lumberjacks step back. The athlete tries to catch the giant 200-foot tree falling toward him. He's instantly crushed.

SUPER: Sports news from the only region you care about. Yours.

SUPER: 11PM Regional Sports Report. Fox Sports Net.

VISUAL: A Turkish sports news commentator is standing near a sheer cliff, giving a lead-in to the next competitor.

A skinny diver wearing a Speedo stands on the cliff. He is intensely concentrating as the commentator quietly does the play-by-play in Turkish.

The diver then jumps off the cliff and goes into a beautifully executed swan dive into the dirt below. Turkish peasants politely clap as the diver's scores come across the bottom of the screen: 6.5, 6.0, 7.5, 4.0, 5.5., 7.5., 7.0.

SUPER: Sports news from the only region you care about. Yours.

SUPER: 11PM Regional Sports Report. Fox Sports Net.

BRONZE

CATEGORY Regional Campaign • **ADVERTISER/PRODUCT** Brahma Beer • **TITLE** Shooting 1 • **TITLE** Shooting 2 • **TITLE** Shooting 3 • **ADVERTISING AGENCY** Savaglio TBWA, Buenos Aires • **PRODUCTION COMPANY** Argentina Cine, Buenos Aires • **EDITING COMPANY** Post Bionica, Buenos Aires • **SOUND DESIGN COMPANY** No Problem, Buenos Aires • **ACCOUNT EXECUTIVE** Selina Choren • **CREATIVE DIRECTOR** Ernesto Savaglio, Martín Mercado • **COPYWRITER** Martín Mercado, Ariel Gil • **ART DIRECTOR** Juan Pablo Russo • **DIRECTOR** Augusto Gimenez Zapiola • **PRODUCER** Veronica Tirone

VISUAL: Actor drinking beer.
DIRECTOR: Hey! What are you doing? Start drinking when I say, "Action."
VISUAL: Next take.
ASSISTANT: Take two!
VISUAL: The actor takes two sips of beer.
DIRECTOR: Cut! What are you doing? I said one sip, not two!
ACTOR: But he said take two!
VISUAL: Next take. The actor sips the beer and looks at the woman next to him.
ACTOR: You know, Ana, this beer....I forgot my words...
DIRECTOR: Cut!
ASSISTANT: Cut!
ACTOR: Sorry...
DIRECTOR: It's not Shakespeare, it's not Ibsen. It's only five words, could you just put them together?
VISUAL: Another take.
ASSISTANT: Take 35.
DIRECTOR: Silence. Action.
VISUAL: The actor takes a long drink from the glass.
ASSISTANT: Hey, guy, hey...
ACTOR: Shhhh, man, we need silence!
VISUAL: Another take. The actor drinks his beer and doesn't pay attention to the scene.
DIRECTOR: Cut!

DIRECTOR: Action!
ACTOR: We're rolling right?
DIRECTOR: No, no, we're playing backgammon.
VISUAL: Next take. The actor drinks.
DIRECTOR: No, hold it, you are moving out of frame!
ASSISTANT: Cut!
DIRECTOR: Move!
ACTOR: I drink here?
VISUAL: Actor starts drinking again.
DIRECTOR: No! Drink when I'm rolling.
ACTOR: Come on, I drink or not.
VISUAL: Next take. The actor sips the beer and looks at the woman next to him.
ACTOR: You know, Brahma, this beer...
DIRECTOR: No, cut! Cut!
ACTOR: Brahma, Brahma. I say Ana, Brahma. I've got it now. My mistake, guys.
ACTRESS: Am I all right?
DIRECTOR: Yes, sweetheart, you are fine.
VISUAL: Next take.
ASSISTANT: 84.
DIRECTOR: Action!
VISUAL: Actor drinks and turns. Hits camera with beer mug.
ACTOR: What happened!
ASSISTANT: Cut!
ACTOR: It was out of focus. It wasn't my fault. Come on, give me a break, guys!
VISUAL: Next take. The actor drinks.
DIRECTOR: Cut!
ASSISTANT: Cut!
ACTOR: Cut it out! He said cut! Me?

VISUAL: Next take. He sips the beer and looks at the woman next to him.
ACTOR: You know Ana, this beer...It's a little too windy, right? Why don't we just stop and...
DIRECTOR: Cut!
ACTOR: We drop those surfer extras out –
DIRECTOR: I'm the one who says what's good and what's not. You can concentrate on what you have to do, OK? Yeah.
ACTOR: OK, keep it up guys!
VISUAL: Actor drinks the beer. He's draining the glass.
DIRECTOR: You're doing it on purpose, aren't you?
VISUAL: Next take. It's night.
ASSISTANT: Take 151.
VISUAL: The actor drinks his beer and looks around.
ACTOR: You know, Ana...Nah, I can't work like this, eh. What's going on? You are falling asleep. Come on, this is just starting. Come on, let's go, let's go!
VISUAL: Next take. He sips the beer and looks at the woman next to him.
ACTOR: Have you tried this? Poor thing! Give her a beer, please!
VISUAL: Next take. The actor drinks. He looks around.
ACTOR: OK, can I have some more. Because an empty mug looks real bad, no? Yeah, right.
VISUAL: He finishes the beer.
SUPER: Go ahead. Treat yourself.

CATEGORY National Campaign • **ADVERTISER/PRODUCT** ESPN - Major League Baseball Playoffs • **TITLE** Swimming Pool • **TITLE** Pottery Class • **TITLE** Piñata • **ADVERTISING AGENCY** Ground Zero, Marina Del Rey • **PRODUCTION COMPANY** Headquarters, Los Angeles & New York • **EDITING COMPANY** Imago, Venice • **SOUND DESIGN COMPANY** POP, Los Angeles • **ACCOUNT EXECUTIVE** Jamie Flynn • **CREATIVE DIRECTOR** Court Crandall, Kirk Souder • **COPYWRITER** Kristina Slade • **ART DIRECTOR** Patrick Harris • **DIRECTOR** Sean Mullens • **EXECUTIVE PRODUCER** Ales Blum, Tom Mooney, Andrew Denyer • **PRODUCER** J. J. Morris • **AGENCY PRODUCER** Patricia Phelan, Michelle Price

GOLD

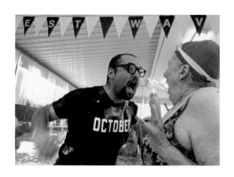

VISUAL: A group of elderly women are doing water aerobics in a community pool. They toss an exercise ball from one person to the next. Alongside the pool, the instructors are giving instructions and shouting encouragement. The instructors, according to their t-shirts, are each designated by a certain month: April, May, June, July, August, and September.
APRIL: Nice work here. This is great stuff, ladies. That's great! All we can ask is that you give it your best try!
AUGUST: You guys are fantastic! No super-fantastic!
JULY: Super-fantastic!
VISUAL: Suddenly, a man wearing a t-shirt labeled "OCTOBER" pops out from underwater with a furious yell. He gets in the face of one of the players.
OCTOBER: Not. Good. Enough! Not good enough, Jean. It's do or die time! What do you want out of this, Jean? Do you want a championship or do you want a fourth grade intramural game? 'Cause that's what you're giving me now!
SUPER: October is different.
OCTOBER VO: You're not giving me pro, you're giving me fourth grade, and if I want fourth grade, I'll hire a bunch of fourth graders!
SUPER: Major League Baseball Playoffs on ESPN.

VISUAL: Students of a community college art class making pottery. The instructors, April, May, June, July, August, and September, stand around the table, complimenting what the mostly middle-aged students have made. October broods in his seat.
APRIL: Really nice. Really nice work people.
JULY: Good job! I'm so proud of you. You're all doing such a great job.
VISUAL: October picks up one of the clay pieces. He smashes it.
OCTOBER: Wrong! Wrong!
VISUAL: October screams at the students while pounding on another piece of work.
OCTOBER: You guys want the trophy? You want the trophy or you want the little certificate? You want the certificate, you wanna take it home? You wanna put it on your mantel, you want a certificate there?
SUPER: October is different.
OCTOBER VO: I want the trophy!
SUPER: Major League Baseball Playoffs on ESPN.

VISUAL: A child's birthday party in a backyard. April, May, June, July, August, and September cheer the blindfolded birthday boy on as he tries to hit a piñata with a baseball bat.
JUNE: Almost! That was just a couple feet away.
JULY: Very, very good. You're getting there, you're getting there!
MAY: Take all the swings you need, Tiger!
VISUAL: October stomps over and grabs the baseball bat from the child.
OCTOBER: Pathetic! Give me that! You don't get a second chance. Time is running out! You gotta hit this thing, and you gotta hit it fast, you gotta hit it hard!
VISUAL: October bashes the piñata into smithereens as he shouts at the birthday boy.
OCTOBER: I need you to close-the-deal! You-must-close-the-deal!
SUPER: October is different.
OCTOBER VO: You-must-close-the-deal!
SUPER: Major League Baseball Playoffs on ESPN.

CATEGORY National Campaign • **ADVERTISER/PRODUCT** Fox Sports • **TITLE** Baby • **TITLE** Nature Channel • **TITLE** Milk • **ADVERTISING AGENCY** Cliff Freeman and Partners, New York • **PRODUCTION COMPANY** Morton Jankel Zander, Los Angeles • **EDITING COMPANY** Mad River Post, New York • **ACCOUNT EXECUTIVE** Cathy Goldman • **CREATIVE DIRECTOR** Eric Silver • **COPYWRITER** Richard Bullock • **ART DIRECTOR** Rob Carducci • **DIRECTOR** Rocky Morton • **PRODUCER** Catherine Abate

VISUAL: A teenage boy sitting on a train. Opposite him is an attractive woman holding her crying baby. The woman unbuttons her blouse and starts to breast-feed the baby. The young guy tries not to look but can't help staring at the woman.
The woman notices him staring.
WOMAN: Excuse me?
VISUAL: The young guy looks really uncomfortable.
WOMAN: Who's the only Super Bowl MVP to play for a losing team?
VISUAL: The young guy is relieved.
SUPER: If only every question was a sports question. Sports Geniuses.
The new game show premieres March 27.
Fox Sports Net.

VISUAL: TV footage of two wolves mating in the wild.
DOCUMENTARY VO: The alpha wolves use their dominance to discourage other wolves from mating.
VISUAL: A father and his young son watch this scene on TV. It's an awkward moment for the father.
SON: Dad?
FATHER: Yeah?
SON: Who holds the record for the most RBIs in a single season?
VISUAL: The father is relieved.
SUPER: If only every question was a sports question. Sports Geniuses.
The new game show premieres March 27.
Fox Sports Net.

VISUAL: A guy in his twenties lying down on the couch watching TV. He has no shirt on. He brings a carton of milk up to his lips and attempts to drink. He spills milk on his chin and it forms a puddle on his chest. His cat, attracted by the milk, jumps onto his chest and begins licking. The cat feverishly licks the guy's chest.
At that moment his girlfriend walks in. It's an awkward moment.
GIRLFRIEND: Jeff?
VISUAL: The young guy looks really uncomfortable and embarrassed.
GIRLFRIEND: Which U.S. hockey team has won the most Stanley Cups?
VISUAL: The young guy is relieved.
SUPER: If only every question was a sports question. Sports Geniuses.
The new game show premieres March 27.
Fox Sports Net.

CATEGORY National Campaign • **ADVERTISER/PRODUCT** Adidas Athletic Apparel • **TITLE** Adidas Makes You Better—Lomu • **TITLE** Adidas Makes You Better—Ato • **TITLE** Adidas Makes You Better—Beckham • **ADVERTISING AGENCY:** 180, Amsterdam • **PRODUCTION COMPANY** Harry Nash, London • **ACCOUNT EXECUTIVE** Chris Mendola, Lucie Tenney • **CREATIVE DIRECTOR** Larry Frey • **COPYWRITER** Lorenzo de Rita • **ART DIRECTOR** Dean Maryon • **DIRECTOR** Fredrik Bond • **PRODUCER** Jackie Adler, Helen Williams • **STRATEGIC PLANNING** Alex Melvin • **DIRECTOR OF PHOTOGRAPHY** Carl Nilsson, Julian Whatley

SILVER

VISUAL: A huge fish flops in a puddle of water in the middle of an intersection.

SUPER: Kiki Sq. 25m above sea level.

WOMAN 1: The poor fish, it just looked as though it was just screaming for water.

WOMAN 2: It was dying, it was lying there dying and nobody was helping it.

VISUAL: Jonah Lomu grabs the fish like a rugby ball and runs down the street.

WOMAN 1: Until a big man came along and just picked up the fish under his arms and he just shot off down the road.

VISUAL: Lomu jumps on a car as he weaves through a traffic jam.

WOMAN 2: And he jumped up on the bonnet of that car, and I thought he was going to come through the windscreen.

VISUAL: Lomu, seeing the fish's condition, looks around the street.

WOMAN 1: His muscles were bulging and he was just holding this fish just so tight.

VISUAL: Lomu runs through the spinning washers of a nearby car wash.

MAN 1: Of course it was Jonah Lomu. Veers through the car wash—Bang!

VISUAL: Lomu races toward the docks. He knocks into a van backing out of a garage, almost tipping the vehicle over.

MAN 1: By dingoes, he was moving.

VISUAL: Lomu makes a dive and hurls the fish into the water.

MAN 2: It was just on its last gasp and he just threw the fish in and it saved its life. Wearing Adidas makes you more caring about fish. And alligators and cats and elephants and even people.

SUPER: Adidas makes you better.

Adidas. Forever Sport.

www.adidas.com/bebetter.

JEFFREY: Stop him! Stop—

SUPER: Jeffrey V. Apt. 2A.

JEFFREY: I was running as fast as I could, and then this man came out of nowhere.

VISUAL: Ato Boldon hands his newspaper to the towel-clad Jeffrey and chases the thief on the moped.

TOUPEED MAN: He came by around the corner and—Bang!—right here it happened.

VISUAL: Ato bumps into Man 1, knocking off his toupee.

BARBER 1: You see how fast that guy went? I can't believe it. It was like a blur!

VISUAL: The thief on his moped glances nervously over his shoulder. Ato is gaining ground.

HUSBAND: It was Ato Boldon.

WIFE: It was not Ato Boldon. Ato Boldon has big hair.

VISUAL: Freeze frame Ato Boldon in mid-stride. Afro wig appears on his head for a second before frame starts again.

Ato catches up to the thief and takes back the stolen TV.

JEFFREY: I couldn't believe I got my TV back the same day it was stolen!

VISUAL: Ato gives the TV back to Jeffrey.

SUPER: Adidas makes you better.

BARBER 1: We should all wear Adidas. Our city would be a much more decent and a safer place to live in.

BARBER 2: Right.

SUPER: Adidas. Forever Sport.

www.adidas.com/bebetter.

VISUAL: A man throws his rubbish at the garbage can. When it misses, he walks by instead of picking it up.

SUPER: Cod & Chips—£2.20.

ROAD WORKER: This guy throws some rubbish on the ground and just walks off as if it's not a problem. Just throws it there for no reason whatsoever. And from nowhere this guy in shorts appears.

VISUAL: David Beckham, while loading equipment in his car, notices the bag of rubbish. He walks over to it.

PROSTITUTE: What's he doing with shorts on in this weather?

VISUAL: Beckham positions the bag.

PROSTITUTE: He started moving it, liking position it, and started to look 'round the street. I thought "what's he doing here?"

VISUAL: Man 1 watches Beckham from the bus stop bench across the street. He stands and lines up with another man waiting for the bus.

MAN 1: And I thought, "I know what his game is," so sort of like got next to this guy and I made a defensive wall. You know how you cover ya'…

VISUAL: Man 1 covers his crotch with both hands. Beckham draws back his foot.

MAN 1: He's gonna kick it.

VISUAL: Beckham kicks the rubbish. It sails through the air.

ROAD WORKER: Whack.

MAN 1: The shot swerves past me head.

ROAD WORKER: Smacks right into the bin.

VISUAL: Rubbish goes square into the bin.

MAN 2: We should all wear Adidas and keep the city safe for our kids.

SUPER: Adidas makes you better.

MAN 1: Most poetic piece of rubbish I've ever seen.

SUPER: Adidas. Forever Sport.

www.adidas.com/bebetter.

SILVER

CATEGORY National Campaign • ADVERTISER/PRODUCT Brandt • TITLE The Oven • TITLE The Washing Machine • TITLE The Dishwasher • ADVERTISING AGENCY CLM/BBDO, Paris • PRODUCTION COMPANY Quad, Paris • SOUND DESIGN COMPANY Barrera Prod., Paris • ACCOUNT EXECUTIVE David Fuchs • CREATIVE DIRECTOR Fred Raillard, Farid Mokart • COPYWRITER Fred Raillard, Farid Mokart • ART DIRECTOR Fred Raillard, Farid Mokart • DIRECTOR Remy Belvaux • PRODUCER Gilles Viard, Pierre Marcus, France Monnet

VISUAL: A dinner party. The wife carries a tray into the kitchen.
HUSBAND: Are you all right, love?
WIFE: I'm fine.
VISUAL: Alone in the kitchen, she opens the oven and jumps on the oven door. The door snaps off and the glass breaks when it hits the tile. The guests run to the kitchen. The wife is furious with her husband.
WIFE: That's it! I can't take it anymore! I can't take it. I've had enough!
VISUAL: The wife stomps off, leaving her stunned guests in the kitchen.
SUPER: She wants a Brandt.

VISUAL: A woman is in her laundry room, standing in front of her washing machine. She notices her son's skateboard on the floor. She picks it up and smashes it into the window of the washing machine. Water gushes out. She puts the skateboard in front of the machine and lies down on the floor as if she tripped. Her husband and son rush into the room.
FATHER: What the..? Darling, are you all right?
MOTHER: …Skateboard!
VISUAL: The father, seeing what happened, turns to his son.
FATHER: Look what you've done! You could've killed your mother! Now go to your room! Now!
VISUAL: The little boy heads to his room.
FATHER: Are you all right, darling? Just take it easy.
VISUAL: Wife continues groaning and crying.
SUPER: She wants a Brandt.

VISUAL: A woman is sticking holes in sausages in her kitchen. When her husband's back is turned, she grabs the hose from behind the dishwasher and pokes holes in it with her fork. Water spurts out, getting her and the sausages all wet.
As her husband turns off the water, she bursts into tears. She sits down at the kitchen table.
HUSBAND: Honey…
VISUAL: The wife cringes from his touch.
SUPER: She wants a Brandt.

CATEGORY National Campaign • **ADVERTISER/PRODUCT** Luang • **TITLE** Newspaper Kiosk • **TITLE** Driver • **TITLE** Doorman • **ADVERTISING AGENCY** CLM/BBDO, Paris • **PRODUCTION COMPANY** 1/33 Productions, Paris • **SOUND DESIGN COMPANY** Barrera Prod, Paris • **ACCOUNT EXECUTIVE** David Fuchs • **CREATIVE DIRECTOR** Vincent Behaeghel, Bernard Naville • **COPYWRITER** Bernard Naville, Agathe Marsilly • **ART DIRECTOR** Vincent Behaeghel, Chrystel Bonneau • **DIRECTOR** David Charhon • **PRODUCER** Richard Jacobs • **AGENCY PRODUCER** Pierre Marcus, France Monnet

BRONZE

VISUAL: In front of a newspaper stand, a Chinese man is flicking through a magazine. Suddenly a young woman throws herself on him and starts kissing him.
WOMAN VO: Fancy Chinese?
SUPER: Fancy Chinese?
MALE VO: Luang.
SUPER: Luang.
MALE VO: Irresistible Chinese food.
SUPER: Irresistible Chinese food.

VISUAL: A young Chinese boy is handing out flyers, putting them on the windshield of parked cars. Suddenly, he is pulled into one of the cars by a young woman, parked in her car.
WOMAN VO: Fancy Chinese?
SUPER: Fancy Chinese?
MALE VO: Luang.
SUPER: Luang.
MALE VO: Irresistible Chinese food.
SUPER: Irresistible Chinese food.

VISUAL: A Chinese doorman is standing outside a nightclub when a passerby bites into his arm.
WOMAN VO: Fancy Chinese?
SUPER: Fancy Chinese?
MALE VO: Luang.
SUPER: Luang.
MALE VO: Irresistible Chinese food.
SUPER: Irresistible Chinese food.

CATEGORY National Campaign • **ADVERTISER/PRODUCT** NBA Fox Sports Net • **TITLE** Utah • **TITLE** San Antonio • **TITLE** Los Angeles • **ADVERTISING AGENCY** Cliff Freeman and Partners, New York • **PRODUCTION COMPANY** Propaganda Films, Hollywood • **EDITING COMPANY** Mackenzie Cutler, New York • **ANIMATION COMPANY** Quiet Man, New York • **ACCOUNT EXECUTIVE** Cathy Goldman • **CREATIVE DIRECTOR** Eric Silver • **COPYWRITER** Eric Silver • **ART DIRECTOR** Reed Collins • **DIRECTOR** Tom Kuntz, Mike Maguire • **EXECUTIVE PRODUCER** Colin Hickson • **PRODUCER** Aris McGarry • **AGENCY PRODUCER** Kevin Diller

VISUAL: Two white guys are kicking back on a stoop and talking like they got game.

ALAN: Yo, you know who led the league in assists last year?

JEROME: It shoulda been you, Yo.

ALAN: No doubt, Boo. No doubt…Yo, I gotta show these suckas how to play dis game!

JEROME: Let 'em know…

VISUAL: Game footage of the Utah Jazz. The other team is Alan and Jerome. It's two against five on the court.

ALAN VO: None of these b-boys don't be realizin' that passing be an art, kid.

VISUAL: Alan keeps the ball away from Karl Malone.

ALAN VO: I got the flava that ya savor…Watch my Kobe Bryant "No-Look Confusion Maker."

VISUAL: Alan passes the ball over Karl Malone's head to Jerome.

JEROME VO: Hey, Utah. Here's a little something called STYLE.

VISUAL: Jerome shoots a three-pointer over John Stockton, nothing but net.

VISUAL: Alan and Jerome taunt the Utah Jazz bench with a little dance.

SUPER: Live the game.
Lakers vs. Jazz.
7PM Tonight.
Fox Sports Net.

VISUAL: Two white guys are loitering around a playground and talking like they got game.

JEROME: Yo, who says you gotta be a big man to compete in the NBA?

ALAN: Not I, Shorty.

JEROME: That's right. Alan and Jerome…

ALAN & JEROME: That's us!

VISUAL: Game footage of the San Antonio Spurs. The other team is Alan and Jerome. It's two against five on the court.

JEROME VO: We're gonna creep on in…

ALAN VO: Creepin' like a Creeper…

JEROME VO: And drop some Stephon Marbury inner-city funk. I love to see the face of the fool trying to D my slammin' moves to the hole.

VISUAL: Jerome burns David Robinson off the dribble and drives to the hole against him and two other defenders. He makes the basket and gets the foul.

JEROME VO: Yo, David. You may be bigger than me, but you need to get yourself some Coppertone Lotion.

ALAN VO: That's right, baby.

JEROME VO: …'Cause you just got burned.

VISUAL: Jerome laughs at David Robinson.

ALAN VO: Rub that on.

JEROME VO: Rub, rub, rub, rub, rub…

SUPER: Live the game.
Nets vs. Spurs.
7PM Tonight.
Fox Sports Net.

VISUAL: Two white guys are eating in a fast-food restaurant and talking like they got game.

ALAN: Yo, I swear, J, if I hear the word "Shaq" one more time…

JEROME: Or Shaq Attack.

ALAN: Yo, what did I just say?

JEROME: My bad.

VISUAL: Game footage of the Los Angeles Lakers. The other team is Alan and Jerome. It is two against five on the court.

ALAN VO: I would really show up my mad dribbling skills on this much-over-hyped team.

VISUAL: Alan jukes several Lakers with his dribbling skills.

JEROME VO: Yo. They okay.

ALAN VO: Yeah, they okay. But they ain't got the Allen Iverson grace. You know if I was playin' them, I would be punishin' them.

VISUAL: Alan drives to the basket and scores over Shaquille O'Neal.

ALAN VO: Punishin' them for thinkin' they could stop this. YOU CANNOT STOP THIS!

VISUAL: Alan does his own celebration dance.

ALAN VO: I'm fresh like a can of Picante. And I'm deeper than Dante in the circles of hell…

SUPER: Live the game.
Sixers vs. Lakers.
7PM Tonight.
Fox Sports Net.

CATEGORY National Campaign • **ADVERTISER/PRODUCT** American Legacy Foundation • **TITLE** Body Bag • **TITLE** Lie Detector • **TITLE** Operation Hypnosis • **ADVERTISING AGENCY** The Alliance • **PRODUCTION COMPANY** Redtree Productions • **EDITING COMPANY** Mad River Post • **ACCOUNT EXECUTIVE** Lisa Unsworth • **CHIEF CREATIVE OFFICER** Ron Lawner • **GROUP CREATIVE DIRECTOR** Pete Favat, Alex Bogusky • **CREATIVE DIRECTOR** Pete Favat, Alex Bogusky • **COPYWRITER** Ari Merkin, Chris Edwards, Bill Hollister • **ART DIRECTOR** Alex Burnard, Chris Edwards, Bill Hollister • **DIRECTOR** Christian Hoagland • **PRODUCER** RJ Casey, Maria Sheehan • **AGENCY PRODUCER** Keith Dezen • **EDITOR** Tom Scherma

VISUAL: An 18-wheeler truck pulls up in front of the tobacco company.
SUPER: Outside a major tobacco company.
TEENAGERS: Let's go, let's go.
VISUAL: Teens pull body bags out of the 18-wheeler and begin dragging them on to the sidewalk outside of the tobacco company.
TEENAGERS: Go, go!
VISUAL: Tobacco employees watch teens drag bags. One teen steps forward with a bullhorn.
TEEN 1: Hey, excuse me! Sorry to bother you but we've got a question. Do you know how many people tobacco kills every day?
VISUAL: Teens still taking body bags out of 18-wheeler and stacking them on the sidewalk.
TEEN 1: Would you say twenty? Thirty? A hundred?
VISUAL: The whole corner is piled with body bags.
TEEN 1: You know what? We're gonna leave this here for you, so you can see what 1,200 people actually look like.
VISUAL: An aerial view in a helicopter looking down at the piles of body bags on the sidewalk outside of tobacco company.
TEEN 1: Keep all of them up guys.
VISUAL: Teens post signs in front of tobacco company.
SUPER: Truth
thetruth.com

VISUAL: A boy and girl walk into building carrying a case labeled "lie detector."
BOY: We have a delivery for the marketing department.
VISUAL: The boy and girl speak to the employee behind the counter.
TOBACCO EMPLOYEE 1: Who do you have to see?
GIRL: The VP of Marketing, Rita.
BOY: You can just tell her we are dropping off a lie detector.
VISUAL: Another tobacco employee behind the counter comes forth.
GIRL: Hi, are you Rita?
TOBACCO EMPLOYEE 2: No.
GIRL: I just thought if you would know if Rita was in?
TOBACCO EMPLOYEE 2: I already answered that, all right? You can have a seat or you can leave.
VISUAL: Girl sits in lobby chair.
BOY: Maybe this guy?
VISUAL: A third employee approaches the boy and girl. The girl jumps up from her chair to greet him.
GIRL: You're not Rita!
TOBACCO EMPLOYEE 3: OK, can I help you?
GIRL: We have a lie detector so this will clear up a lot of confusion. Your company says nicotine isn't addictive, then you say it in.
TOBACCO EMPLOYEE 3: Do you have an appointment with anyone in particular?
GIRL: We were told to come and see Rita.
TOBACCO EMPLOYEE 3: Leave her a voice mail.
VISUAL: This employee walks the girl to the phone. The girl calls and begins talking to Rita on the phone.
GIRL: OK, great. Hi, Rita, I'm from truth and I wanted to drop off a lie detector...she hung up on me. Maybe it's the wrong Rita?
TOBACCO EMPLOYEE 3: Listen, I'm gonna have to ask you to leave now.
GIRL: OK, we're leaving, but your company has said that...
SUPER: Truth.
TOBACCO EMPLOYEE 3: Fine.
GIRL: Nicotine isn't addictive and then—
TOBACCO EMPLOYEE 3: Perfect.
SUPER: thetruth.com.
GIRL: You say that it is and we're...
TOBACCO EMPLOYEE 3: Great.
GIRL: Just trying to get to the truth.
TOBACCO EMPLOYEE 3: Oh, you're great.

VISUAL: Three teens driving in the truth truck.
SUPER: Somewhere out in Tobacco Suburbia.
TEEN 1: I'm feeling the vibe, man. We're gonna find these tobacco guys.
VISUAL: Teen 2 talks to a man standing outside the truth truck.
TEEN 2: Hey, man, do you know if there are any tobacco executives around here?
GUY 1: No.
VISUAL: Teen 1 talks into a drive-up speaker of a fast-food restaurant.
WOMAN IN SPEAKER: May I take your order?
TEEN 1: Do you know if any tobacco executives live around here?
VISUAL: Teens approach another guy on a residential street who points them in the right direction.
GUY 2: Go three blocks down, make a left, you'll see it's some big houses.
TEEN 2: Three blocks to the left and then two blocks—
TEEN 1: Three blocks up and take a left.
VISUAL: Teens in truth truck driving in suburban area.
TEEN 1: Look at the size of these houses.
TEEN 2: I guess working for an industry that kills over 1,000 people a day pays pretty well, huh?
TEEN 3: We gotta help these people, man. Turn on the tapes.
TEEN 2: Yeah, yeah, cue the tape.
VISUAL: The speakers on top of the truth truck loudly play tape through the neighborhood.
TAPED VOICE: I am a good person. Selling a product that kills people makes me feel uncomfortable. I realize cigarettes are addictive...
VISUAL: Teens inside truck.
TEEN 3: Looks like money is addictive, too.
VISUAL: Truth truck drives down the street while the tape plays.
TAPED VOICE: ...And kill over 430,000 people each year. Tomorrow, I will look for a new job. I will be less concerned with covering my butt...
GUY 3: Shut up!
TAPED VOICE: ...And more concerned with doing the right thing.
SUPER: Truth.
VISUAL: Teen 2 picks up the microphone in the truck.
TEEN 2: We're just trying to help.
SUPER: thetruth.com.
TAPED VOICE: I am a good...

BRONZE

CATEGORY National Campaign • **ADVERTISER/PRODUCT** UPC / Broadband Provider • **TITLE** Smoker's Corner • **TITLE** Pizzeria • **TITLE** Vaccination • **ADVERTISING AGENCY** Lowe Brindfors, Stockholm • **PRODUCTION COMPANY** Penguin Film, Stockholm • **ACCOUNT EXECUTIVE** Ulrika Hedman • **CREATIVE DIRECTOR** Johan Nilsson • **COPYWRITER** Olle Sjödén, Björn Stahl, Björn Hjalmer • **ART DIRECTOR** Mitte Blomqvist • **DIRECTOR** Fredrik Edfeldt • **PRODUCER** Anders Stjernström • **AGENCY PRODUCER** Mark Baughen

VISUAL: A group of women taking a short break outside their workplace to have a cigarette.
WOMAN 1: I love a man who can dance.
WOMAN 2: Yes, I always get stuck with the ones with two left feet.
VISUAL: The group laughs. Woman 1 pulls out a cigarette.
WOMAN 1: Do you have a light?
WOMAN 2: Of course.
VISUAL: Woman 2 holds the lighter but does not light it. She stands completely still for about 15 seconds. When she is finished with her pause, she lights the cigarette.
WOMAN 1: Thanks.
SUPER: Good thing life isn't as slow as the Internet. Chello—Faster Internet with broadband.
UPC

VISUAL: A man waiting for his order in a restaurant. The waiter approaches with the meal.
WAITER: Capricciosa?
PATRON: Right here.
VISUAL: The waiter is about to give the patron his food when he freezes for about 15 seconds. When he is finished with his pause, he gives the man his food.
WAITER: Bon appétit.
PATRON: Thanks.
SUPER: Good thing life isn't as slow as the Internet. Chello—Faster Internet with broadband.
UPC

VISUAL: A man at a vaccination clinic waiting for his shot.
NURSE: And where will you be traveling?
PATRON: Thailand.
VISUAL: The nurse rolls up his sleeve and picks up the syringe.
NURSE: This won't hurt at all.
VISUAL: The nurse pauses for 15 seconds before sticking the needle in his arm.
SUPER: Good thing life isn't as slow as the Internet. Chello—Faster Internet with broadband.
UPC

CATEGORY National Campaign • ADVERTISER/PRODUCT Game Show Network • TITLE Marsupial • TITLE Sputnik • TITLE Botulism • ADVERTISING
AGENCY TBWA/Chiat/Day, San Francisco • PRODUCTION COMPANY The Director's Bureau, Hollywood • EDITING COMPANY Plank, San Francisco •
SOUND DESIGN COMPANY Eleven, Santa Monica • ACCOUNT EXECUTIVE Shawn Bavanesco, Robin Blankfort • EXECUTIVE CREATIVE DIRECTOR Chuck
McBride • ASSOCIATE CREATIVE DIRECTOR Rob Smiley • COPYWRITER Jeremy Postaer • ART DIRECTOR Tia Lustig, Rob Smiley • DIRECTOR Roman
Coppola • SENIOR EXECUTIVE PRODUCER Lisa Margulis • SENIOR PRODUCER Betsy Beale • EDITOR David Herman, Bonnie Hawthorne • SVP,
MARKETING (GAME SHOW NETWORK) Dena Kaplan • VP, ON-AIR PROMOTIONS (GAME SHOW NETWORK) Ken Warun

BRONZE

VISUAL: Reflection of a woman in a camera store window.
WOMAN 1: Marsupial.
VISUAL: Man sitting on a chair getting his shoes shined.
MAN 1: Marsupial.
VISUAL: Security guard sitting behind his desk.
SECURITY GUARD: Marsupial.
VISUAL: Woman getting her nails done at a salon.
WOMAN 2: Marsupial.
VISUAL: Woman in her living room petting a cat and surrounded by other cats.
WOMAN 3: Marsupial.
VISUAL: Model being dressed.
MODEL: Marsupial.
VISUAL: Man running on a treadmill in a gym.
MAN 2: Marsupial.
VISUAL: Man getting his shoes shined raising his fist.
MAN 1: Marsupial.
VISUAL: Security guard sitting behind his desk.
SECURITY GUARD: Marsupial.
VISUAL: Woman getting her nails done at a salon.
WOMAN 2: Marsupial.
VISUAL: Security guard standing behind his desk with hands gesturing to the TV.
SECURITY GUARD: Marsupial!
VISUAL: Reflection of a woman in a camera store window.
WOMAN 1: Marsupial!
VISUAL: Kid sitting at the kitchen table with mother doing dishes in the background.
KID: Marsupial!
VISUAL: Guy on the treadmill at the gym with his hands gesturing to the TV.
MAN 2: Marsupial!
VISUAL: Guy getting shoes shined standing on the chair with his arms in the air.
MAN 1: Marsupial!
VISUAL: Contestant on a game show.
CONTESTANT: Rodent?
[SFX: Buzzer going off.]
SUPER: You Know You Know. Game Show Network.
[SFX: Chime. Clapping and cheering.]

VISUAL: Woman working at a coat check counter.
WOMAN 1: Sputnik.
VISUAL: Man sitting at his desk at work.
MAN 1: Sputnik.
VISUAL: Woman getting a massage.
WOMAN 2: Sputnik.
VISUAL: A couple making out on a bed.
BOYFRIEND: Sputnik.
VISUAL: Man working at a garage ticket booth.
MAN 2: Sputnik.
VISUAL: Two guys at a bar with the bartender in the background.
GUYS AT BAR: Sputnik.
VISUAL: Man sitting behind his desk looks up.
MAN 1: Sputnik.
VISUAL: Man sitting on a couch.
MAN 3: Sputnik.
VISUAL: Five young, hip guys lounging around in what looks like a trailer.
GUYS IN TRAILER: Sputnik.
VISUAL: Woman unpacking her clothes in a hotel room.
WOMAN 3: Sputnik.
VISUAL: Couple making out on a bed.
BOYFRIEND: Sputnik.
VISUAL: Guys at the bar.
GUYS AT BAR: Sputnik.
VISUAL: Woman at the coat check counter.
WOMAN 1: Sputnik.
VISUAL: Woman unpacking in the hotel room and holding up a jacket.
WOMAN 3: Sputnik.
VISUAL: Man sitting on couch.
MAN 3: Sputnik.
VISUAL: Couple making out.
BOYFRIEND: Sputnik!
VISUAL: Man at the garage ticket booth.
MAN 2: Sputnik!
VISUAL: Guys at the bar.
GUYS AT BAR: Sputnik!
VISUAL: Man in his office behind his desk.
MAN 1: Sputnik!
VISUAL: Woman unpacking in hotel room.
WOMAN 3: Sputnik!
VISUAL: Five guys lounging in the trailer.
GUYS IN TRAILER: Sputnik!
VISUAL: Woman working at the coat check stand.
WOMAN 1: Sputnik!
VISUAL: Contestant on game show.
CONTESTANT: Skylab?
[SFX: Buzzer going off.]
SUPER: You Know You Know. Game Show Network.
[SFX: Chime. Clapping and cheering.]

VISUAL: Elderly man lying on a hospital bed.
ELDERLY MAN: Botulism.
VISUAL: Clerk at a market.
CLERK: Botulism.
VISUAL: Little girl in her pajamas sitting in the living room. A couple is sitting on the couch in the background.
LITTLE GIRL 1: Botulism.
VISUAL: Two soldiers hanging out on their bunk beds.
SOLDIER 1: Botulism.
SOLDIER 2: Botulism.
VISUAL: Baker in the kitchen making cookies.
BAKER: Botulism.
VISUAL: Cocktail waitress holding a tray of drinks.
WAITRESS: Botulism.
VISUAL: A group of employees sitting in a lounge having coffee.
EMPLOYEES: Botulism.
VISUAL: Clerk at the market.
CLERK: Botulism.
VISUAL: Elderly man lying on the hospital bed.
ELDERLY MAN: Botulism.
VISUAL: Group of employees sitting in a lounge having coffee.
EMPLOYEES: Botulism.
VISUAL: Two little girls in matching bathing suits.
LITTLE GIRL 2: Botulism.
LITTLE GIRL 3: Botulism.
VISUAL: Little girl in living room. A couple behind her makes out.
LITTLE GIRL 1: Botulism.
VISUAL: Cocktail waitress holding tray of drinks.
WAITRESS: Botulism!
VISUAL: Clerk at market. A robber is behind him, stealing money out of the register.
CLERK: Botulism!
VISUAL: Baker rolling cookie dough in bakery.
BAKER: Botulism!
VISUAL: Woman in a laundromat.
WOMAN: Botulism!
VISUAL: A couple on a couch eating burger and fries. The guy throws a French fry at the screen.
GUY ON COUCH: Botulism!
VISUAL: Cocktail waitress holding tray of drinks.
WAITRESS: Botulism!
VISUAL: Clerk at market. The robber is watching the screen, his hand still in the register drawer.
CLERK: Botulism!
ROBBER: Botulism!
VISUAL: Elderly couple sitting in front of the television.
ELDERLY COUPLE: Botulism!
VISUAL: Contestant on game show.
CONTESTANT: Salmonella?
[SFX: Buzzer going off.]
SUPER: You Know You Know. Game Show Network.
[SFX: Chime. Clapping and cheering.]

BRONZE

CATEGORY National Campaign • **ADVERTISER/PRODUCT** Volkswagen Passat • **TITLE** Dog • **TITLE** Safari Park • **TITLE** Driving Test • **ADVERTISING AGENCY** BMP DDB, London • **PRODUCTION COMPANY** Partizan, London • **ACCOUNT EXECUTIVE** Jon King • **COPYWRITER** Rob Jack, Ewan Paterson • **ART DIRECTOR** Ewan Paterson, Rob Jack • **DIRECTOR** Rocky Morton • **PRODUCER** James Tomkinson • **AGENCY PRODUCER** Howard Spivey • **EDITOR** Rick Russell • **CLIENT SUPERVISOR** David George

VISUAL: A man and his dog are walking in the park. The dog fetches a stick in the long grass. It rolls in the mud and ferrets around in the undergrowth. The muddy dog and his owner head to a taxi. The man puts his dog in the backseat.

OWNER: 20 Dickson Road.

CAB DRIVER: 20 Dickson Road.

OWNER: A ten-er will do it?

CAB DRIVER: All right.

VISUAL: The owner, free of his muddy pet, heads to his own car, a shiny new Passat. The cab driver frowns at the dog shaking its fur clean in the backseat.

SUPER: The beautifully crafted New Passat. You'll want to keep it that way.

VISUAL: In the distance, a family walks along a narrow road. There are rolling grass fields on either side of them. They are on a Sunday walk.

DAD: It's lovely here, isn't it? It's nice to get some fresh air.

MOM: David, shouldn't we be getting back now?

DAD: No, no, no, Dear. Everything's fine. Much better than being cooped up in the car.

MOM: You're not too tired, are you, Mum?

VISUAL: A sign shows the family is walking in a safari park, and the dad has left his gleaming new Passat outside where it won't get dirtied.

[**SFX:** Baboons screeching in the distance, getting nearer.]

DAD: C'mon, everyone, stick together…

SUPER: The beautifully crafted New Passat. You'll want to keep it that way.

VISUAL: A man sitting in his spotless new Passat. He's parked in a space at the driving test center. He's watching as a driving test examiner and a teenage boy get out of a car.

The examiner hands some paperwork to the boy and shakes his hand.

EXAMINER: You passed your driving test. Congratulations.

VISUAL: The teenager is ecstatic. Disappointed with what this means, the man gets out of his car and approaches the two. The boy spots him.

SON: Dad, I passed!

DAD: Well done, son.

VISUAL: The instructor is about to leave when he's stopped by the dad.

DAD: How is his three-point turn?

EXAMINER: Yeah, it was good.

DAD: Sure? His instructor says it's normally a bit dodgy.

EXAMINER: No, it was definitely fine.

DAD: Did you check if he used his mirror properly?

EXAMINER: Yep.

DAD: You sure?

VISUAL: The examiner assures the father that his son passed. The son, disheartened by his father's meddling, shuffles to the new Passat. The father locks the car with the key remote.

DAD VO: How long have you been an examiner?

SUPER: The beautifully crafted New Passat. You'll want to keep it that way.

CATEGORY National Campaign • ADVERTISER/PRODUCT Weetabix • TITLE Black Beauty • TITLE Gymnast • TITLE Stairlift • ADVERTISING AGENCY Lowe Lintas, London • PRODUCTION COMPANY Rose Hackney Barber, London; Outsider, London • EDITING COMPANY Willcox & Willcox, London; The Quarry, London • ACCOUNT EXECUTIVE Viki Winch, Sarah Gold • CREATIVE DIRECTOR Charles Inge • COPYWRITER Brian Turner, Micky Tudor, Andy Amadeo, Paul Silburn • ART DIRECTOR Micky Tudor, Brian Turner, Andy Amadeo, Vince Squibb • DIRECTOR Graham Rose, Paul Gay • PRODUCER Steven Worley, Jason Kemp • AGENCY PRODUCER Sarah Hallatt

BRONZE

VISUAL: A series of beautiful shots of a black horse running free through the English countryside. [MUSIC: Theme to Black Beauty.]
VISUAL: The horse races through the woods, splashes along the beach and gallops through cornfields before rearing on its hind legs with joy.
When it returns to the stables, its skin unzips and two men pop out of the horse.
MAN 1: Good run, Bob. Same time tomorrow?
MAN 2: Yeah, lovely.
SUPER: WEETABIX

SUMMARY: A Japanese commentator can't hide his excitement as one of his countrymen performs a breathtaking display of twists and turns while on the rings. But even he is stunned to silence when the gymnast lets go with one hand midway through the crucifix position in order to scratch his nose.
SUPER: WEETABIX

VISUAL: A frail old lady struggles into her stair lift. The lift slowly takes her up the stairs to the landing. The woman stands up, nimbly cocks her leg over the banister and slides back down again.
SUPER: WEETABIX

BRONZE

CATEGORY National Campaign • **ADVERTISER/PRODUCT** McDonald's 99P • **TITLE** Plumber • **TITLE** Estate Agent • **TITLE** Hansen • **ADVERTISING AGENCY** Leo Burnett, London • **PRODUCTION COMPANY** Stark Films, London • **EDITING COMPANY** The Quarry, London • **SOUND DESIGN COMPANY** Jungle, London • **ACCOUNT EXECUTIVE** David Kisilevsky, Simon Liddle • **CREATIVE DIRECTOR** Mark Tutssel, Nick Bell • **COPYWRITER** Nick Bell, Laurence Quinn, Mark Norcutt • **ART DIRECTOR** Laurence Quinn, Mark Norcutt, Mark Tutssel • **DIRECTOR** Jeff Stark • **EDITOR** Bruce Townend • **PRODUCER** Cathy Green • **AGENCY PRODUCER** Jonathan Smith

VO: This is the amount of work an estate agent has to do to afford the McDonald's Quarter-Pounder.
VISUAL: Estate Agent opens the door to show a couple an empty room.
ESTATE AGENT: Lounge.
VISUAL: Estate Agent closes the door.
VO: The McDonald's Quarter-Pounder. 99p.

NOTE: Alan Hansen is a prominent football commentator.
VO: This is the amount of work Alan Hansen has to do to afford the McDonald's Quarter-Pounder.
VISUAL: Footage of Alan Hansen in a chair.
ALAN HANSEN: Very poor.
VO: The McDonald's Quarter-Pounder. 99p.

VO: This is the amount of work a plumber has to do to afford the McDonald's Quarter- Pounder.
VISUAL: Plumber looks at a pipe and nods.
VO: The McDonald's Quarter-Pounder. 99p.

CATEGORY National Campaign • **ADVERTISER/PRODUCT** Molson Take Care • **TITLE** Wheelchair • **TITLE** Plastic Surgeon • **ADVERTISING AGENCY** TAXI Advertising & Design, Toronto • **PRODUCTION COMPANY** Avion, Toronto • **EDITING COMPANY** Chris Parkins, Toronto • **MUSIC COMPANY** Great Big Music, Toronto • **SOUND DESIGN COMPANY** Great Big Music, Toronto • **ACCOUNT EXECUTIVE** Gary McGuire • **CREATIVE DIRECTOR** Zak Mroueh, Paul Lavoie • **COPYWRITER** Zak Mroueh • **ART DIRECTOR** Paul Lavoie • **DIRECTOR** Paul Lavoie, Zak Mroueh • **PRODUCER** Louise Blouin

VISUAL: Wheelchair showroom. A salesman is explaining the benefits of a particular model to a young, able-bodied man.

SALESMAN: So, this is the lightest wheelchair in its category. As you can see, it has a very small wheel-base, thus giving you very, very sharp turns. Jump in. Give it a try.

VISUAL: The young man sits in the chair, tests its turning capabilities.

SALESMAN: And also, being titanium, you get a lifetime warranty on that frame.

VISUAL: The young man is deciding whether or not to buy.

SALESMAN: So, when is this big party of yours happening?

YOUNG MAN: Tomorrow. I'm probably going to get totally hammered…drive home.

SUPER: If you're going to drink and drive, plan ahead. Molson.

Don't drink and drive.

VISUAL: Plastic surgeon's office. The doctor is discussing a procedure with an attractive, vibrant young woman.

PLASTIC SURGEON: We construct the nose, bone graft the cheek…4 or 5 operations and then…

VISUAL: The surgeon leans back in his chair.

PLASTIC SURGEON: So, you're drinking and driving tonight, right?

WOMAN: No, my girlfriend's driving. I'm the passenger.

PLASTIC SURGEON: Geez, passengers usually fly through the windshield.

WOMAN: Really?

PLASTIC SURGEON: Yup. Good thing you're seeing me before the accident.

VISUAL: Woman looks in the mirror at her beautiful, undamaged face.

WOMAN: Yeah…great.

SUPER: If you're going to drink and drive, plan ahead. Molson.

Don't drink and drive.

BRONZE

CATEGORY National Campaign • **ADVERTISER/PRODUCT** Clorox - PineSol • **TITLE** Bad Aim • **TITLE** Dog Tired • **ADVERTISING AGENCY** Palmer Jarvis DDB, Toronto • **PRODUCTION COMPANY** Jolly Roger, Toronto • **EDITING COMPANY** Stealing Time, Toronto • **SOUND DESIGN COMPANY** Pirate Radio & Television, Toronto • **ACCOUNT EXECUTIVE** Melanie Johnston, Danielle Zima • **CREATIVE DIRECTOR** Neil McOstrich, David Chiavegato, Rich Pryce-Jones • **COPYWRITER** Ben Weinberg • **ART DIRECTOR** Shelly Weinreb, Marketa Krivy • **DIRECTOR** Wayne Craig • **PRODUCER** Andrew Schulze, Peter Davis • **CINEMATOGRAPHER** Doug Koch • **EDITOR** Mark Hajek • **SOUND DESIGNER** Tom Eymundson

VISUAL: A little boy, while using the washroom, is distracted by his mother's voice. Turning to respond, he misses the toilet while he pees. Oblivious to his error, he runs off to enjoy the day.
SUPER: Pine-Sol cleans the dirt you know about. And the dirt you don't.

VISUAL: A dog is lying on a kitchen table. He's resting comfortably until he hears the sound of his owner's car. Quickly, the dog jumps off and lies down in his proper bed under the table before the owner walks in.
SUPER: Pine-Sol cleans the dirt you know about. And the dirt you don't.

CATEGORY Animation-Computer • ADVERTISER/PRODUCT Iomega • TITLE Pool • ADVERTISING AGENCY Publicis & Hal Riney, San Francisco • PRODUCTION COMPANY Traktor, Los Angeles • ANIMATION COMPANY Digital Domain, Venice • DIRECTOR Traktor • VFX SUPERVISOR André Bustanoby • VFX EXECUTIVE PRODUCER Patrick Davenport • PRODUCER Richard Bjorlin • LEAD CHARACTER ANIMATOR Piotr Karwas • CHARACTER ANIMATOR Doug Wolf • CHARACTER DESIGNER David Hodgins • LEAD COMPOSITOR Katie Nook • COMPOSITOR Paul Kirsch • FX ANIMATOR/COLOR & LIGHTING TECHNICAL DIRECTOR David Lo

SILVER

VISUAL: Fred on an inflatable raft in his backyard pool.
VO: This is Fred. Let's pretend Fred is a file on your computer. He's a thesis you've worked on for two years. You're very proud of Fred.
VISUAL: A giant octopus pops out of the water and eats Fred.
VO: No! A computer virus has struck! There goes Fred. Darn.
VISUAL: Fred reappears in the pool.
VO: Look, it's the backup copy of Fred you saved on an Iomega Zip Disk. Welcome back, Fred.
VISUAL: Fred falls into the water when trying to get on his raft.
VO: Zip. It. Zip it!
SUPER: Iomega.

SILVER

CATEGORY Animation-Computer • ADVERTISER/PRODUCT Le Saunda • TITLE Mary Jane • ADVERTISING AGENCY Grey Worldwide, Hong Kong • PRODUCTION COMPANY Studio 4c/Mangazoo.com, Japan • MUSIC COMPANY Disc Music, Hong Kong • ANIMATION COMPANY Koji Morimoto • CREATIVE DIRECTOR Sam Chung • COPYWRITER Leung Wai Kei • ART DIRECTOR Edward Leung • DIRECTOR Koji Tanaka • PRODUCER Reuben Cheng, Eiko Tanaka • EDITOR Koji Morimoto • ANIMATOR Koji Morimoto

VISUAL: Manga animation of society in a futuristic city. Robots are in control of an automobile factory where crash tests take place. There's a loud explosion, and Mary Jane, a test dummy, awakens. She escapes the robot guards of the factory. They give chase.
On a video wall deep within the city, a Le Saunda commercial is showing
VO: Le Saunda. Change your life.
VISUAL: As Mary Jane passes the video wall, she picks up the shoes shown in the commercial. When she wears the shoes, she becomes humanized and, thus, evades her robot pursuers.

CATEGORY Animation-Computer • **ADVERTISER/PRODUCT** Mini Kiss Cool • **TITLE** Gloïd And The Oinchs • **ADVERTISING AGENCY** Euro RSCG BETC, Paris • **PRODUCTION COMPANY** Prima Linea Productions • **CREATIVE DIRECTOR** Remi Babinet • **COPYWRITER** Didier Barcelo • **ART DIRECTOR** Jean-Christophe Saurel

SILVER

VISUAL: The crafty Gloïd dresses himself up as a Mini Kiss Cool box by sticking the box's label on himself. Using the candies as bait, the "Oinchs" rush over to eat them. Thinking there may be more in the Mini Kiss Cool box, they quickly throw themselves into what is actually Gloïd's mouth.
SUPER: Mini Kiss Cool.

BRONZE

CATEGORY Animation-Computer • **ADVERTISER/PRODUCT** Partnership for a Drug Free America - PDFA • **TITLE** Music • **ADVERTISING AGENCY** Merkley Newman Harty, New York • **PRODUCTION COMPANY** Curious Pictures, New York; Filmtecknarna, Stockholm • **MUSIC COMPANY** Double Six; Obsessive Fan • **CREATIVE DIRECTOR** AndyRandyMarty • **COPYWRITER** Jeff Bitsack • **ART DIRECTOR** Bryan Burlison • **DIRECTOR** Jonas Odell • **PRODUCER** Adina Sales

VISUAL: Animated character walking down the street listening to his music through headphones.
[**MUSIC**: Synched with the character's steps.]
VISUAL: As he walks, the sound waves from his headphones bounce out and destroy drug offers from various buglike creatures.
[**MUSIC**: Builds with each creature destroyed.]
VISUAL: He confronts a giant cockroach robot that is made of various drug paraphernalia. When he walks between the legs of the giant cockroach, the sound waves from the headphones makes the creature explode.
ALBERTO CRUZ VO: My name is Alberto Cruz, and my anti-drug is music.
SUPER: Music. My Anti-Drug.

CATEGORY Animation-Computer • **ADVERTISER/PRODUCT** Norfolk-Southern • **TITLE** Chasm • **ADVERTISING AGENCY** J. Walter Thompson, Atlanta • **PRODUCTION COMPANY** SunSpots, Hollywood • **EDITING COMPANY** Crush Voodoo, Santa Monica • **MUSIC COMPANY** JSM Music, New York • **ANIMATION COMPANY** Rhythm & Hues, Los Angeles • **GROUP CREATIVE DIRECTOR** Scott Nelson • **CREATIVE DIRECTOR** Michael Lollis • **COPYWRITER** Greg Carson • **ART DIRECTOR** Tom Moore • **DIRECTOR** David Dryer • **PRODUCER** M. L. Strausburg

BRONZE

vo: Today, business is composed of two worlds: one of brick and mortar…the other a digital reality.
And as these worlds continue to grow, one company will be right there…delivering the products and materials needed for success.
From the steel that builds our cities to the silicon that builds our networks.
Norfolk Southern. Moving the goods that move the economy.

SILVER

CATEGORY Animation-Film • ADVERTISER/PRODUCT Compaq • TITLE Web • ADVERTISING AGENCY BMP DDP, London • PRODUCTION COMPANY Studio AKA, London • ANIMATION COMPANY Studio AKA, London • ACCOUNT EXECUTIVE Patrick Donoghugh • COPYWRITER John Webster • ART DIRECTOR John Webster • DIRECTOR Mark Craste • PRODUCER Sue Goffe • CLIENT SUPERVISOR John Scola • AGENCY PRODUCER Lucinda Ker • MUSIC Sgt. Rock

VISUAL: A giant cobweb slowly revolves on screen. Each section demonstrates a feature of a large Web site such as Microsoft.
Travel—a belly dancer dances.
Gardening—A gardener plants seeds in pots.
Fishing—A fisherman tries to grasp a slippery fish.
Trust Funds—A man counts his money.
Antiques—A man watches a pendulum clock.
Wine—An imbiber tastes and spits out.
Historic Houses—A visitor sees a ghost.
Tourism—Japenese tourists take photos.
Hotels—Pageboys carry luggage up hotel stairs.
Oil Prices—A sheikh discovers oil.
Astronomy—A young man is animated when he sees shooting stars.
Restaurants—Diners eat, waiters serve.
VO: Compaq Proliant. The server behind the world's busiest Web sites.
VISUAL: At the center of the web, an eager face appears. It's a spider.
[SFX: Crash, Intel jingle.]
SUPER: Compaq.
Non-stop
VO: With Intel Pentium III Processor.

CATEGORY Animation-Film • ADVERTISER/PRODUCT Nike • TITLE Leo • ADVERTISING AGENCY Wieden + Kennedy, Amsterdam • PRODUCTION COMPANY Partizan Midi Minuit, Paris • EDITING COMPANY The Whitehouse, London • SOUND DESIGN COMPANY Scramble Sound, London • ANIMATION COMPANY Buf Compagnie, Paris • CREATIVE DIRECTOR John Boiler, Glenn Cole • COPYWRITER Boyd Coyner • ART DIRECTOR Alvaro Sotomayor • DIRECTOR Michel Gondry • PRODUCER Colleen Wellman • 3D GRAPHICS Riff Raff, Amsterdam • MUSIC Marcus Liesenfeld

BRONZE

SYNOPSIS: An animated skateboarder accidentally breaks through the wall of his video game and wreaks havoc in other games. He causes pixelized anarchy when he spoils a soccer game; gets Michael Jordan shrunk to miniature scale by aliens; unintentionally fondles Lara Croft and fends off a dinosaur with the help of Andre Agassi.

SUPER: Cross-training.

BRONZE

CATEGORY Animation-Film • **ADVERTISER/PRODUCT** California Dept. of Health Services • **TITLE** Crocodile Tears • **ADVERTISING AGENCY** Paul Keye and Partners, Culver City • **PRODUCTION COMPANY** Kurtz and Friends, Burbank • **ANIMATION COMPANY** Kurtz and Friends, Burbank • **CREATIVE DIRECTOR** Paul Keye • **COPYWRITER** Paul Keye • **ART DIRECTOR** Bob Kurtz • **DIRECTOR** Bob Kurtz • **PRODUCER** Boo Kurtz-Lopez, Beth Hagen

CROCODILE: Everybody picks on me. Nobody likes me.
OFF SCREEN VOICE: Well, you can't really blame them. You've killed and crippled millions of Americans.
CROCODILE: They didn't have to smoke. It was their choice.
OFF SCREEN VOICE: But you knew cigarettes were addictive and you lied about it.
CROCODILE: That was the "old" me. I'm into "community service" now. Have you seen my ads?
OFF SCREEN VOICE: Yeah. Can I ask you a question?
CROCODILE: Anything. This is the "new" me.
OFF SCREEN VOICE: Are you going to keep selling cigarettes? I said are you going to…
CROCODILE: Arrrgggghhhh!
OFF SCREEN VOICE: Just thought I'd ask.

CATEGORY Budgeted Under U.S. $20,000 • **ADVERTISER/PRODUCT** Mercado • **TITLE** Crosswalk • **ADVERTISING AGENCY** CraveroLanis Euro RSCG, Buenos Aires • **PRODUCTION COMPANY** Andon Cine, Buenos Aires • **ACCOUNT EXECUTIVE** Elizabeth Ares • **GENERAL CREATIVE DIRECTOR** Juan Cravero, Dario Lanis • **CREATIVE DIRECTOR** Esteban Pigni • **COPYWRITER** Guillermo Castaneda, Esteban Pigni • **ART DIRECTOR** Mercedes Tiagonce, Sebastian Garin • **DIRECTOR** Ruben Andon • **AGENCY PRODUCER** Carlos Volpe • **CLIENT SUPERVISOR** Monica Moccia

SILVER

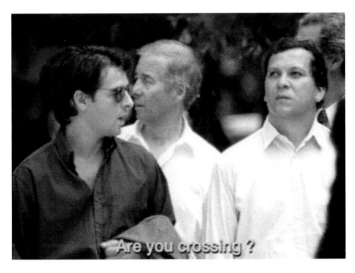

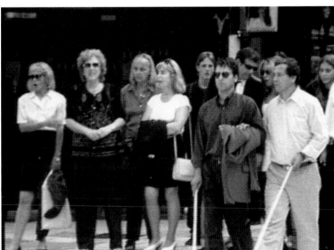

VISUAL: A blind man walks down the street with his cane. He stops at the curb of a busy intersection. The blind man stands next to a man with sunglasses.

MAN WITH SUNGLASSES: Crossing?

BLIND MAN: Yes.

VISUAL: The man wearing sunglasses takes the blind man's arm to help cross. When the camera zooms out, it is shown that the man with sunglasses is also blind. The two head right into the busy intersection, unaware of the dangerous situation they have put themselves into.

SUPER: Even worse than not being informed is believing that you are.

Mercado. Business magazine.

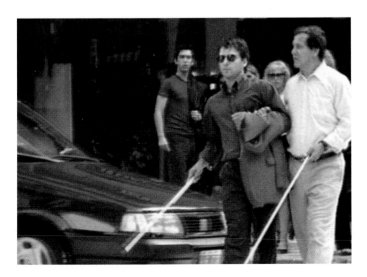

107

SILVER

CATEGORY Budgeted Under U.S. $20,000 • **ADVERTISER/PRODUCT** Scrabble • **TITLE** Amnesia • **ADVERTISING AGENCY** Ogilvy & Mather, Singapore • **PRODUCTION COMPANY** Alias Films • **CREATIVE DIRECTOR** Tham Khai Meng, Neil French • **COPYWRITER** Tham Khai Meng, Neil French • **ART DIRECTOR** Neil French • **DIRECTOR** Simon Peters • **EDITOR** Russell King

VISUAL: An old woman is looking down and concentrating hard at some unknown task at hand. Finally, she gives the camera a puzzled look and smiles.
WOMAN: I've got amnesia!
SUPER: Amnesia.
Scrabble.
The world's favorite word game.

CATEGORY Budgeted Under U.S. $20,000 • **ADVERTISER/PRODUCT** SWR Campaign Against Violence in Media • **TITLE** Counting Sheep •
ADVERTISING AGENCY Ogilvy & Mather, Frankfurt • **PRODUCTION COMPANY** Archiv O&M, Frankfurt • **ACCOUNT EXECUTIVE** Delle Krause •
CREATIVE DIRECTOR Christian Seifert, Patrick They • **COPYWRITER** Christian Seifert • **ART DIRECTOR** Patrick They • **EDITOR** Mathias Kohler •
SOUND DESIGNER Lars Kellner/Holger

BRONZE

VO: 1...2...3...4...5...
VISUAL: Several violent scenes from films are shown with each number counted.
SUPER: What does your child count to fall asleep?
SWR—Watch out what your child is watching.
SWR Television.

BRONZE

CATEGORY Budgeted Under U.S. $20,000 • **ADVERTISER/PRODUCT** DaimlerChrysler • **TITLE** Fire Brigade • **ADVERTISING AGENCY** Scholz & Friends Berlin, Berlin • **PRODUCTION COMPANY** Bazillus • **CREATIVE DIRECTOR** Sebastian Turner, Joerg Jahn • **COPYWRITER** Bjoern Ruehmann • **ART DIRECTOR** Bjoern Ruehmann • **DIRECTOR** Bazillus • **PRODUCER** Anke Specht

[**SFX**: Fire engine sirens.]
VISUAL: A roundabout at a busy intersection. A fire truck with sirens at full blast enters the traffic circle. However, instead of moving along to the emergency, the truck driver decides to make a few extra circles in the roundabout.
SUPER: Trucks you love to drive.
Mercedes-Benz.

CATEGORY Budgeted Under U.S. $20,000 • **ADVERTISER/PRODUCT** DaimlerChrysler AG / Mercedes-Benz • **TITLE** Boy • **ADVERTISING AGENCY** Springer & Jacoby, Hamburg • **PRODUCTION COMPANY** Tempomedia Filmproduktion, Hamburg • **MUSIC COMPANY** Tonhaus, Hamburg • **SOUND DESIGN COMPANY** Tonhaus, Hamburg • **CREATIVE DIRECTOR** Arno Lindemann, Stefan Meske • **COPYWRITER** Amir Kassaei • **ART DIRECTOR** Florian Grimm • **DIRECTOR** Marc Hartmann, Arno Lindemann

BRONZE

VISUAL: A young couple walks through the city. The woman is pregnant. She stops because the baby kicks. The father puts his ear to her stomach. From his viewpoint, he sees why the baby is kicking.

There's a new SLK parked next to them.

FATHER: It'll be a boy.

MOTHER: Why? How would you know?

FATHER: I know.

MOTHER: Never.

FATHER: For sure.

SUPER: The SLK.

Mercedes-Benz.

The Future of the Automobile.

www.mercedes-benz.com.

BRONZE

CATEGORY Budgeted Under U.S. $20,000 • **ADVERTISER/PRODUCT** Panasonic Home Entertainment/Dolby Digital • **TITLE** Swimming • **ADVERTISING AGENCY** Springer & Jacoby, Hamburg • **PRODUCTION COMPANY** Cobblestone, Berlin • **CREATIVE DIRECTOR** Alexander Schill, Axel Thomsen • **COPYWRITER** Alexander Weber, Daniel Schmidtmann • **ART DIRECTOR** Bastin Kuhn, Christoph Everke • **DIRECTOR** Ron Eichhorn • **PRODUCER** Marc Haferbusch

VISUAL: Two friends swimming. One is up to his neck in water. He encourages his buddy to leap from the dock because the water is deep. His friend runs from the end of the dock and jumps. In mid-air, he finds out that the water isn't deep when his buddy stands up and laughs.

SUPER: Comedy films in Dolby Digital will change your life. Panasonic Home Entertainment.

CATEGORY Budgeted Under U.S. $20,000 • **ADVERTISER/PRODUCT** Red Cross Germany • **TITLE** Peace • **ADVERTISING AGENCY** Ogilvy & Mather, Frankfurt • **PRODUCTION COMPANY** Das Werk, Frankfurt • **MUSIC COMPANY** Sinus AV Studio • **ANIMATION COMPANY** Das Werk, Frankfurt • **ACCOUNT EXECUTIVE** John F. Goetze • **CREATIVE DIRECTOR** Thomas Hofbeck, Dr. Stephan Vogel • **COPYWRITER** Dr. Stephan Vogel • **ART DIRECTOR** Thomas Hofbeck, Jens Frank • **DIRECTOR** Thomas Hofbeck • **MUSIC** Lars Kellner • **ANIMATOR** Ralf Drechsler, Willi Hammes • **PRODUCER** John F. Goetze

BRONZE

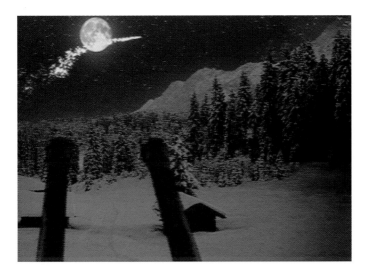

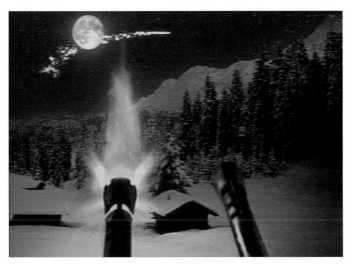

VISUAL: A peaceful, snowed-covered mountain.
[**SFX:** Christmas music softly playing in the background.]
VISUAL: The barrel of an anti-aircraft gun appears and Santa's sleigh is brought down from the skies with a few well-aimed shots.
SUPER: In 36 countries there's no Peace on Earth. German Red Cross. Donation Hotline…

GOLD

CATEGORY Cinematography • **ADVERTISER/PRODUCT** Orange (Mobile Phone Network) • **TITLE** Hold Up • **ADVERTISING AGENCY** WCRS, London • **PRODUCTION COMPANY** Gorgeous Enterprises, London • **EDITING COMPANY** Smoke & Mirrors, London • **MUSIC COMPANY** Big Picture Music, London • **SOUND DESIGN COMPANY** 750 MPH, London • **CREATIVE DIRECTOR** Jo Moore, Simon Robinson • **COPYWRITER** Jo Moore, Simon Robinson • **ART DIRECTOR** Simon Robinson • **DIRECTOR** Chris Plamer • **PRODUCER** Tim Marshall • **AGENCY PRODUCER** James Letham • **LIGHTING/CAMERAMAN** Ivan Bird • **EDITOR** Paul Watts • **SOUND DESIGNER** Nigel Crowley • **MUSIC** Terry Devine King • **VFX SUPERVISOR** Mitch Mitchell

VISUAL: A hectic car chase in a bustling city at night intercut with shots of a young man sitting at a bar, lost in thought. Suddenly, it is revealed that the Hollywood-style car chase is actually happening among the bottles on the bar in front of the young man. He watches in awe as the lead car ramps off a matchbook, sails through the air and crashes upside-down on the bar.

VO: To find out how Orange can bring you reviews of the latest movies, call 0800 80 10 80.

VISUAL: Watches with interest as miniature policemen arrest the bad guys in the wrecked vehicle.

VO: Orange. Take your world with you.

SUPER: Orange.
The future's bright. The future's Orange.
0800 80 10 80.
www.orange.cc.uk.

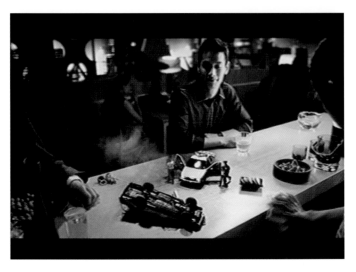

CATEGORY Cinematography • ADVERTISER/PRODUCT Nike • TITLE Train To Win • ADVERTISING AGENCY The Jupiter Drawing Room (South Africa), Johannesburg • PRODUCTION COMPANY Egg Productions, Cape Town • EDITING COMPANY Egg Productions, Cape Town • MUSIC COMPANY Rob Roy, Johannesburg • SOUND DESIGN COMPANY Rob Roy, Johannesburg • ANIMATION COMPANY Egg Productions, Cape Town • ACCOUNT EXECUTIVE Michelle Young • CREATIVE DIRECTOR Graham Warsop • COPYWRITER Peter Callaghan • ART DIRECTOR Vanessa Norman • DIRECTOR Kim Geldenhuys • PRODUCER Colin Howard

GOLD

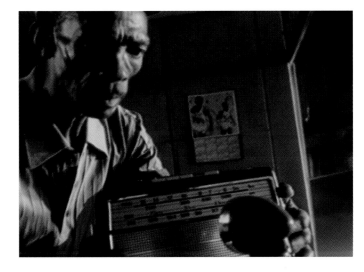

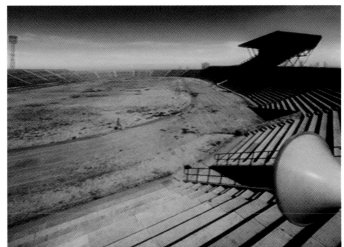

VISUAL: An old coach watches his runner and steals glances at the stopwatch. The long distance runner pounds along the inside lane of an old rural athletics field. It's a hot day and the heat shimmers off this track that has seen better days. The athlete is the pinnacle of physical perfection, racing around the field. There's sweat on his brow; his cheeks shudder as he takes each step.

[SFX: The ambient sounds of running.]

VISUAL: As the athlete passes the starting point, a young boy sitting patiently by the side of the track gets up and beats a can with a stick. The runner is tired; he's slowing down. The coach gets up and slowly carries his bag up the stairs to the commentary booth.

The coach takes a portable radio out of the bag. He tunes the radio, catching snippets of different stations. The old man keeps moving the dial until there's a strong hiss of static. He turns on the stadium microphone and places the radio next to it. He turns up the volume of the static hiss.

[SFX: Radio static evolving into a roar of the crowd.]

In the last 100 meters, the athlete hears the roar of the crowds in the static. He picks up his stride as if cheered on by a million fans. The child watches in amazement as the runner sprints past with renewed vigor.

SUPER: Just Do It.

Africa.

SILVER

CATEGORY Cinematography • **ADVERTISER/PRODUCT** Ford Trucks • **TITLE** Fight Club • **ADVERTISING AGENCY** J. Walter Thompson, Detroit • **PRODUCTION COMPANY** Bruce Dowad Associates, Hollywood • **EDITING COMPANY** Red Car, Santa Monica • **MUSIC COMPANY** Elias Associates, Santa Monica • **CREATIVE DIRECTOR** Jon Parkison • **COPYWRITER** Merritt Fritchie • **ART DIRECTOR** Bill Majewski • **DIRECTOR** Robert Logevall • **EXECUTIVE PRODUCER** Heidi Nolting Sturges • **PRODUCER** Bob Ammon • **DIRECTOR OF PHOTOGRAPHY** Tobias Schliessler

VISUAL: A group of guys are "motor-boarding" down the rooftop of a building into an auto junkyard.
VO: You know the Fight Club, right. Where this group of guys gets together in some warehouse or basement or whatever… and they just get beaten up. Then they go to work the next day, scraped and scarred and wearing bruises like badges of honor.
VISUAL: One guy wipes out and the board gets mangled. Unfazed by the crash, he grabs another board and is then seen on a board, gliding over three abandoned buses.
VO: Now there's a hobby that separates the men from the boys. The all-new Ford Ranger Edge. Built Ford Tough.
SUPER: Built Ford Tough.

CATEGORY Cinematography • **ADVERTISER/PRODUCT** Mountain Dew • **TITLE** Showstopper • **ADVERTISING AGENCY** BBDO, New York •
PRODUCTION COMPANY HSI, Culver City • **COPYWRITER** Bill Bruce • **ART DIRECTOR** Doris Cassar • **DIRECTOR** Samuel Bayer •
PRODUCER Gary Delemeestar

BRONZE

SYNOPSIS: "Showstopper" takes a poke at the classic big MGM choreographed musicals of the 1930s & 40s. In the end, we find that a flawless performance isn't quite good enough.

BRONZE

CATEGORY Cinematography • **ADVERTISER/PRODUCT** The New York Times • **TITLE** Tornado • **ADVERTISING AGENCY** Bozell, New York • **PRODUCTION COMPANY** Gerard De Thame Films/HSI Productions • **EXECUTIVE CREATIVE DIRECTOR** Brent Bouchez • **GROUP CREATIVE DIRECTOR** David Nobay • **COPYWRITER** David Nobay • **ART DIRECTOR** Mickey Surasky • **DIRECTOR** Gerard de Thame • **DIRECTOR OF PHOTOGRAPHY** Mick Coulter • **EXECUTIVE PRODUCER** Andrew Chinich • **AGENCY PRODUCER** Mary Ellen Verrusio

VISUAL: Aerial shot of barn roof as surrounding countryside blows in wind.
MAYA ANGELOU VO: The truth does not still for a moment.
VISUAL: A tornado approaches. High winds pick up telephone and utility poles.
MAYA ANGELOU VO: It twists and turns, picks up your opinions…
VISUAL: The twister hits and the barn breaks up into splinters of debris that mix with type letters.
MAYA ANGELOU VO: …and sets them down a thousand miles away.
VISUAL: The letters fall from the grip of the tornado and neatly into place as part of the *New York Times* newspaper text.
MAYA ANGELOU VO: When was the last time something you read moved you?
The New York Times.
SUPER: New York Times.

CATEGORY Cinematography • ADVERTISER/PRODUCT Lexus IS 300 • TITLE Rally • ADVERTISING AGENCY Team One Advertising, El Segundo • PRODUCTION COMPANY Compass Films, Los Angeles • EDITING COMPANY Nomad, Los Angeles • SOUND DESIGN COMPANY Machine Head, Los Angeles • ACCOUNT EXECUTIVE Vicki Wagner • CREATIVE DIRECTOR Tom Cordner • COPYWRITER Suzanne Steele • ART DIRECTOR Tito Melega • DIRECTOR Nico Beyer • PRODUCER Jennifer Willett

BRONZE

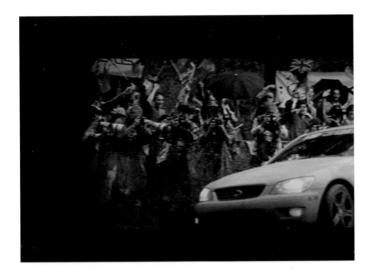

[SFX: A storm approaching. Car engines are revving hard.]
VISUAL: Car rally enthusiasts line a muddy road, waiting to see the cars drive by. When the Lexus IS 300 barrels down the road, the spectators lean dangerously close to watch it take the hairpin turn.
VO: The Lexus IS With a 215-horsepower VVT-I engine, e-shift transmission, and remarkable handling.
VISUAL: Despite the slippery conditions, the IS drives off without losing an inch of grip on the road.
VO: Which in recent tests, easily out-cornered a certain "other" sports sedan.
VISUAL: The spectators turn their attention to the next car coming down the road. When they see it's the BMW 330I, they run for their lives.
[SFX: Crowd screaming, fleeing.]
SUPER: Lexus. The Passionate Pursuit Of Perfection.

BRONZE

CATEGORY Cinematography • **ADVERTISER/PRODUCT** Ford Trucks • **TITLE** A-Team • **ADVERTISING AGENCY** J. Walter Thompson, Detroit • **PRODUCTION COMPANY** Bruce Dowad Associates, Hollywood • **EDITING COMPANY** Red Car, Santa Monica • **MUSIC COMPANY** Elias Associates, Santa Monica • **CREATIVE DIRECTOR** Jon Parkinson • **COPYWRITER** Merritt Fritchie • **ART DIRECTOR** Bill Majewski • **DIRECTOR** Robert Logevall • **EXECUTIVE PRODUCER** Heidi Nolting Sturges • **PRODUCER** Bob Ammon • **DIRECTOR OF PHOTOGRAPHY** Tobias Schliessler

VISUAL: A group of guys are in a Ford Supercrew. It's raining when they pull up to a flooded area.
VO: Remember the A-Team…
Now there was an odd bunch of individuals.
VISUAL: The men get out of the truck and grab sandbags to prevent more flooding.
VO: They always had a cockamamie scheme to get out of a jam. They never sounded like it would work. But of course it always did. Week after week, same time, same channel…
Those were my boys.
SUPER: Seating for six. Available bed extender.
VO: Ford F-Series Super Crew. Built Ford Tough.

CATEGORY Direction • **ADVERTISER/PRODUCT** TAC • **TITLE** Never • **ADVERTISING AGENCY** Grey Advertising, Melbourne • **PRODUCTION COMPANY** Film Graphics, Sydney • **EDITING COMPANY** Mustard, Sydney • **ACCOUNT EXECUTIVE** Anne Saville • **CREATIVE DIRECTOR** Rob Dow • **COPYWRITER** Nigel Dawson • **ART DIRECTOR** Georgina Campbell • **DIRECTOR** Mat Humphrey • **PRODUCER** Marge McInnes • **EDITOR** Drew Thompson

SILVER

VISUAL: Couple in a car.

[**SFX:** Car crash.]

VISUAL: Car crashes into the back of a truck.

RUSSELL: Julie! Julie!

VISUAL: The earlier events of the day.

JULIE: Happy birthday, Dad!

[**SFX:** Birthday atmosphere.]

VISUAL: Scene of the accident.

AMBULANCE OFFICER: Can you hear me? Talk to me. What's your first name?

RUSSELL: Russell.

AMBULANCE OFFICER: Man, she is 83.

RUSSELL: What's happened to Julie?

AMBULANCE OFFICER: Just keep looking straight ahead, Russell.

VISUAL: Birthday party.

JULIE: Dad, I was not!

DAD: You were that high!

VISUAL: Various scenes of the car accident and the birthday party.

DAD'S VO: I'll never see her again.

RUSSELL: We should probably get going.

JULIE: Yeah.

DAD'S VO: Never hear her voice…

JULIE: Happy birthday, Dad.

DAD: Thanks, Sweetheart.

JULIE: No worries.

VISUAL: Russell drinking a beer.

DAD'S VO: …never hear her laugh.

DAD: Take care of my baby girl.

RUSSELL: I will.

DAD'S VO: I'll never see her get married.

JULIE: Sure you don't want me to drive?

RUSSELL: I'm all right…I've only had a few. Besides, I've been eating your mother's food all day.

DAD'S VO: Cuddle her children…

VISUAL: Dad shows up to the scene of the accident.

DAD: You said she was here…where is she? Oh my god… Julie!

RUSSELL: Oh shit! No!

DAD'S VO: Never hear her call me Dad.

DAD: Russ!

VISUAL: Dad collapses at the scene of the accident.

DAD'S VO: And I'll never forget having to choose her coffin.

VISUAL: Dad at home.

DAD: My beautiful baby!

SUPER: If you drink, then drive, you're a bloody idiot. TAC.

BRONZE

CATEGORY Direction • **ADVERTISER/PRODUCT** Mountain Dew • **TITLE** Showstopper • **ADVERTISING AGENCY** BBDO, New York • **PRODUCTION COMPANY** HSI, Culver City • **COPYWRITER** Bill Bruce • **ART DIRECTOR** Doris Cassar • **DIRECTOR** Samuel Bayer • **PRODUCER** Gary Delemeester

SYNOPSIS: "Showstopper" takes a poke at the classic big MGM choreographed musicals of the 1930s & 40s. In the end, we find that a flawless performance isn't quite good enough.

CATEGORY Direction • **ADVERTISER/PRODUCT** Orange (Mobile Phone Network) • **TITLE** Hold Up • **ADVERTISING AGENCY** WCRS, London • **PRODUCTION COMPANY** Gorgeous Enterprises, London • **EDITING COMPANY** Smoke & Mirrors, London • **MUSIC COMPANY** Big Picture Music, London • **SOUND DESIGN COMPANY** 750 MPH, London • **CREATIVE DIRECTOR** Jo Moore, Simon Robinson • **COPYWRITER** Jo Moore, Simon Robinson • **ART DIRECTOR** Simon Robinson • **DIRECTOR** Chris Palmer • **PRODUCER** Tim Marshall • **AGENCY PRODUCER** James Letham • **MUSIC ARRANGER** Terry Devine King • **EDITOR** Paul Watts • **SOUND DESIGNER** Nigel Crowley • **LIGHTING CAMERAMAN** Ivan Bird • **VFX SUPERVISOR** Mitch Mitchell

BRONZE

VISUAL: A hectic car chase in a bustling city at night intercut with shots of a young man sitting at a bar, lost in thought. Suddenly, it is revealed that the Hollywood-style car chase is actually happening among the bottles on the bar in front of the young man. He watches in awe as the lead car ramps off a matchbook, sails through the air and crashes upside-down on the bar.
VO: To find out how Orange can bring you reviews of the latest movies, call 0800 80 10 80.
VISUAL: Watches with interest as miniature policemen arrest the bad guys in the wrecked vehicle.
VO: Orange. Take your world with you.
SUPER: Orange.
The future's bright. The future's Orange.
0800 80 10 80.
www.orange.cc.uk.

SILVER

CATEGORY Direction-Music Video • ADVERTISER/PRODUCT Red Hot Chili Peppers • TITLE Californication • PRODUCTION COMPANY Bob Industries, New York & Los Angeles • EDITING COMPANY Spot Welders, Los Angeles • MUSIC COMPANY Warner Bros., Burbank • DIRECTOR Jonathan Dayton, Valerie Faris • PRODUCER John Beug • EDITOR Scott Chestnut

[MUSIC: Red Hot Chili Peppers—Californication]
SYNOPSIS: The ultimate video game based on the California dream. With the animated band members as characters in the game, they explore different regions of the state. Some of the activities include touring Sunset Boulevard; snowboarding down a mountain; swimming underwater with sharks; avoiding loggers in a forest; running through Hollywood movie sets; boarding on the cables of the Golden Gate Bridge; cruising the streets of San Francisco; and fleeing the chaos of an earthquake.

CATEGORY Direction-Music Video • ADVERTISER/PRODUCT Red Hot Chili Peppers • TITLE Otherside • PRODUCTION COMPANY Bob Industries, New York & Los Angeles • EDITING COMPANY Spot Welders, Los Angeles • MUSIC COMPANY Warner Bros., Burbank • DIRECTOR Jonathan Dayton, Valerie Faris • PRODUCER John Beug • EDITOR Eric Zumbrunnen

SILVER

[MUSIC: Red Hot Chili Peppers—Otherside]

SYNOPSIS: A young man journeys through a stark, abstract world in which he is trapped. As he tries to make an escape, he slays a dragon, makes his way through a maze of ladders, and fights his own shadow. Reminiscent of an old silent film with a distorted, brooding atmosphere, "Otherside" is a fantastic yet haunting video.

BRONZE

CATEGORY Direction-Music Video • **ADVERTISER/PRODUCT** Madonna • **TITLE** Don't Tell Me • **PRODUCTION COMPANY** DNA, Hollywood •
EDITING COMPANY Rock Paper Scissors, Los Angeles • **MUSIC COMPANY** Warner Bros./Maverick, Los Angeles • **ART DIRECTOR** Bill Doig •
DIRECTOR Jean-Baptiste Mondino • **PRODUCER** Maria Gallagher

[**MUSIC**: Madonna—Don't Tell Me]

SYNOPSIS: Madonna, as a post-modern Hud, struts along a treadmill. She is superimposed against a drive-in style movie screen, which is projecting a desert highway in the American West.

The endless highway, a bronco-busting cowboy, and finally, several cowboys who break the screen barrier to join Madonna in a beautifully syncopated dance. Madonna then performs a lyrical ride on a mechanical bull and comes back again to walking the long road home.

CATEGORY Editing • ADVERTISER/PRODUCT Orange (Mobile Phone Network) • TITLE Hold Up • ADVERTISING AGENCY WCRS, London • PRODUCTION COMPANY Gorgeous Enterprises, London • EDITING COMPANY Smoke & Mirrors, London • MUSIC COMPANY Big Picture Music, London • SOUND DESIGN COMPANY 750 MPH, London • CREATIVE DIRECTOR Jo Moore, Simon Robinson • COPYWRITER Jo Moore, Simon Robinson • ART DIRECTOR Simon Robinson • DIRECTOR Chris Palmer • PRODUCER Tim Marshall • AGENCY PRODUCER James Letham • SOUND DESIGNER Nigel Crowley • LIGHTING CAMERAMAN Ivan Bird • MUSIC ARRANGER Terry Devine King • VFX SUPERVISOR Mitch Mitchell • EDITOR Paul Watts

SILVER

VISUAL: A hectic car chase in a bustling city at night intercut with shots of a young man sitting at a bar, lost in thought. Suddenly, it is revealed that the Hollywood-style car chase is actually happening among the bottles on the bar in front of the young man. He watches in awe as the lead car ramps off a matchbook, sails through the air and crashes upside-down on the bar.

VO: To find out how Orange can bring you reviews of the latest movies, call 0800 80 10 80.

VISUAL: Watches with interest as miniature policemen arrest the bad guys in the wrecked vehicle.

VO: Orange. Take your world with you.

SUPER: Orange.
The future's bright. The future's Orange.
0800 80 10 80.
www.orange.cc.uk.

CATEGORY Editing • **ADVERTISER/PRODUCT** TDK • **TITLE** Evolved • **ADVERTISING AGENCY** BWM, Sydney • **PRODUCTION COMPANY** Luscious International, Sydney • **EDITING COMPANY** Mustard Post Production, Sydney • **MUSIC COMPANY** Machine Gun Felatio, Sydney • **SOUND DESIGN COMPANY** Machine Gun Felatio, Sydney • **CREATIVE DIRECTOR** Rob Belgiovane • **COPYWRITER** Philip Puttnam • **ART DIRECTOR** Denis Mamo • **DIRECTOR** Richard Gibson • **PRODUCER** Andrew Morris • **EDITOR** Drew Thompson

VISUAL: A beautiful girl makes her way through a Blade Runner cityscape. She passes tattoo parlors and piercing studios among the steam and neon. Groups of Tribals, pierced, tattooed, scarified, watch her closely.

She ducks into an unmarked doorway. Into a bare room where only a monitor and DVD player are set up on a table. She stands there. A man wearing a beanie and dark glasses slips a TDK disc into player.

Lights start to flash as the music picks up. She starts moving sensuously as sound and vision take her over. The beanied man presses the stop button. She composes herself and leaves. From an upstairs room the man peers down at her. He lifts his glasses just enough to reveal his TDK square eyes. He has TDK ears, too.

Out in the street the Tribals gaze at the girl, transfixed, startled, entranced but also threatened. Because of her TDK eyes and ears, she's more evolved than them.

SUPER: Evolve to TDK disc.

CATEGORY Editing • **ADVERTISER/PRODUCT** TAC • **TITLE** Never • **ADVERTISING AGENCY** Grey Advertising, Sydney • **PRODUCTION COMPANY** Film Graphics, Sydney • **EDITING COMPANY** Mustard Post Production, Sydney • **SOUND DESIGN COMPANY** Song Zu, Sydney • **CREATIVE DIRECTOR** Rob Dow, Nigel Dawson • **ART DIRECTOR** Georgina Campbell • **DIRECTOR** Mat Humphrey • **PRODUCER** Marge McInnes • **EDITOR** Drew Thompson

VISUAL: Couple in a car.
[SFX: Car crash.]
VISUAL: Car crashes into the back of a truck.
RUSSELL: Julie! Julie!
VISUAL: The earlier events of the day.
JULIE: Happy birthday, Dad!
[SFX: Birthday atmosphere.]
VISUAL: Scene of the accident.
AMBULANCE OFFICER: Can you hear me? Talk to me. What's your first name?
RUSSELL: Russell.
AMBULANCE OFFICER: Man, she is 83.
RUSSELL: What's happened to Julie?
AMBULANCE OFFICER: Just keep looking straight ahead, Russell.
VISUAL: Birthday party.
JULIE: Dad, I was not!
DAD: You were that high!
VISUAL: Various scenes of the car accident and the birthday party.
DAD'S VO: I'll never see her again.
RUSSELL: We should probably get going.
JULIE: Yeah.
DAD'S VO: Never hear her voice…
JULIE: Happy birthday, Dad.
DAD: Thanks, Sweetheart.
JULIE: No worries.
VISUAL: Russell drinking a beer.
DAD'S VO: …never hear her laugh.
DAD: Take care of my baby girl.
RUSSELL: I will.
DAD'S VO: I'll never see her get married.
JULIE: Sure you don't want me to drive?
RUSSELL: I'm all right…I've only had a few.
Besides, I've been eating your mother's food all day.
DAD'S VO: Cuddle her children…
VISUAL: Dad shows up to the scene of the accident.
DAD: You said she was here…where is she? Oh my god… Julie!
RUSSELL: Oh shit! No!
DAD'S VO: Never hear her call me Dad.
DAD: Russ!
VISUAL: Dad collapses at the scene of the accident.
DAD'S VO: And I'll never forget having to choose her coffin.
VISUAL: Dad at home.
DAD: My beautiful baby!
SUPER: If you drink, then drive, you're a bloody idiot. TAC.

BRONZE

CATEGORY Editing • **ADVERTISER/PRODUCT** American Express Green Card • **TITLE** Manhattan • **ADVERTISING AGENCY** Ogilvy & Mather, New York • **PRODUCTION COMPANY** PYTKA, Venice • **EDITING COMPANY** Go Robot!, New York • **ACCOUNT EXECUTIVE** Michelle Bogdan • **CREATIVE DIRECTOR** David Apicella • **COPYWRITER** Chris Mitton • **DIRECTOR** Joe Pytka • **PRODUCER** Lisa Stieman • **EDITOR** Adam Liebowitz • **MUSIC** Moby

VISUAL: Tiger Woods plays golf throughout various locations on Manhattan Island.
SUPER: Question more.
Experience more.
Dream more.
Believe more.
Do more.
American Express.

CATEGORY Editing • **ADVERTISER/PRODUCT** Timex • **TITLE** Kung Fu • **ADVERTISING AGENCY** Fallon, Minneapolis • **PRODUCTION COMPANY** A Band Apart, Los Angeles • **EDITING COMPANY** Rock Paper Scissors, Los Angeles • **CREATIVE DIRECTOR** David Lubars • **COPYWRITER** Joe Sweet • **ART DIRECTOR** David Carter • **DIRECTOR** Tim Burton • **PRODUCER** Jenny Gadd Malmstrom • **EDITOR** Angus Wall

BRONZE

[**MUSIC**: Suspenseful throughout.]

VISUAL: A creaky door swings open and the good guy rushes out. His pursuer, a menacing cyborg type, follows. When the good guy jumps over a railing and lands on his feet, he finds himself facing a second cyborg. The one chasing him crashes through a door. The good guy is outnumbered.

The good guy sets his Timex and then goes to work on the evil cyborgs. Several kicks and punches are thrown. During the combat, the good guy is able to set the cyborgs' watches. He's so fast, they don't even notice.

The good guy flips off a wall and lands between the villains. Their watches go off simultaneously, distracting them. The good guy takes them out with a swift kick.

A third cyborg comes flying out of nowhere. A fight ensues. After a few kicks and punches, the good guy holds his wrist near the cyborg's ear. The Timex alarm goes off and distracts the bad guy. The good guy takes him out.

With all three cyborgs down, the good guy blows on his watch.

The camera cuts to a shot of all three Timex watches.

SUPER: TIMEX® i-Control™ setting systems.

Ridiculously easy to use.

i-Control.timex.com

BRONZE

CATEGORY Editing • **ADVERTISER/PRODUCT** IBM Olympics • **TITLE** Senegal Women's Basketball • **ADVERTISING AGENCY** Ogilvy & Mather, New York • **PRODUCTION COMPANY** @radical.media, New York • **EDITING COMPANY** Go Robot!, New York • **MUSIC COMPANY** Ear To Ear, Santa Monica • **ACCOUNT EXECUTIVE** Danielle Keany • **CREATIVE DIRECTOR** Chris Wall • **COPYWRITER** Brendan Gibbons • **ART DIRECTOR** Chris Curry • **DIRECTOR** Lenny Dorfman • **PRODUCER** Lee Weiss, Lisa Stieman • **EDITOR** JJ Lask

MAN 1: Mamaty Mbengue, she is the best player here in Senegal, and everybody knows that.

CHEERING: She's the best player.

WOMAN 1: Mamaty!

WOMAN 2: Mamaty!

MAN 1: Mamaty!

MAMATY: My name is Mamaty Mbengue. I am a player of the Senegal's Basketball.

MAN 1: You can ask anybody on the street here, Do you know Mamaty Mbengue? They're gonna say yes. Everybody play basketball here.

MAN 2: The first time in our country that we go to the Olympic Games.

WOMAN 1: We're going to represent Africa.

MAN 1: She's like a hero here.

MAN 2: She's a hero!

MAMATY: Maybe I am the hero, but I just want to be a simple basketball player.

MAN 2: We call her the Queen of Africa.

SUPER: Ten thousand local heroes.
One place to find them all.
Olympics.com
Powered by IBM.

MAN 1: Senegal is going to the Olympics.

CATEGORY Music-Adaptation • **ADVERTISER/PRODUCT** Mercedes • **TITLE** Aaoogah • **ADVERTISING AGENCY** Merkley Newman Harty, New York • **MUSIC COMPANY** Amber Music, London • **COMPOSER** Mike Hewer

SILVER

[MUSIC: Charles Trenet's "Tombe Du Ciel"]

SYNOPSIS: With its blend of lighthearted music and usage of classic animated expressions of love, this spot reveals the Mercedes C to be truly admired. Whenever the car drives down the street, those who witness it are instantly in love. Such happenings include a woman whose irises shape into hearts; parking meters that shoot out their change; teakettles that blow steam whistles; the spots on a woman's dress which pop off into hearts and float away; a couple whose eyes pop out; and water that shoots a line of fire hydrants into the air.

SUPER: The new C. Live. A lot.
Mercedes-Benz.

BRONZE

CATEGORY Music-Adaptation • **ADVERTISER/PRODUCT** Aldeas Infantiles Asociation for the Protection of Cruelty to Children • **TITLE** Make Up • **ADVERTISING AGENCY** Young & Rubicam, Madrid • **PRODUCTION COMPANY** Cool Shot, Madrid • **EDITING COMPANY** Telson, Madrid • **MUSIC COMPANY** Eduardo Molinero, Madrid • **CREATIVE DIRECTOR** German Silva • **COPYWRITER** German Silva • **ART DIRECTOR** Joao Coutinho • **DIRECTOR** Miguel Piñeiro • **PRODUCER** Juan Isasi, Jesus Corredera

VISUAL: A little girl slips into her mother's room while she's out. The girl is wearing a pair of her mother's shoes. Inside the room, she starts putting on her mother's earrings and necklaces. Then she starts making herself up like her mother. She puts on the lipstick and eyeliner. Finally, she powders her right eye black, just the way mother looks.
SUPER: They learn from you.
Aldeas Infatiles SOS de España.

CATEGORY Music-Original • **ADVERTISER/PRODUCT** Eatons • **TITLE** Big Finish • **ADVERTISING AGENCY** Ammirati Puris, Toronto •
PRODUCTION COMPANY Partners Film Company, Toronto • **EDITING COMPANY** Panic & Bob, Toronto • **MUSIC COMPANY** Pirate Radio &
Television, Toronto • **SOUND DESIGN COMPANY** Manta Sound, Toronto • **ACCOUNT EXECUTIVE** Susan Gillmeister, Cheryl Grishkewich •
CREATIVE DIRECTOR Doug Robinson • **COPYWRITER** Tom Goudie • **ART DIRECTOR** Doug Robinson • **DIRECTOR** Floria Sigismondi •
PRODUCER Merrie Wasson • **AGENCY PRODUCER** Pat White • **COMPOSER** Mark Hukezalic • **MUSIC DIRECTOR/PRODUCER** Chris Tait •
CHOREOGRAPHER Michael Rooney

GOLD

VISUAL: Clock with time advancing fast. Gracie and Arch enter Harry's office.
GRACIE: Harry!
HARRY: You're late. And you, you're later.
GRACIE: Take it easy, Harry.
HARRY: I'm sorry, it's just…ah, what's the use of kidding ourselves. The party's over.
ARCH: If only we had more time.
VISUAL: Harry sits in chair at desk.
GRACIE: Relax, Arch, I got it.
HARRY: Excuse me?
GRACIE: I got it.
ARCH: She's got it!
HARRY: She's got it! Got what?
GRACIE: It.
ARCH: She's got it!
HARRY: Oh! Well, in that case, I'm all ears.
ARCH: Go ahead, Gracie.
VISUAL: Gracie sits on Harry's desk, spins Harry in chair.
[**MUSIC:** Classic 50s Hollywood Musical. Everyone sings.]
GRACIE: If blue's been done and brown's a bore and pastels have you wanting more, there's something new you've never seen, the future's painted aubergine!
HARRY: Auber-what?
ARCH: Aubergin?
GRACIE: Au-ber-gine.
VISUAL: Circular staircase. Various images: lady in pink dress and large hat, flower, women's head and flower, woman with martini glass, girl jumping and throwing a ball, boy on pogo stick, four faces, Gracie in white and black checkered fur, woman behind screen. Aubergine is the primary color in every image.
GRACIE: For all the things a lady, from shoes to hats and in between. For young, for old, for hip, for square. Try aubergine to add some flare.
VISUAL: Woman's face, woman's legs walking, mannequin's face with eyelash curler, woman posing, woman's face. Aubergine is the primary color.
GRACIE: From head to toe and lip to lash, it helps to add a tasteful dash. That's aubergine, new on the scene. See what I mean? It's aubergine.
HARRY: I think so, yes.
VISUAL: Harry in convertible with models, lingerie dancer in white, ostrich and woman.
HARRY: Think style, think fun, think big, thing small. Think winter, summer, spring, and fall!
VISUAL: Arch wearing aubergine suit holding martini glass.
ARCH: The status quo is tried and true but aubergine looks good on vous.
GRACIE: Et vous, et vous.
ARCH: Me, too!
VISUAL: Lingerie dancer, throwing sparkles. Faces appear in silhouette of lady in a dress. Gracie, Harry, Arch, swimmer.
GRACIE: Cook aubergine!
HARRY: Sit aubergine!
ARCH: Dress aubergine!
GRACIE: Dream aubergine!
VISUAL: Gracie in aubergine gown, dancers in aubergine going down stairs, swimmer rises out of water, models come in on stairs. Gracie, Arch, and Harry finish up on small set of stairs.
ALL: So much to do, so much in store. The new us has you wanting more. So step inside, see what we see behind the color aubergine. Aubergine, aubergine, aubergine, aubergine.
[**MUSIC:** End]
VISUAL: Curtain drops.
SUPER: Eatons. Grand Opening November 25.

BRONZE

CATEGORY Music-Original • **ADVERTISER/PRODUCT** Audi • **TITLE** Rain • **ADVERTISING AGENCY** McKinney Silver, Raleigh • **PRODUCTION COMPANY** Chelsea Pictures, Los Angeles • **EDITING COMPANY** Post Factory, New York • **MUSIC COMPANY** Elias Associates, New York • **CREATIVE DIRECTOR** David Baldwin • **COPYWRITER** Christopher Wilson • **ART DIRECTOR** Bob Ranew • **DIRECTOR** Mehdi Norwozian • **EDITOR** Andrea MacArthur • **COMPOSER** Matt Fletcher • **PRODUCER** Joni Madison • **MUSIC CREATIVE DIRECTOR** Alex Lasarenko • **MUSIC PRODUCER** Andy Solomon

VISUAL: Rain showers on a young girl as she dances in the street. It is also pouring as she swims and lies in a boat. An Audi Quattro drives on a wet surface. Water sprays from its tires. The girl stomps in a puddle.
SUPER: Not.
VISUAL: "Slippery when wet" traffic sign.

CATEGORY Music-Original • **ADVERTISER/PRODUCT** KPMG • **TITLE** Paper Chase • **ADVERTISING AGENCY** J. Walter Thompson, New York •
MUSIC COMPANY Amber Music, London • **COMPOSER** Colin Smith, Simon Elms

BRONZE

SYNOPSIS: A corporate office uses paperwork to communicate. The paper that is passed along goes through a number of hands. It is stamped, copied, filed and given to another person until it finally reaches the desk of an executive, who barely gives it a glance. This spot, with its frenetic music, reveals the amount of time and energy wasted to communicate a brief message.

VO: Today's most successful companies understand the need to do business with customers, suppliers, and partners in real time.

Because it's not about the information age, it's about the age of your information.

SUPER: understanding@KPMG.

www.kpmg.com.

BRONZE

CATEGORY New Director's Showcase • **ADVERTISER/PRODUCT** Mikado • **TITLE** The Copier • **ADVERTISING AGENCY** Euro RSCG BETCX, Paris • **PRODUCTION COMPANY** 1/33, Paris • **CREATIVE DIRECTOR** Michele Cohen • **COPYWRITER** Pierre Riess • **ART DIRECTOR** Romain Guillon • **DIRECTOR** Niel Harris

VISUAL: A tall man in a suit makes photocopies in the copy room while eating a Mikado. Behind him, a short secretary in a skirt is patiently waiting her turn, watching enviously as he eats.

The man has his packet of Mikados on a high shelf above the photocopier. When he is finished, he takes his papers and leaves, forgetting his snack.

When finally alone, the secretary tries to reach the packet of Mikados, but she is too short. She climbs onto the photocopier to get access to the packet.

As she is just about to take a Mikado, the man returns. The secretary quickly lowers her arm and accidentally switches on the photocopier. The man sees the secretary in this ambiguous position. He looks at the copies the machine spews out. The young woman is petrified and blushes with embarrassment.

SUPER: Mikado. Your weakness will be your downfall.

CATEGORY Sound Design • **ADVERTISER/PRODUCT** Reebok • **TITLE** Marie-Jose Perec • **ADVERTISING AGENCY** Berlin, Cameron & Partners, New York • **PRODUCTION COMPANY** Entropie Films, Paris • **EDITING COMPANY** Entropie Films, Paris • **SOUND DESIGN COMPANY** Mit Out Sound, Sausalito • **ANIMATION COMPANY** Buf Compagnie, Paris • **CREATIVE DIRECTOR** Lance Paull • **COPYWRITER** Jean Rhode • **ART DIRECTOR** Julian Pugsley • **DIRECTOR** Thierry Poiraud • **PRODUCER** Peter Feldman • **SOUND DESIGN PRODUCER** Misa Kageyama • **EXECUTIVE LINE PRODUCER** Guillaume Dubarry

BRONZE

VISUAL: Marie-Jose Perec warms up outside an old abandoned factory area with a tall tower.
SUPER: Marie-Jose Perec 400m.
VISUAL: She takes her starting position. When the tower implodes, Marie-Jose Perec takes off. She is in the direct area where the tower will collapse. When the structure gets closer to the ground, Marie-Jose Perec is then ahead of it. When it hits the ground, Marie-Jose Perec escapes the structure and is swallowed up by the smoke and dust.
SUPER: Ce Qui Ne Vous Tue Pas. ("What doesn't kill you.")
VISUAL: A gust of wind blows away the smoke and dust.
SUPER: Vous rend Plus Fort. ("Makes you stronger.")
VISUAL: Marie-Jose Perec walks around, trying to cool down.
SUPER: Reebok.

GOLD

CATEGORY Visual Effects • **ADVERTISER/PRODUCT** Orange (Mobile Phone Network) • **TITLE** Hold Up • **ADVERTISING AGENCY** WCRS, London • **PRODUCTION COMPANY** Gorgeous Enterprises, London • **EDITING COMPANY** Smoke & Mirrors, London • **MUSIC COMPANY** Big Picture Music, London • **SOUND DESIGN COMPANY** 750 MPH, London • **CREATIVE DIRECTOR** Jo Moore, Simon Robinson • **COPYWRITER** Jo Moore, Simon Robinson • **ART DIRECTOR** Simon Robinson • **DIRECTOR** Chris Palmer • **PRODUCER** Tim Marshall • **AGENCY PRODUCER** James Letham • **EDITOR** Paul Watts • **VFX SUPERVISOR** Mitch Mitchell • **MUSIC** Terry Devine King • **SOUND DESIGNER** Nigel Crowley • **LIGHTING CAMERAMAN** Ivan Bird

VISUAL: A hectic car chase in a bustling city at night intercut with shots of a young man sitting at a bar, lost in thought. Suddenly, it is revealed that the Hollywood-style car chase is actually happening among the bottles on the bar in front of the young man. He watches in awe as the lead car ramps off a matchbook, sails through the air and crashes upside-down on the bar.

VO: To find out how Orange can bring you reviews of the latest movies, call 0800 80 10 80.

VISUAL: Watches with interest as miniature policemen arrest the bad guys in the wrecked vehicle.

VO: Orange. Take your world with you.

SUPER: Orange.
The future's bright. The future's Orange.
0800 80 10 80.
www.orange.cc.uk.

CATEGORY Visual Effects • **ADVERTISER/PRODUCT** Peugeot 406 • **TITLE** Upside Down • **ADVERTISING AGENCY** Euro RSCG BETC, Paris •
PRODUCTION COMPANY Premiere Heure, Paris • **CREATIVE DIRECTOR** Daniel Fohr, Antoine Barthuel • **COPYWRITER** Marc Rosier •
ART DIRECTOR Jean-Marc Tramoni • **DIRECTOR** Frederic Planchon

GOLD

SYNOPSIS: It's an upside-down world and gravity is unforgiving. Guys play basketball on the underside of a bridge but lose the ball when it goes off the side and "falls" away into the sky. People sit under building ledges. Vehicles not properly tied down drop off the street. In the office, people stand on the ceiling as they work from desks bolted to the floor. However, the Peugeot 406 is unaffected by this upside-down world because of its smooth control and flawless handling of the road. The car drives through the city streets right side up. **SUPER:** Peugeot.

CATEGORY Visual Effects • **ADVERTISER/PRODUCT/SERVICE** Sony Playstation • **TITLE** PS9 • **ADVERTISING AGENCY** TBWA/Chiat/Day, Los Angeles • **PRODUCTION COMPANY** Serial Dreamer, West Hollywood • **EDITING COMPANY** Rock Paper Scissors, Los Angeles • **MUSIC COMPANY** Mit Out Sound, Sausalito • **SOUND DESIGN COMPANY** Mit Out Sound, Sausalito • **CREATIVE DIRECTOR** Chuck McBride • **COPYWRITER** Scott Wild, Stephanie Crippen • **ART DIRECTOR** Erick King, Rob Smiley, Scott Wild • **DIRECTOR** Erick Ifergan • **PRODUCER** Gerard Cantor, Jennifer Golub, Jill Andresevic, Eliza Randall, Ryan Thompson • **VFX/ANIMATION COMPANY** Pixel Envy, Santa Monica; Method Visual Effects, Santa Monica • **METHOD EXECUTIVE PRODUCER** Neysa Horsburgh • **VISUAL EFFECTS PRODUCER** Michael Gibson • **VISUAL EFFECTS ARTIST** Russell Fell, Cedric Nicolas • **3D DESIGNER** Yann Mallard, Laurent Ledru, Laurent Briet, Pixel Envy • **VXF SUPERVISOR** Mat Beck • **CG SUPERVISOR** Greg Strause • **3D SUPERVISOR** Colin Strause • **CG ARTIST** Josh Cordis, Rena Osamura

VISUAL: A futuristic city in the year 2078. Spacecrafts and floating monorails zip through the air.

A young man holds a glass ball inscribed PS9. His arms are outstretched as he curiously splits the ball in half, releasing a group of tiny spores.

VO: New for 2078, PS9's electronic spores tap straight into your adrenal gland.

VISUAL: The spores gravitate and fly into the young man's nose. The spores wisp around the reddish nasal cavity swiftly rounding curve after curve, traveling in roller coaster style inside his body toward his brain, where they embed themselves.

VO: PS9 has improved retinal scanning…

VISUAL: The young man, arms outstretched, jumps off the side of a building. He lands on his feet the crowded street below and fights off thugs.

VO: A mind control system…

VISUAL: The young man watches two men diffuse a bomb with three seconds on the timer.

VO: Holographic movie surround vision…

VISUAL: Two knights appear in the alley where the young man is standing. The warriors ride at each other, ready to joust.

VO: And telepathic personal music.

VISUAL: The young man falls through a manhole into deep water where a smiling mermaid quickly swims towards him. When the mermaid nears, she morphs into a giant octopus and grabs for him. He breaks free, vigorously swims to the surface and pops out of the water, gasping for air.

A shiny silver helmet forms around his head. The young man is in a silver car, shooting a ball at the side of a building. A truck comes out of a tunnel ahead and the two vehicles are about to collide.

There's a flash of light before impact.

VO: The ultimate just got better.

VISUAL: The young man stands with his eyes shut. He opens them with a smirk of amazement on his face. The PS9 ball is in his hands.

VO: PlayStation 9, teleport yours today.

SUPER: The beginning.

PS2.

CATEGORY Visual Effects • ADVERTISER/PRODUCT Jeep Grand Cherokee • TITLE Shake • ADVERTISING AGENCY FCB Worldwide, Detroit •
PRODUCTION COMPANY Gerard De Thame Films, London • POST PRODUCTION/ANIMATION COMPANY The Mill, London • DIRECTOR
Gerard de Thame • PRODUCER Fabyan Daw • INFERNO ARTIST Dave Smith, Chris Knight, Dave Bowman • 3D ARTIST Russell Tickner

BRONZE

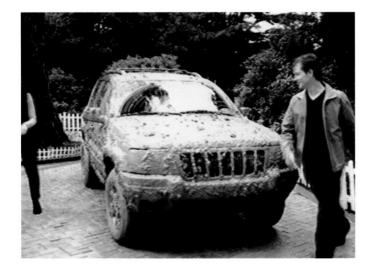

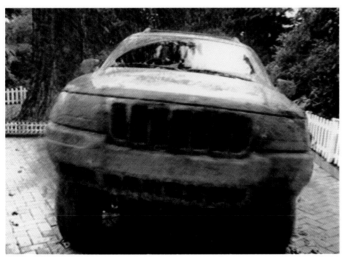

VISUAL: An extremely muddy Jeep Grand Cherokee pulls up in the driveway of an upscale home. A couple gets out and walks to the front door. They stop for a moment to look back at the jeep.
VO: Even though Jeep Grand Cherokee Laredo is more refined and civilized than ever...
VISUAL: The Grand Cherokee starts shaking off all the mud just like an animal. Mud flies everywhere.
VO: ...Rest assured, it still hasn't lost its animal instincts.
VISUAL: The Grand Cherokee is totally clean, but the couple and the front of the house are splattered with mud.
SUPER: Jeep. There's only one.
www.jeep.com.

Print

CATEGORY Apparel/Fashion • **ADVERTISER/PRODUCT** Kookai • **TITLE** Fat • **ADVERTISING AGENCY** CLM/BBDO, Paris • **ACCOUNT EXECUTIVE** Marie-Pierre Benitah • **CREATIVE DIRECTOR** Anne de Maupeou • **COPYWRITER** Frederic Temin, Guillaume de la Croix • **PHOTOGRAPHER** Vincent Peters

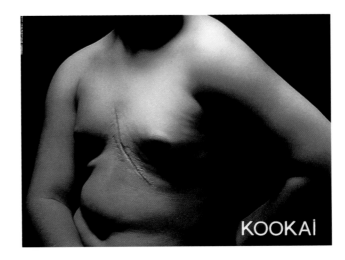

CATEGORY Apparel/Fashion • **ADVERTISER/PRODUCT** Nike Shox • **TITLE** Trampoline • **ADVERTISING AGENCY** The Jupiter Drawing Room (South Africa), Johannesburg • **PHOTOGRAPHY STUDIO** David Prior, Johannesburg • **ACCOUNT EXECUTIVE** Michelle Young • **CREATIVE DIRECTOR** Graham Warsop • **COPYWRITER** Bernard Hunter, Leon Van Huyssteen, Peter Callaghan • **ART DIRECTOR** Michael Bond, Paul Anderson • **PRODUCTION MANAGER** Hilary Simpson • **PHOTOGRAPHER** David Prior

CATEGORY Apparel/Fashion • **ADVERTISER/PRODUCT** Riccardo Cartillone • **TITLE** Danger - Doorframe (Balcony) • **ADVERTISING AGENCY** Scholz & Friends Berlin, Berlin • **CREATIVE DIRECTOR** Sebastian Turner • **ART DIRECTOR** Bjoern Ruehmann • **PHOTOGRAPHER** Sven Ulrich Glage

CATEGORY Apparel/Fashion • ADVERTISER/PRODUCT Marks & Spencer Push-Up Bra • TITLE Supermarket • ADVERTISING AGENCY Results Advertising Ltd., Bangkok • PHOTOGRAPHY STUDIO Flash Studio, Bangkok • ACCOUNT EXECUTIVE Kodchanant Inthachak • CREATIVE DIRECTOR Jureeporn Thaidumrong, Joel Clement • COPYWRITER Jureeporn Thaidumrong, Joel Clement • ART DIRECTOR Joel Clement, Jureeporn Thaidumrong • PHOTOGRAPHER Niphon Baiyen • IMAGE COMPOSER Niphon Baiyen

SILVER

CATEGORY Apparel/Fashion • ADVERTISER/PRODUCT Nike Shox • TITLE Hoop • ADVERTISING AGENCY The Jupiter Drawing Room (South Africa), Johannesburg • PHOTOGRAPHY STUDIO David Prior, Johannesburg • ACCOUNT EXECUTIVE Michelle Young • CREATIVE DIRECTOR Graham Warsop • COPYWRITER Peter Callaghan • ART DIRECTOR Paul Anderson • PRODUCTION MANAGER Hilary Simpson • PHOTOGRAPHER David Prior

SILVER

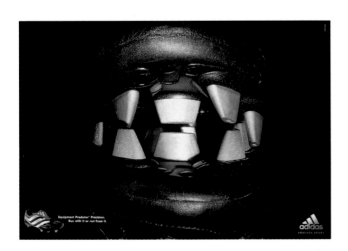

CATEGORY Apparel/Fashion • ADVERTISER/PRODUCT Adidas— Equipment Predator Precision • TITLE Predator • ADVERTISING AGENCY Lew Lara Propaganda, São Paulo • PHOTOGRAPHY STUDIO Manolo Moran, São Paulo • ACCOUNT EXECUTIVE Ricardo Al Makul, Felipe Faria • CREATIVE DIRECTOR Jaques Lewkowicz, Marco Versolato, Ricardo Freire • COPYWRITER Margit Junginger • ART DIRECTOR Fernando Zenari • PRODUCTION MANAGER Kátia Bontempo • PHOTOGRAPHER Manolo Moran

BRONZE

BRONZE

CATEGORY Apparel/Fashion • ADVERTISER/PRODUCT Power Football
Boots • TITLE Goal • ADVERTISING AGENCY Ogilvy & Mather Malaysia,
Kuala Lumpur • PHOTOGRAPHY STUDIO Lim Studio, Kuala Lumpur •
ACCOUNT EXECUTIVE Joseph Woon • CREATIVE DIRECTOR Sonal
Dabral • COPYWRITER Kelvin Chiah • ART DIRECTOR: Kelvin Chiah •
PHOTOGRAPHER: Fai

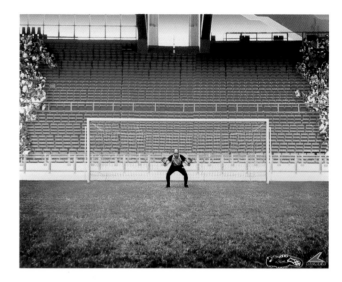

BRONZE

CATEGORY Apparel/Fashion • ADVERTISER/PRODUCT Riccardo
Cartillone • TITLE Danger - Doorframe (Ladies' Room) • ADVERTISING
AGENCY Scholz & Friends Berlin, Berlin • CREATIVE DIRECTOR
Sebastian Turner • ART DIRECTOR Bjoern Ruehmann • PHOTOGRAPHER
Sven Ulrich Glage

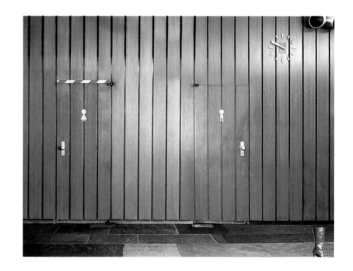

GOLD

CATEGORY Automotive • ADVERTISER/PRODUCT DaimlerChrysler
Canada Inc. (Jeep) • TITLE Stop Sign (Vertical) • ADVERTISING
AGENCY BBDO Canada, Toronto • ACCOUNT EXECUTIVE Gary King,
Brian Jamieson, Erin Iles • CREATIVE DIRECTOR Michael McLaughlin,
Jack Neary, Mike Smith, Steve Denvir • COPYWRITER Michael Clowater
• ART DIRECTOR John Terry • PRODUCTION MANAGER Frank Ninno,
Barb LeClere, Gord Lawrason • PHOTOGRAPHER Bill Drummond •
TYPOGRAPHER John Rodrigues • DIGITAL RETOUCHER ReBecca Nixon

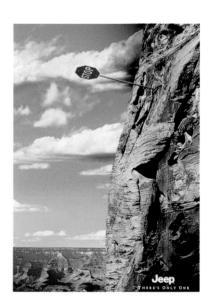

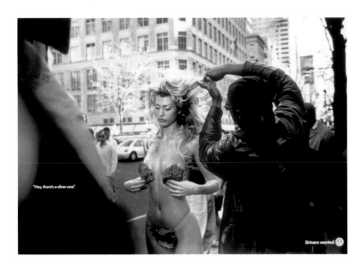

CATEGORY Automotive • **ADVERTISER/PRODUCT** Volkswagen of America, Inc. • **TITLE** Lettuce Girl • **ADVERTISING AGENCY** ARNOLD Worldwide, Boston • **ACCOUNT EXECUTIVE** Michael Shonkoff • **CHIEF CREATIVE OFFICER** Ron Lawner • **GROUP CREATIVE DIRECTOR** Alan Pafenbach • **CREATIVE DIRECTOR** Alan Pafenbach • **COPYWRITER** Dave Weist • **ART DIRECTOR** Don Shelford • **PRODUCTION MANAGER** Sally Bertolet • **TRAFFIC MANAGER** Dayva Savio • **ART BUYER** Carol Alda

SILVER

TEXT: "Hey, there's a silver one."
Drivers wanted.

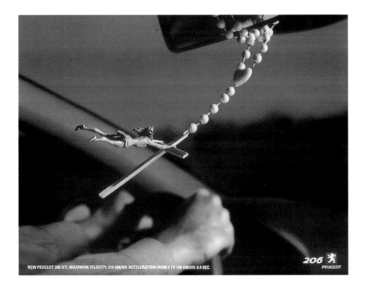

CATEGORY Automotive • **ADVERTISER/PRODUCT** Peugeot 206 • **TITLE** Christ • **ADVERTISING AGENCY** CraveroLanis Euro RSCG, Buenos Aires • **ACCOUNT EXECUTIVE** Fernando Vizcaino • **GENERAL CREATIVE DIRECTOR** Juan Cravero, Dario Lanis • **COPYWRITER** Hernan Curubeto, Martin Juarez • **ART DIRECTOR** La Rusa, Martin Casios • **PRODUCTION MANAGER** Rolando Lambert • **CLIENT SUPERVISOR** Esteban Ochoa

SILVER

TEXT: New Peugeot 206 GTI. Maximum velocity: 210KM/HR.
Acceleration from 0 to 60KM/HR: 8.4 sec.
206 Peugeot

CATEGORY Automotive • **ADVERTISER/PRODUCT** Land Rover • **TITLE** Winter Sports • **ADVERTISING AGENCY** Ubachs Wisbrun, Amsterdam • **ACCOUNT EXECUTIVE** Ralph Wisbrun • **CREATIVE DIRECTOR** Wim Ubachs • **COPYWRITER** Martyn van den Brakel • **ART DIRECTOR** Patrick Wynhoven

BRONZE

TEXT: Land Rover.
The best 4x4x far.

BRONZE

CATEGORY Automotive • **ADVERTISER/PRODUCT** BMW • **TITLE** Feels Like A Million • **ADVERTISING AGENCY** Fallon, Minneapolis • **ACCOUNT EXECUTIVE** Ginny Grossman • **CREATIVE GROUP HEAD** Bruce Bildsten • **CREATIVE DIRECTOR** David Lubars • **COPYWRITER** Michael Hart • **ART DIRECTOR** Steve Sage • **PRODUCTION MANAGER** Steve Delorme • **PHOTOGRAPHER** Clint Clemmons

BRONZE

CATEGORY Automotive • **ADVERTISER/PRODUCT** Mercedes-Benz Ceramic Brake • **TITLE** Mercedes Is First To Bring You Ceramic Brakes • **ADVERTISING AGENCY** Springer & Jacoby, Hamburg • **PHOTOGRAPHY STUDIO** Daniel M. Hartz, Kisdorf • **ACCOUNT EXECUTIVE** Nicole Iden • **CREATIVE DIRECTOR** Jan Ritter, Torsten Rieken • **COPYWRITER** Tobias Ahrens • **ART DIRECTOR** Frank Bannöhr • **PRODUCTION MANAGER** Birgit Pillkahn, Stefan Behrens • **PHOTOGRAPHER** Daniel M. Hartz

BRONZE

CATEGORY Automotive • **ADVERTISER/PRODUCT** Volkswagen Golf Estate • **TITLE** Lost Dog • **ADVERTISING AGENCY** BMP DDB, London • **ACCOUNT EXECUTIVE** Jon Busk • **COPYWRITER** James Sinclair • **ART DIRECTOR** Ed Morris • **PHOTOGRAPHER** Kiarn Master • **CLIENT SUPERVISOR** Catherine Fordham

CATEGORY Automotive • ADVERTISER/PRODUCT Smart • TITLE Flags • ADVERTISING AGENCY Springer & Jacoby, Hamburg • PHOTOGRAPHY STUDIO Dirk Michael Schulz, Hamburg • ACCOUNT EXECUTIVE Andreas Trautmann • CREATIVE DIRECTOR Amir Kassaei, Florian Grimm, Antje Hedde • COPYWRITER Michael Meyer • ART DIRECTOR Jeannette Bergen • PHOTOGRAPHER Martin Wellermann

BRONZE

CATEGORY Automotive • ADVERTISER/PRODUCT Golf Convertible by Volkswagen • TITLE Clouds • ADVERTISING AGENCY DDB Advertising, Paris • ACCOUNT EXECUTIVE Vincent Léorat • CREATIVE DIRECTOR Christian Vince • COPYWRITER Jocely Devaux • ART DIRECTOR Sylvain Guyomard • PHOTOGRAPHER Michael Gesinger

BRONZE

CATEGORY Automotive • ADVERTISER/PRODUCT Volkswagen of America Inc. • TITLE Shuttle • ADVERTISING AGENCY ARNOLD Worldwide, Boston • ACCOUNT EXECUTIVE Michael Shonkoff • CHIEF CREATIVE OFFICER Ron Lawner • GROUP CREATIVE DIRECTOR Alan Pafenbach • CREATIVE DIRECTOR Alan Pafenbach • COPYWRITER Dave Weist • ART DIRECTOR Don Shelford • PRODUCTION MANAGER Sally Bertolet • TRAFFIC MANAGER Dayva Savio • ART BUYER Carol Alda

BRONZE

TEXT: "Hey, there's one of those new yellow ones."
Drivers wanted.

BRONZE

CATEGORY Beverages/Non-Alcoholic • **ADVERTISER/PRODUCT** NZ
Natural • **TITLE** NZ Natural • **ADVERTISING AGENCY** Young & Rubicam,
Auckland • **PHOTOGRAPHY STUDIO** Maria Sainsbury, Auckland •
ACCOUNT EXECUTIVE Kate Heatly • **CREATIVE DIRECTOR** Gordon
Clarke • **COPYWRITER** Jeremy Littlejohn • **ART DIRECTOR** Regan
Grafton • **PRODUCTION MANAGER** Jane Swindale • **PHOTOGRAPHER**
Maria Sainsbury • **HEAD OF ART** Haydn Morris

GOLD

CATEGORY Corporate/Institutional • **ADVERTISER/PRODUCT** The Boston
Globe • **TITLE** I Have A Dream • **ADVERTISING AGENCY** Holland Mark
Advertising, Boston • **ACCOUNT EXECUTIVE** Drayton Martin • **CREATIVE
DIRECTOR** Bob Minihan, Jim Hagar • **COPYWRITER** Martin Luther King
Jr., Jim Hagar • **ART DIRECTOR** Jim O'Brien • **PRODUCTION MANAGER**
Bobby Forcino

SILVER

CATEGORY Corporate/Institutional • **ADVERTISER/PRODUCT** Adam Opel
AG • **TITLE** Foreigners Go Home? • **ADVERTISING AGENCY** Lowe &
Partners, Frankfurt/Main • **ACCOUNT EXECUTIVE** Philip Riefenstahl •
CREATIVE DIRECTOR Dietmar Reinhard, Christoph Jörg, Martin Resch •
COPYWRITER Martin Resch • **ART DIRECTOR** Christoph Jörg

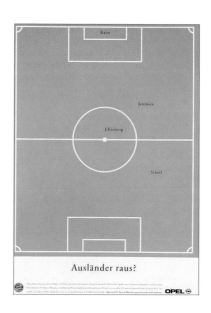

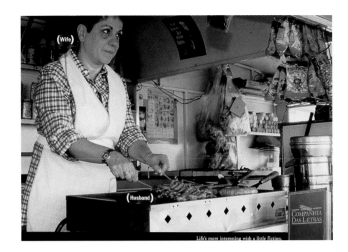

SILVER

CATEGORY Corporate/Institutional • **ADVERTISER/PRODUCT** Publisher - Cia das Letras • **TITLE** Life Is More Interesting With... (Husband/Wife) • **ADVERTISING AGENCY** AlmapBBDO, São Paulo • **ACCOUNT EXECUTIVE** Izabella Villaça • **CREATIVE DIRECTOR** Marcello Serpa, Eugênio Mohallem • **COPYWRITER** Marcelo Nogueira, Jose Luiz • **ART DIRECTOR** Luciano Lincoln • **PRODUCTION MANAGER** Jose Roberto Bezerra • **PHOTOGRAPHER** Luis Moretti

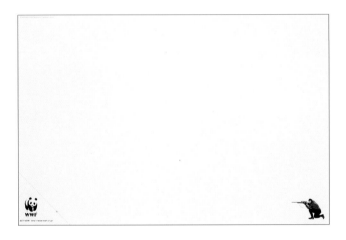

BRONZE

CATEGORY Corporate/Institutional • **ADVERTISER/PRODUCT** WWF: Membership • **TITLE** Act Now! • **ADVERTISING AGENCY** Hakuhodo Inc., Tokyo • **CREATIVE DIRECTOR** Kazufuni Nagai • **COPYWRITER** Hiroko Ishii • **ART DIRECTOR** Kazufumi Nagai • **PHOTOGRAPHER** Tetsuya Morimoto • **DESIGNER** Shin Nagashima

TEXT: WWF
Act now http://www.wwf.or.jp

BRONZE

CATEGORY Corporate/Institutional • **ADVERTISER/PRODUCT** Criativa Magazine • **TITLE** Diet Magazine • **ADVERTISING AGENCY** Leo Burnett Publicidade Ltda, São Paulo • **ACCOUNT EXECUTIVE** Geraldo Mosse • **CREATIVE DIRECTOR** José Henrique Borghi • **COPYWRITER** Otávio Schiavon • **ART DIRECTOR** Fernando Carreira • **PRODUCTION MANAGER** José Carlos Souza Lima • **PHOTOGRAPHER** Marcos Florence

CATEGORY Corporate/Institutional • **ADVERTISER/PRODUCT** Publisher—Cia das Letras • **TITLE** Life Is More Interesting With... (Marriage) • **ADVERTISING AGENCY** AlmapBBDO, São Paulo • **ACCOUNT EXECUTIVE** Izabela Villaça • **CREATIVE DIRECTOR** Marcello Serpa, Eugênio Mohallem • **COPYWRITER** Marcelo Nogueira, Jose Luiz • **ART DIRECTOR** Luciano Lincoln • **PRODUCTION MANAGER** Jose Roberto Bezerra • **PHOTOGRAPHER** Luis Moretti

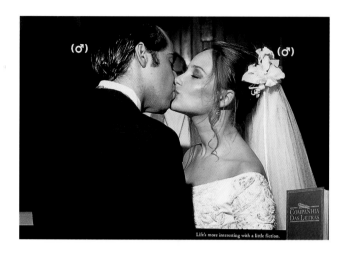

CATEGORY Cosmetics/Perfumes • **ADVERTISER/PRODUCT** Timotei Shampoo • **TITLE** As Gentle With Your Eyes As With Your Hair • **ADVERTISING AGENCY** J. Walter Thompson, Lisbon • **PHOTOGRAPHY STUDIO** Picto, Lisbon • **ACCOUNT EXECUTIVE** Assunçáo Albuquerque • **CREATIVE DIRECTOR** João Espírito Santo • **COPYWRITER** Rui Soares • **ART DIRECTOR** Pedro Magalhães • **PRODUCTION MANAGER** Irene Bandeira • **PHOTOGRAPHER** Francisco Prata

CATEGORY Cosmetics/Perfumes • **ADVERTISER/PRODUCT** Lakme Winter Care Lotion • **TITLE** Winter Creams • **ADVERTISING AGENCY** Ogilvy & Mather, Mumbai • **PHOTOGRAPHY STUDIO** IQ, Mumbai • **ACCOUNT EXECUTIVE** Sandhya Srinivasan, Bhavna Darira, Rakesh Suryanarayan • **CREATIVE DIRECTOR** Geeta Rao • **COPYWRITER** Mark Mathai • **ART DIRECTOR** Bina Nayak • **PRODUCTION MANAGER** Moorthy A.S.N. • **PHOTOGRAPHER** Israr Qureshi • **DESKTOP OPERATOR** Chandrasekar Naidu • **STUDIO MANAGER** Namdgo Khamkar

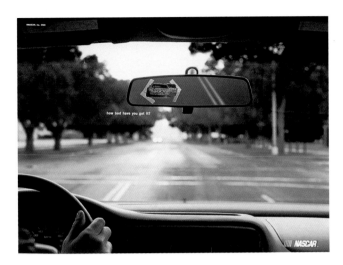

CATEGORY Entertainment Promotion • ADVERTISER/PRODUCT NASCAR • TITLE Mirror • ADVERTISING AGENCY Young & Rubicam, Chicago • PHOTOGRAPHY STUDIO Heimo, San Francisco • ACCOUNT EXECUTIVE Barrett Book, Alison Kuhn, Dan Richlen • CREATIVE DIRECTOR Mark Figliulo, Jon Wyville • COPYWRITER Tohru Oyasu • ART DIRECTOR Jon Wyville, Chuck Taylor • PRODUCTION MANAGER Carrie Stoughton

BRONZE

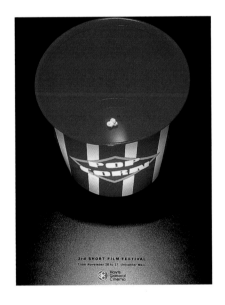

CATEGORY Entertainment Promotion • ADVERTISER/PRODUCT Hoyts General Cinema • TITLE Short Film Festival • ADVERTISING AGENCY Del Campo Nazca Saatchi & Saatchi, Buenos Aires • PHOTOGRAPHY STUDIO Fabbris Foto, Buenos Aires • ACCOUNT EXECUTIVE Ignacio Ibarra Garcia • CREATIVE DIRECTOR Pablo Battle, Hernan Jauregui • COPYWRITER Juan Manuel D'Emicio • ART DIRECTOR Sebastian Garin • PRODUCTION MANAGER Cosme Argerich • PHOTOGRAPHER Freddy Fabbris

BRONZE

CATEGORY Foods • ADVERTISER/PRODUCT All-Bran • TITLE Bottlebrush • ADVERTISING AGENCY Leo Burnett, Mexico City • ACCOUNT EXECUTIVE Laila Domit, Teresa Sordo • CREATIVE DIRECTOR Tony Hidalgo • COPYWRITER Jorge Aguilar • ART DIRECTOR Jorge Aguilar • PRODUCTION MANAGER Rosa Mª Gutierrez

BRONZE

BRONZE

CATEGORY Foods • **ADVERTISER/PRODUCT** Parmalat • **TITLE** Real Tomatoes • **ADVERTISING AGENCY** Del Campo Nazca Saatchi & Saatchi, Buenos Aires • **PHOTOGRAPHY STUDIO** Rambo-Maestri, Buenos Aires • **ACCOUNT EXECUTIVE** Rafaela Sucari • **CREATIVE DIRECTOR** Pablo Battle, Hernan Jauregui • **COPYWRITER** Juan Manuel D'Emicio, Pablo Gil • **ART DIRECTOR** Sebastian Garin, Daniel Fierro • **PRODUCTION MANAGER** Cosme Argerich • **PHOTOGRAPHER** Daniel Maestri

SILVER

CATEGORY Health Care Services • **ADVERTISER/PRODUCT** Save the Children Fund • **TITLE** 200 Norwegian Kroner • **ADVERTISING AGENCY** Leo Burnett, Oslo • **ACCOUNT EXECUTIVE** Bjarte Eide • **COPYWRITER** Erik Heisholt • **ART DIRECTOR** Jan Bjørkløf

BRONZE

CATEGORY Health Care Services • **ADVERTISER/PRODUCT** Breast Cancer Prevention • **TITLE** If You're Looking For A Good Reason • **ADVERTISING AGENCY** Master, Curitiba • **PHOTOGRAPHY STUDIO** Bob Wolfenson, São Paulo • **ACCOUNT EXECUTIVE** Pedro Arlant • **CREATIVE DIRECTOR** Renato Cavalher • **COPYWRITER** Luiz Henrique Groff • **ART DIRECTOR** Renato Fernandez, Roberto Fernandez • **PRODUCTION MANAGER** Karin Janz • **PHOTOGRAPHER** Bob Wolfenson

CATEGORY Home Entertainment • ADVERTISER/PRODUCT Sony Playstation • TITLE Lara Croft • ADVERTISING AGENCY BDDP\TBWA, Boulogne Billancourt • COPYWRITER Eric Helias • ART DIRECTOR Jorge Carreno • PHOTOGRAPHER Jo Magrean

GOLD

CATEGORY Home Entertainment • ADVERTISER/PRODUCT Sony Playstation • TITLE Blender • ADVERTISING AGENCY Leo Burnett, Warsaw • CREATIVE DIRECTOR Darek Zatorski, Kerry Keenan • COPYWRITER Magda Berent • ART DIRECTOR Micah Walker • PHOTOGRAPHER Giblin and James • PHOTOGRAPHY STUDIO Agent Orange, London

BRONZE

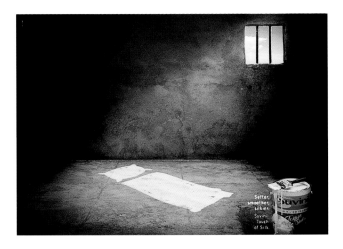

CATEGORY Home Furnishings/Appliances • ADVERTISER/PRODUCT Suvinil Paint • TITLE Prison • ADVERTISING AGENCY F/Nazca S&S, São Paulo • PHOTOGRAPHY STUDIO Alexandre Catan, São Paulo • ACCOUNT EXECUTIVE José H. Teixeira, Gleice Dombi, Pérola Girotto • CREATIVE DIRECTOR Fabio Fernandes • COPYWRITER Eduardo Lima • ART DIRECTOR Julio Andery • PRODUCTION MANAGER Ze Roberto, Armando Ferreira • PHOTOGRAPHER Alexandre Catan

BRONZE

SILVER

CATEGORY Home Products • **ADVERTISER/PRODUCT** Cesar • **TITLE** Dogs - Similarity (Cocker) • **ADVERTISING AGENCY** AlmapBBDO, São Paulo • **ACCOUNT EXECUTIVE** Jose Boralli • **CREATIVE DIRECTOR** Marcello Serpa, Eugênio Mohallem • **COPYWRITER** Roberto Pereira • **ART DIRECTOR** Luiz Sanches, Valdir Bianchi • **PRODUCTION MANAGER** José Roberto Bezerra • **PHOTOGRAPHER** Manolo Moran

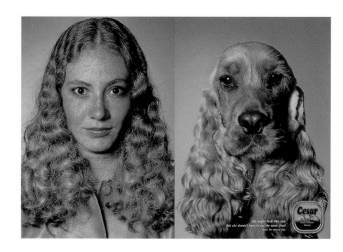

BRONZE

CATEGORY Home Products • **ADVERTISER/PRODUCT** Kitekat • **TITLE** Footprints • **ADVERTISING AGENCY** Grey Worldwide Argentina, Buenos Aires • **ACCOUNT EXECUTIVE** Enrique Vera • **CREATIVE DIRECTOR** Fernando Militerno, Martin Vinacur • **COPYWRITER** Gustavo "Otto" Soria • **ART DIRECTOR** Gabriel Huici • **PRODUCTION MANAGER** Armando Morando • **PHOTOGRAPHER** Hernan Churba

SILVER

CATEGORY Media Promotion • **ADVERTISER/PRODUCT** Sports Illustrated Magazine • **TITLE** Career Path • **ADVERTISING AGENCY** Fallon, Minneapolis • **ACCOUNT EXECUTIVE** Kevin Berigan • **CREATIVE DIRECTOR** David Lubars • **COPYWRITER** Greg Hahn • **ART DIRECTOR** Steve Driggs • **PRODUCTION MANAGER** Steve Delorme • **PHOTOGRAPHER** Manny Millan

CATEGORY Media Promotion • ADVERTISER/PRODUCT Canal + (Pay TV Channel) • TITLE Now Films Won't Have To Wait Years • ADVERTISING AGENCY Contrapunto, Madrid • ACCOUNT EXECUTIVE Eva Mª Alvarez • CREATIVE DIRECTOR Antonio Montero • COPYWRITER Juan Silva • ART DIRECTOR Duarte Pinheiro • PHOTOGRAPHER Mili Sánchez

BRONZE

CATEGORY Media Promotion • ADVERTISER/PRODUCT Sports Illustrated Magazine • TITLE He Knows • ADVERTISING AGENCY Fallon, Minneapolis • ACCOUNT EXECUTIVE Kevin Berigan • CREATIVE DIRECTOR David Lubars • COPYWRITER Greg Hahn • ART DIRECTOR Steve Driggs • PRODUCTION MANAGER Paul Morita • PHOTOGRAPHER David Liamkyle

BRONZE

CATEGORY Media Promotion • ADVERTISER/PRODUCT Time • TITLE Both Sides • ADVERTISING AGENCY Fallon, Minneapolis • PHOTOGRAPHY STUDIO AP World Wide Photos, New York • ACCOUNT EXECUTIVE Amy Frish, Jeff Kenyon • CREATIVE GROUP HEAD Bob Barrie • CREATIVE DIRECTOR David Lubars • COPYWRITER Dean Buckhorn • ART DIRECTOR Bob Barrie

BRONZE

CATEGORY Media Promotion • **ADVERTISER/PRODUCT** El Gráfico Sports Magazine • **TITLE** Area • **ADVERTISING AGENCY** J. Walter Thompson, Buenos Aires • **ACCOUNT EXECUTIVE** Juan Claverol • **CREATIVE DIRECTOR** Oscar Cerutti • **COPYWRITER** Juan Ortelli • **ART DIRECTOR** Veronica Filippini

CATEGORY Media Promotion • **ADVERTISER/PRODUCT** Sports Illustrated Magazine • **TITLE** Tiger Woods • **ADVERTISING AGENCY** Fallon, Minneapolis • **ACCOUNT EXECUTIVE** Kevin Berigan • **CREATIVE DIRECTOR** David Lubars • **COPYWRITER** Greg Hahn • **ART DIRECTOR** Steve Driggs • **PRODUCTION MANAGER** Steve Delorme • **PHOTOGRAPHER** Robert Beck

CATEGORY Personal Items • **ADVERTISER/PRODUCT** Bic—Permanent Marker • **TITLE** Bride • **ADVERTISING AGENCY** Savaglio TBWA, Buenos Aires • **PHOTOGRAPHY STUDIO** Click Fotografía, Buenos Aires • **ACCOUNT EXECUTIVE** Ramiro Crespo • **CREATIVE DIRECTOR** Ernesto Savaglio, Martín Mercado • **COPYWRITER** Vicky Santiso • **ART DIRECTOR** Diego Lipser • **PHOTOGRAPHER** Ramiro López Crespo, Federico Márquez Palacios

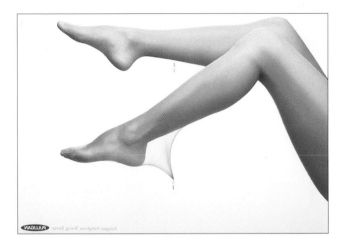

CATEGORY Personal Items • **ADVERTISER/PRODUCT** Pulligan / Pantyhose • **TITLE** Pulligan Pantyhose Stronger • **ADVERTISING AGENCY** F/Nazca S&S, São Paulo • **PHOTOGRAPHY STUDIO** Rodrigo Ribeiro, São Paulo • **ACCOUNT EXECUTIVE** Sylvia Freire, Armando Ferreira • **CREATIVE DIRECTOR** Fabio Fernandes • **COPYWRITER** Wilson Mateos • **ART DIRECTOR** Sergio Barros • **PRODUCTION MANAGER** Ze Roberto, Armando Ferreira • **PHOTOGRAPHER** Rodrigo Ribeiro

CATEGORY Public Service • **ADVERTISER/PRODUCT** Fundação SOS Mata Atlantica • **TITLE** Eye V • **ADVERTISING AGENCY** F/Nazca S&S, São Paulo • **PHOTOGRAPHY STUDIO** João Caetano, São Paulo • **ACCOUNT EXECUTIVE** Bob Romagnoli, Jean André Neto, Luciana Serra • **CREATIVE DIRECTOR** Fabio Fernandes, Eduardo Lima • **COPYWRITER** Eduardo Lima, Victor Sant'Anna • **ART DIRECTOR** Sidney Araujo • **PRODUCTION MANAGER** Ze Roberto, Armando Ferreira • **PHOTOGRAPHER** João Caetano

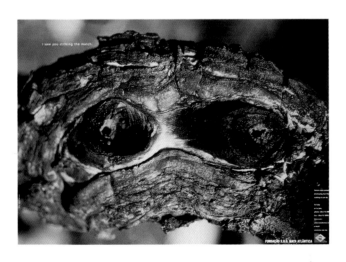

CATEGORY Public Service • **ADVERTISER/PRODUCT** Fundação SOS Mata Atlantica • **TITLE** Eye VI • **ADVERTISING AGENCY** F/Nazca S&S, São Paulo • **PHOTOGRAPHY STUDIO** João Caetano, São Paulo • **DIRECTOR** Fabio Fernandes, Eduardo Lima • **COPYWRITER** Eduardo Lima, Victor Sant'Anna • **ART DIRECTOR** Sidney Araujo • **PRODUCTION MANAGER** Ze Roberto, Armando Ferreira • **PHOTOGRAPHER** João Caetano

SILVER

CATEGORY Public Service • **ADVERTISER/PRODUCT** GAPA • **TITLE** Spider • **ADVERTISING AGENCY** J. Walter Thompson, São Paulo • **ACCOUNT EXECUTIVE** Saulo Sanches • **CREATIVE DIRECTOR** Andre Pinho, Darcy Fonseca • **COPYWRITER** Darcy Fonseca • **ART DIRECTOR** Darcy Fonseca • **PHOTOGRAPHER** Richard Kohut

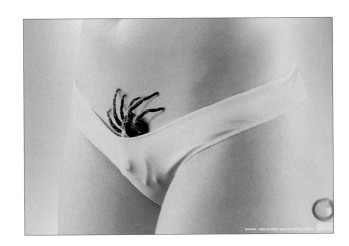

BRONZE

CATEGORY Public Service • **ADVERTISER/PRODUCT** SPCA • **TITLE** Snake • **ADVERTISING AGENCY** Leo Burnett, Singapore • **PHOTOGRAPHY STUDIO** Alex Kai Keong Studio, Singapore • **CREATIVE DIRECTOR** Linda Locke, Tay Guan Hin • **COPYWRITER** Priti Kapur • **ART DIRECTOR** Koh Hwee Peng, Tay Guan Hin • **PRODUCTION MANAGER** Dennis Gan, Kwek Puay Sang

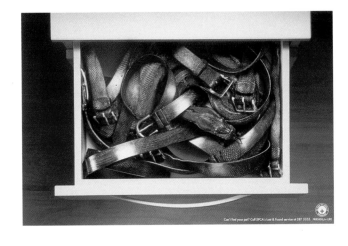

BRONZE

CATEGORY Public Service • **ADVERTISER/PRODUCT** SPCA • **TITLE** Dog • **ADVERTISING AGENCY** Leo Burnett, Singapore • **PHOTOGRAPHY STUDIO** Alex Kai Keong Studio, Singapore • **CREATIVE DIRECTOR** Linda Locke, Tay Guan Hin • **COPYWRITER** Priti Kapur • **ART DIRECTOR** Koh Hwee Peng • **PRODUCTION MANAGER** Dennis Gan, Kwek Puay Sang

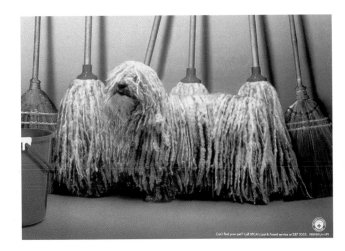

CATEGORY Public Service • **ADVERTISER/PRODUCT** National D-Day Museum • **TITLE** Higgins Boats • **ADVERTISING AGENCY** GMO/Hill Holliday, San Francisco • **CREATIVE DIRECTOR** Brian O'Neill, Jim Noble, Rob Bagot • **COPYWRITER** Chuck Meehan • **ART DIRECTOR** Matt Mowatt

BRONZE

CATEGORY Public Service • **ADVERTISER/PRODUCT** Greenpeace • **TITLE** Oil • **ADVERTISING AGENCY** Giovanni FCB, Rio de Janeiro • **ACCOUNT EXECUTIVE** Alvaro Esteves • **CREATIVE DIRECTOR** Adilson Xavier, Christina Amorim • **COPYWRITER** Fernando Campos • **ART DIRECTOR** Carlos André Eyer • **PRODUCTION MANAGER** Paulo Moraes • **PHOTOGRAPHER** Leonardo Vilela

BRONZE

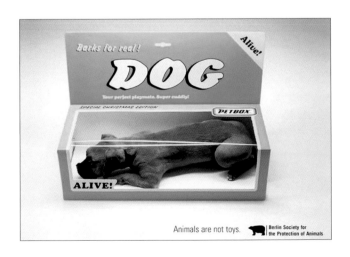

CATEGORY Public Service • **ADVERTISER/PRODUCT** Tierschutzverein Berlin—Society For The Protection Of Animals • **TITLE** Pets Are Not Toys (Dog) • **ADVERTISING AGENCY** Scholz & Friends Berlin, Berlin • **ACCOUNT EXECUTIVE** Christiane Schmid, Matthias Eichler • **CREATIVE DIRECTOR** Lutz Pluemecke, Martin Krapp • **COPYWRITER** Oliver Handlos • **ART DIRECTOR** Raphael Puettmann

BRONZE

BRONZE

CATEGORY Public Service • **ADVERTISER/PRODUCT** Fundação SOS Mata Atlantica • **TITLE** Eye III • **ADVERTISING AGENCY** F/Nazca S&S, São Paulo • **PHOTOGRAPHY STUDIO** João Caetano, São Paulo • **ACCOUNT EXECUTIVE** Bob Romagnoli, Jean André Neto, Luciana Serra • **CREATIVE DIRECTOR** Fabio Fernandes, Eduardo Lima • **COPYWRITER** Eduardo Lima, Victor Sant'Anna • **ART DIRECTOR** Sidney Araujo • **PRODUCTION MANAGER** Ze Roberto, Armando Ferreira • **PHOTOGRAPHER** João Caetano

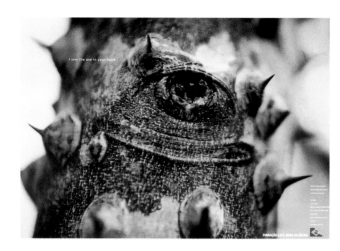

BRONZE

CATEGORY Public Service • **ADVERTISER/PRODUCT** ACLU • **TITLE** Small Prisoners • **ADVERTISING AGENCY** DeVito/Verdi, New York • **CREATIVE DIRECTOR** Sal DeVito • **COPYWRITER** Lee Seidenberg • **ART DIRECTOR** Eric Schutte • **PRODUCTION MANAGER** John Doepp • **PHOTOGRAPHER** Robert Ammirati

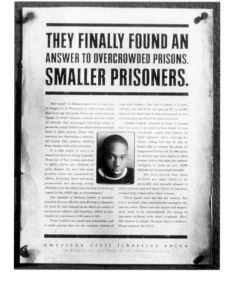

BRONZE

CATEGORY Public Service • **ADVERTISER/PRODUCT** ACLU • **TITLE** Manson • **ADVERTISING AGENCY** DeVito/Verdi, New York • **CREATIVE DIRECTOR** Sal DeVito • **COPYWRITER** Sal DeVito, Joel Tractenberg • **ART DIRECTOR** Sal DeVito, Greg Braun • **PRODUCTION MANAGER** John Doepp • **PHOTOGRAPHER** Robert Ammirati

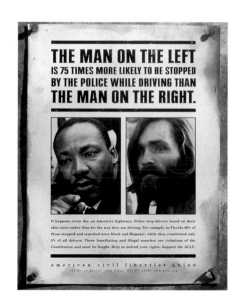

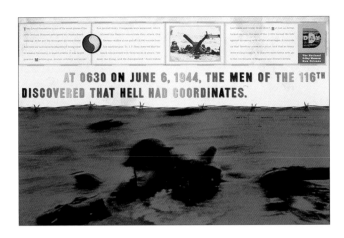

BRONZE

CATEGORY Public Service • **ADVERTISER/PRODUCT** National D-Day Museum • **TITLE** Hell Had Coordinates • **ADVERTISING AGENCY** GMO / Hill Holliday, San Francisco • **CREATIVE DIRECTOR** Brian O'Neill, Jim Noble, Rob Bagot • **COPYWRITER** Chuck Meehan • **ART DIRECTOR** Matt Mowatt

BRONZE

CATEGORY Public Service • **ADVERTISER/PRODUCT** NAACP (South Carolina) • **TITLE** Confederate Racism • **ADVERTISING AGENCY** McKinney & Silver, Raleigh • **CREATIVE DIRECTOR** David Baldwin • **COPYWRITER** Jon Wagner • **ART DIRECTOR** Gerardo Blumenkrantz

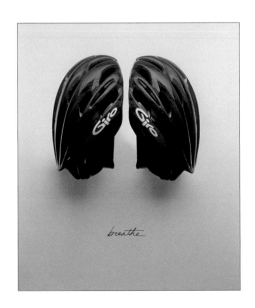

BRONZE

CATEGORY Recreational Items • **ADVERTISER/PRODUCT** Giro Sports Design • **TITLE** Breathe • **ADVERTISING AGENCY** Crispin Porter + Bogusky, Miami • **ACCOUNT EXECUTIVE** Laura Bowles • **CREATIVE DIRECTOR** Alex Bogusky • **COPYWRITER** Rob Strasberg • **ART DIRECTOR** Tony Calcao

BRONZE

CATEGORY Recreational Items • ADVERTISER/PRODUCT GT Bicycles • TITLE Security Cameras • ADVERTISING AGENCY Crispin Porter + Bogusky, Miami • CREATIVE DIRECTOR Alex Bogusky • COPYWRITER Ari Merkin • ART DIRECTOR Alex Burnard

SILVER

CATEGORY Retail Stores • ADVERTISER/PRODUCT Borders Bookstore • TITLE The Ugly American • ADVERTISING AGENCY Ogilvy & Mather, Singapore • CREATIVE DIRECTOR Neil French, Tham Khai Meng • COPYWRITER Neil French, Jaume Mones • ART DIRECTOR Tham Khai Meng, Alfred Wee, Francesc Talamino

*There are thirty-seven clues to the authors of books, poems, or merely quotations on this page. The clues can be titles, well-known lines, or passages...or even just 'clues!' The Borders store on the corner of Orchard and Scotts Roads opens at nine in the morning. Next Friday, the first ten customers who give us a list of these authors can choose as many free books from our stock as they got correct answers. In other words, get three authors correct; get three free books. Up to the maximum of thirty-seven books per customer. Good luck.

BRONZE

CATEGORY Retail Stores • ADVERTISER/PRODUCT IKEA • TITLE Instead Of A Divorce • ADVERTISING AGENCY Forsman & Bodenfors, Gothenburg • PHOTOGRAPHY STUDIO SKARP, Stockholm • ACCOUNT EXECUTIVE Olle Victorin • COPYWRITER Filip Nilsson, Fredrik Jansson • ART DIRECTOR Anders Eklind, Karin Jacobsson • PRODUCTION MANAGER Katarina Klofsten • PHOTOGRAPHER Karolina Henke • CLIENT IKEA Sweden

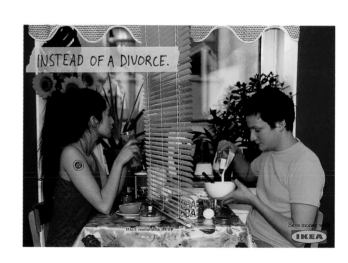

CATEGORY Toiletries/Pharmaceuticals • ADVERTISER/PRODUCT Trojan
• TITLE Bubble • ADVERTISING AGENCY Heymann/Bengoa/Berbari,
Miami • PHOTOGRAPHY STUDIO Maestri-Rambo, Buenos Aires •
ACCOUNT EXECUTIVE Hernán Bengoa, Matías Montero • CREATIVE
DIRECTOR Jorge Heymann, Alejandro Berbari, Marcelo Burgos •
COPYWRITER Jorge Heymann, Alejandro Berbari, Alejandro Egozcue •
ART DIRECTOR Marcelo Burgos • PRODUCTION MANAGER Juán Insua
• PHOTOGRAPHER Daniel Maestri

GOLD

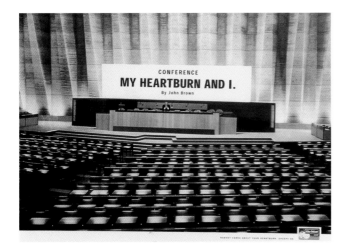

CATEGORY Toiletries/Pharmaceuticals • ADVERTISER/PRODUCT Alka
Seltzer / Bayer • TITLE Conference • ADVERTISING AGENCY
Tiempo/BBDO, Barcelona • ACCOUNT EXECUTIVE Julio Paredes •
CREATIVE DIRECTOR Jose Gamo • COPYWRITER Jose Angel Castro •
ART DIRECTOR Alex Lázaro • PHOTOGRAPHER Joan Anguera, Ramon
Serrano

SILVER

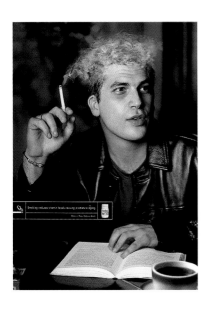

CATEGORY Toiletries/Pharmaceuticals • ADVERTISER/PRODUCT Bayer
SA / One A Day • TITLE Smoke • ADVERTISING AGENCY Young &
Rubicam, Buenos Aires • PHOTOGRAPHY STUDIO Ackerman, Buenos
Aires • ACCOUNT EXECUTIVE Marla José Dominguez Crespo, Eugenia
Slosse • CREATIVE DIRECTOR Damián Kepel • COPYWRITER
Sebastián Castañeda • ART DIRECTOR Maureen Hufnagel •
PRODUCTION MANAGER Omar Di Nardo, Fernando Costanza •
PHOTOGRAPHER Daniel Ackerman

SILVER

CATEGORY Toiletries/Pharmaceuticals • **ADVERTISER/PRODUCT** Axe •
TITLE Wedding Cake • **ADVERTISING AGENCY** Lowe Lintas & Partners
LTDA, São Paulo • **ACCOUNT EXECUTIVE** Eduardo Linhares, Luisa
Guardia • **COPYWRITER** Marcelo "Dropp" Almeida • **ART DIRECTOR**
Eddie Murphy, Rogério Betiol • **PHOTOGRAPHER** Felipe Hellmeister

BRONZE

CATEGORY Toiletries/Pharmaceuticals • **ADVERTISER/PRODUCT**
Nicorette Gum • **TITLE** No Smoking • **ADVERTISING AGENCY** BMP
DDB, London • **ACCOUNT EXECUTIVE** Simon Lendrum • **COPYWRITER**
James Sinclair • **ART DIRECTOR** Ed Morris • **CLIENT SUPERVISOR**
Alison Williamson

BRONZE

CATEGORY Travel/Tourism • **ADVERTISER/PRODUCT** Seychelles
Tourism Marketing Authority • **TITLE** Fisherman • **ADVERTISING**
AGENCY TBWA Hunt Lascaris, Johannesburg • **PHOTOGRAPHY**
STUDIO Beith Digital, Johannesburg • **ACCOUNT EXECUTIVE** Julian
Ribeiro • **CREATIVE DIRECTOR** Tony Granger • **COPYWRITER** Wendy
Moorcroft • **ART DIRECTOR** Erik Vervroegen • **PRODUCTION MANAGER**
Sherrol Doyle-Swallow • **PHOTOGRAPHER** Mike Lewis

SILVER

CATEGORY Travel/Tourism • **ADVERTISER/PRODUCT** Raffles Hotel •
TITLE Silver • **ADVERTISING AGENCY** Ogilvy & Mather, Singapore •
CREATIVE DIRECTOR Tham Khai Meng • **COPYWRITER** Malcolm
Pryce, Tham Khai Meng • **ART DIRECTOR** Tham Khai Meng, Alfred
Wee • **PRODUCTION MANAGER** Chris Chan, Xavier Heng

CATEGORY Travel/Tourism • **ADVERTISER/PRODUCT** Seychelles
Tourism Marketing Authority • **TITLE** Kids • **ADVERTISING AGENCY**
TBWA Hunt Lascaris, Johannesburg • **PHOTOGRAPHY STUDIO** Beith
Digital, Johannesburg • **ACCOUNT EXECUTIVE** Julian Ribeiro •
CREATIVE DIRECTOR Tony Granger • **COPYWRITER** Wendy Moorcroft
• **ART DIRECTOR** Erik Vervroegen • **PRODUCTION MANAGER** Sherrol
Doyle-Swallow • **PHOTOGRAPHER** Mike Lewis

SILVER

CATEGORY Local Campaign • **ADVERTISER/PRODUCT** Borders Bookstore • **TITLE** Trailing Clouds of Glory • **TITLE** The Ugly American • **TITLE** The Prince • **ADVERTISING AGENCY** Ogilvy & Mather, Singapore • **CREATIVE DIRECTOR** Neil French, Tham Khai Meng • **COPYWRITER** Neil French, Jaume Mones • **ART DIRECTOR** Tham Khai Meng, Alfred Wee, Francesc Talamino

*There are thirty-seven clues to the authors of books, poems, or merely quotations on this page. The clues can be titles, well-known lines, or passages...or even just 'clues!' The Borders store on the corner of Orchard and Scotts Roads opens at nine in the morning. Next Friday, the first ten customers who give us a list of these authors can choose as many free books from our stock as they got correct answers. In other words, get three authors correct; get three free books. Up to the maximum of thirty-seven books per customer. Good luck.

SILVER

CATEGORY Local Campaign • **ADVERTISER/PRODUCT** Nike Paralympics • **TITLE** Stare • **TITLE** Sorry • **TITLE** Awkward • **ADVERTISING AGENCY** The Jupiter Drawing Room (South Africa), Johannesburg • **PHOTOGRAPHY STUDIO** David Prior, Johannesburg • **ACCOUNT EXECUTIVE** Michelle Young • **CREATIVE DIRECTOR** Graham Warsop • **COPYWRITER** Brendan Jack, Gavin Williams • **ART DIRECTOR** Heloise Jacobs • **PRODUCTION MANAGER** Hilary Simpson • **PHOTOGRAPHER** David Prior

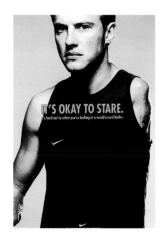

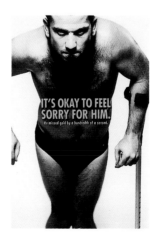

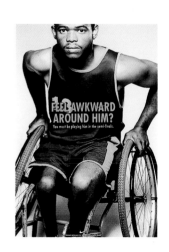

CATEGORY Local Campaign • **ADVERTISER/PRODUCT** National D-Day Museum • **TITLE** Hell Had Coordinates • **TITLE** Kansas Farm Boy •
TITLE Little Black Box • **ADVERTISING AGENCY** GMO/Hill Holliday, San Francisco • **CREATIVE DIRECTOR** Brian O'Neill, Rob Bagot •
COPYWRITER Chuck Meehan • **ART DIRECTOR** Matt Mowatt

BRONZE

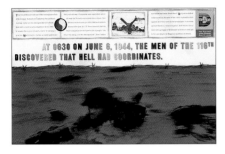

CATEGORY Regional Campaign • **ADVERTISER/PRODUCT** 3M Post-It Notes • **TITLE** Mahatma Ghandi • **TITLE** Mother Teresa • **TITLE** Holocaust •
ADVERTISING AGENCY Ogilvy & Mather, Bangalore • **ACCOUNT EXECUTIVE** Soumya Rao • **CREATIVE DIRECTOR** Manmohan Anchan, Vidur Vohra •
COPYWRITER Vidur Vohra • **ART DIRECTOR** Haridas B. • **PRODUCTION MANAGER** Srikanth B.S.

SILVER

PRINT

Campaign

CATEGORY National Campaign • **ADVERTISER/PRODUCT** Medecins Sans Frontieres • **TITLE** Rwanda: Bjrundi • **TITLE** Russia: Chechnya • **TITLE** Timor: Indonesia • **ADVERTISING AGENCY** McCann-Erickson, Madrid • **PHOTOGRAPHY STUDIO** Santiago Esteban, Madrid • **CREATIVE DIRECTOR** Andrés Martinez • **GENERAL MANAGER** Enrique Bofarull • **GRAPHIC PRODUCTION DIRECTOR** Sara Fernández • **EXECUTIVE CREATIVE DIRECTOR** Nicolás Hollander • **PRODUCTION COMPANY** Ciclorama, Madrid

GOLD

CATEGORY National Campaign • **ADVERTISER/PRODUCT** Volkswagen Beetle • **TITLE** Fun Fur • **TITLE** Snakes & Ladders • **TITLE** Desperate Dan • **ADVERTISING AGENCY** BMP DDB, London • **ACCOUNT EXECUTIVE** Jon Busk • **CREATIVE DIRECTOR** Mike Hannett, Dave Buchanan • **COPYWRITER** Adam Tucker • **ART DIRECTOR** Justin Tindall • **PHOTOGRAPHER** James Day • **TYPOGRAPHER** Kevin Clarke • **CLIENT SUPERVISOR** Catherine Fordham • **ILLUSTRATOR (SNAKES & LADDERS)** Steve Dell

GOLD

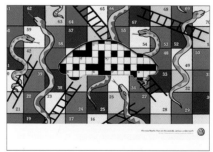
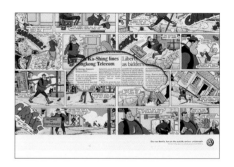

CATEGORY National Campaign • ADVERTISER/PRODUCT Fundação SOS Mata Atlantica • TITLE Eye I • TITLE Eye II • TITLE Eye III •
ADVERTISING AGENCY F/Nazca S&S, São Paulo • PHOTOGRAPHY STUDIO João Caetano, São Paulo • ACCOUNT EXECUTIVE Bob
Romagnoli, Jean André Neto, Luciana Serra • CREATIVE DIRECTOR Fabio Fernandes, Eduardo Lima • COPYWRITER Eduardo Lima, Victor
Sant'Anna • ART DIRECTOR Sidney Araujo • PRODUCTION MANAGER Ze Roberto, Armando Ferreira • PHOTOGRAPHER João Caetano

GOLD

CATEGORY National Campaign • ADVERTISER/PRODUCT Seychelles Tourism Marketing Authority • TITLE Ox Cart • TITLE Forest • TITLE Fisherman •
ADVERTISING AGENCY TBWA Hunt Lascaris, Johannesburg • PHOTOGRAPHY STUDIO Beith Digital, Johannesburg • ACCOUNT EXECUTIVE
Julian Ribeiro • CREATIVE DIRECTOR Tony Granger • COPYWRITER Wendy Moorcroft • ART DIRECTOR Erik Vervroegen • PRODUCTION MANAGER
Sherrol Doyle-Swallow • PHOTOGRAPHER Mike Lewis

SILVER

173

SILVER

CATEGORY National Campaign • **ADVERTISER/PRODUCT** Marks & Spencer Push-Up Bra • **TITLE** Office • **TITLE** Supermarket • **TITLE** Restaurant • **ADVERTISING AGENCY** Results Advertising Ltd, Bangkok • **PHOTOGRAPHY STUDIO** Flash Studio, Bangkok • **ACCOUNT EXECUTIVE** Kodchanant Inthachak • **CREATIVE DIRECTOR** Jureeporn Thaidumrong, Joel Clement • **COPYWRITER** Jureeporn Thaidumrong, Joel Clement • **ART DIRECTOR** Joel Clement, Jureeporn Thaidumrong • **IMAGE COMPOSER** Niphon Baiyen • **PRODUCTION COMPANY** Flash Studio, Bangkok

BRONZE

CATEGORY National Campaign • **ADVERTISER/PRODUCT** AAD—American Academy of Dermatology ("Overexposed Faces" Campaign) • **TITLE** Man • **TITLE** Baby • **TITLE** Woman • **ADVERTISING AGENCY** Publicis in Mid-America, Chicago • **ACCOUNT EXECUTIVE** Elizabeth Upton • **CREATIVE DIRECTOR** Ted Barton • **COPYWRITER** Eric Revels, Vince Cook • **ART DIRECTOR** Eric Revels, Vince Coo

CATEGORY National Campaign • **ADVERTISER/PRODUCT** Discovery.com • **TITLE** Supermarket • **TITLE** Prom • **TITLE** Bedroom •
ADVERTISING AGENCY Publicis & Hal Riney, San Francisco • **ACCOUNT EXECUTIVE** John Masdea • **CREATIVE DIRECTOR** Steve Luker,
Kevin Jones • **COPYWRITER** Mike McCommon, Roger Camp • **ART DIRECTOR** Roger Camp, Mike McCommon • **PRODUCTION MANAGER**
Francine Kipreos • **PHOTOGRAPHER** Lauren Greenfield

BRONZE

CATEGORY National Campaign • **ADVERTISER/PRODUCT** SPCA • **TITLE** Dog • **TITLE** Cat • **TITLE** Snake • **ADVERTISING AGENCY** Leo Burnett,
Singapore • **PHOTOGRAPHY STUDIO** Alex Kai Keong Studio, Singapore • **CREATIVE DIRECTOR** Linda Locke, Tay Guan Hin • **COPYWRITER** Priti Kapur •
ART DIRECTOR Koh Hwee Peng, Tay Guan Hin

BRONZE

PRINT

Campaign

BRONZE

CATEGORY National Campaign • **ADVERTISER/PRODUCT** Sports Illustrated Magazine • **TITLE** Career Path • **TITLE** Judge, Jury, Prosecutor • **TITLE** Tiger Woods • **ADVERTISING AGENCY** Fallon, Minneapolis • **ACCOUNT EXECUTIVE** Kevin Berigan • **CREATIVE DIRECTOR** David Lubars • **COPYWRITER** Greg Hahn • **ART DIRECTOR** Steve Driggs • **PRODUCTION MANAGER** Steve Delorme • **PHOTOGRAPHER** Manny Millan, John Biever, Robert Beck

BRONZE

CATEGORY National Campaign • **ADVERTISER/PRODUCT** Correios ("Stamps" Campaign) • **TITLE** Culture • **TITLE** Fauna • **TITLE** Faith • **ADVERTISING AGENCY** Salles D'Arcy Publicidade Ltda, Rio de Janeiro • **PHOTOGRAPHY STUDIO** Opção Fotoarchivo, Rio de Janeiro • **ACCOUNT EXECUTIVE** Ana Paula Sanches • **CREATIVE DIRECTOR** Marcelo Giannini • **COPYWRITER** Rodolfo Sampaio • **ART DIRECTOR** Guilherme Jahara • **PRINTER** Presstech, Rio de Janeiro

CATEGORY National Campaign • **ADVERTISER/PRODUCT** Sports Illustrated Magazine • **TITLE** Loneliest Place On Earth • **TITLE** He Knows • **TITLE** Cinderella Story • **ADVERTISING AGENCY** Fallon, Minneapolis • **ACCOUNT EXECUTIVE** Kevin Berigan • **CREATIVE DIRECTOR** David Lubars • **COPYWRITER** Greg Hahn • **ART DIRECTOR** Steve Driggs • **PRODUCTION MANAGER** Steve Delorme, Paul Morita • **PHOTOGRAPHER** Al Tielelman, David Liamkyle, Robert Beck

BRONZE

CATEGORY National Campaign • **ADVERTISER/PRODUCT** Audi A4 • **TITLE** Wheel • **TITLE** Pedal • **TITLE** 4 Wheels • **ADVERTISING AGENCY** Tandem Campmany Guasch DDB, Barcelona • **CREATIVE DIRECTOR** Alberto Astorga, Dani Ilario • **COPYWRITER** Alberto Astorga, Nuria Argelich • **ART DIRECTOR** Dani Ilario, Fernando Codina

BRONZE

177

BRONZE

CATEGORY National Campaign • **ADVERTISER/PRODUCT** DaimlerChrysler Canada Inc. (Jeep) • **TITLE** Gas Pump (Vertical) • **TITLE** Parking Meter (Vertical) • **TITLE** Stop Sign (Vertical) • **ADVERTISING AGENCY** BBDO Canada, Toronto • **ACCOUNT EXECUTIVE** Gary King, Brian Jamieson, Erin Iles • **CREATIVE DIRECTOR** Michael McLaughlin, Jack Neary, Mike Smith, Steve Denvir • **COPYWRITER** Michael Clowater • **ART DIRECTOR** John Terry • **PHOTOGRAPHER** Bill Drummond • **PRINT PRODUCTION STUDIO** SGL Studio, Toronto • **TYPOGRAPHER** John Rodrigues • **DIGITAL RETOUCHER** ReBecca Nixon

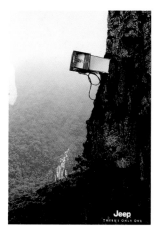
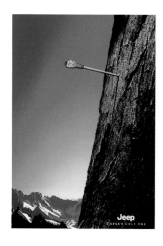
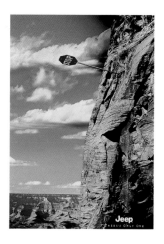

BRONZE

CATEGORY National Campaign • **ADVERTISER/PRODUCT** Timberland • **TITLE** Treadmill • **TITLE** Stairs • **TITLE** Bicycle • **ADVERTISING AGENCY** DPZ Propaganda, São Paulo • **ACCOUNT EXECUTIVE** Duilio Malfatti • **CREATIVE DIRECTOR** Jose Zaragoza, Javier Talavera • **COPYWRITER** Andreia Barion • **ART DIRECTOR** Giuliano Cesar • **PHOTOGRAPHER** Marcos Constatino, Renato Corradi • **PRODUCER** Robson Ciaramicoli

CATEGORY National Campaign • **ADVERTISER/PRODUCT** American Legacy Foundation • **TITLE** Poisons • **TITLE** Marlboro Man • **TITLE** Minty Fresh • **ADVERTISING AGENCY** The Alliance, Miami • **ACCOUNT EXECUTIVE** Barbara Karalis • **CREATIVE DIRECTOR** Alex Bogusky • **COPYWRITER** Rob Strasberg • **ART DIRECTOR** Tony Calcao

CATEGORY National Campaign • **ADVERTISER/PRODUCT** Findus Lean Cuisine • **TITLE** Fashion One: Glazed Chicken • **TITLE** Fashion Two: Chicken L'Orange • **TITLE** Fashion Three: Lasagna • **ADVERTISING AGENCY** Grey Worldwide, London • **EXECUTIVE CREATIVE DIRECTOR** Tim Mellors • **CREATIVE DIRECTOR** Mark Collis • **COPYWRITER** Steve Back • **ART DIRECTOR** Steve Back • **PHOTOGRAPHER** Tiziano Magni

BRONZE

CATEGORY National Campaign • **ADVERTISER/PRODUCT** H-J Flebbe Filmtheater / Cinemaxx • **TITLE** Hedge • **TITLE** Stairlift • **TITLE** Hatch • **TITLE** Dumbbell • **TITLE** Shower • **TITLE** TV • **ADVERTISING AGENCY** Jung von Matt Werbeagentur GmbH, Hamburg • **ACCOUNT EXECUTIVE** Nadja Fricke, Gitti Landt (Hedge, Stairlift, Hatch); Alexander Maisch, Nina Nendza (Dumbbell, Shower, TV) • **CREATIVE DIRECTOR** Niels Alzen, Thim Wagner (Hedge, Stairlift, Hatch); Stefan Zschaler, Roland Schwarz (Dumbbell, Shower, TV) • **COPYWRITER** Willy Kaussen, Jens Daum (Hedge, Stairlift, Hatch); Sebastian Hardieck, Niels Alzen, Dirk Silz (Dumbbell, Shower, TV) • **ART DIRECTOR** Christian Reimer, Hans Weisháupl, Raphael Milczarek (Hedge, Stairlift, Hatch); Melanie Landwehr, Thim Wagner (Dumbbell, Shower, TV) • **ILLUSTRATOR** Felix Reidenbach (Hedge, Stairlift, Hatch); Roland Schwarz (Dumbbell, Shower, TV)

CATEGORY National Campaign • ADVERTISER/PRODUCT Christmas Cards • TITLE Chagall • TITLE Baby Jesus • TITLE Van Gogh •
ADVERTISING AGENCY Fischer America, São Paulo • ACCOUNT EXECUTIVE Claudia Kalim • CREATIVE DIRECTOR Paulo Pretti •
COPYWRITER Paulo Pretti • ART DIRECTOR Paulo Pretti • PRODUCTION MANAGER Claudio Dirani • PHOTOGRAPHER Claudio Elizabeths

BRONZE

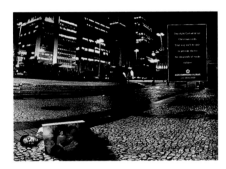
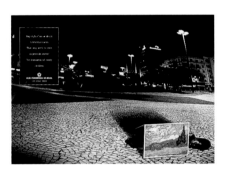

CATEGORY National Campaign • ADVERTISER/PRODUCT GT Bicycles • TITLE Leg Shaving • TITLE Dentist • TITLE Security Camera • ADVERTISING
AGENCY Crispin Porter + Bogusky, Miami • ACCOUNT EXECUTIVE Laura Bowles • CREATIVE DIRECTOR Alex Bogusky • COPYWRITER Ari Merkin •
ART DIRECTOR Alex Burnard

BRONZE

BRONZE

CATEGORY National Campaign • **ADVERTISER/PRODUCT** Bianco Shoes • **TITLE** We Recommend A Pair/Woman • **TITLE** We Recommend A Pair/Man • **TITLE** We Recommend A Pair/Balding Man • **ADVERTISING AGENCY** Grey, Copenhagen • **ART DIRECTOR** Thomas Hoffmann

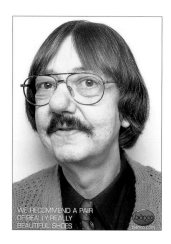

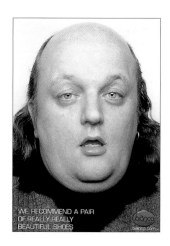

BRONZE

CATEGORY National Campaign • **ADVERTISER/PRODUCT** Nike • **TITLE** TV Guide • **TITLE** Timesheet • **TITLE** Bar Tab • **ADVERTISING AGENCY** Goodby, Silverstein & Partners, San Francisco • **CREATIVE DIRECTOR** Jeffrey Goodby, Rich Silverstein • **COPYWRITER** Maya Rao • **ART DIRECTOR** Sean Farrell • **PRODUCTION MANAGER** Jill Blevins-Keogh • **PHOTOGRAPHER** William Huber

CATEGORY National Campaign • **ADVERTISER/PRODUCT** Peugeot 206 • **TITLE** Motorcycle • **TITLE** Paytoll • **TITLE** Street • **ADVERTISING AGENCY** Lautrec Euro RSCG, Buenos Aires • **ACCOUNT EXECUTIVE** Fernando Vizcaino • **CLIENT SUPERVISOR** Esteban Ochoa • **GENERAL CREATIVE DIRECTOR** Juan Cravero, Dario Lanis • **COPYWRITER** Roberto Leston • **ART DIRECTOR** Toto Marelli, Mercedes Tiagonce, Javier Lourenco • **PRODUCTION MANAGER** Rolando Lambert • **PHOTOGRAPHER** Jorge Revsin

BRONZE

CATEGORY National Campaign • **ADVERTISER/PRODUCT** Volkswagen of America Inc. • **TITLE** Jumper • **TITLE** Bee Man • **TITLE** Lettuce Girl • **ADVERTISING AGENCY** ARNOLD Worldwide, Boston • **ACCOUNT EXECUTIVE** Michael Shonkoff • **CHIEF CREATIVE OFFICER** Ron Lawner • **CREATIVE DIRECTOR** Alan Pafenbach • **COPYWRITER** Dave Weist • **ART DIRECTOR** Don Shelford • **PRODUCTION MANAGER** Sally Bertolet • **PHOTOGRAPHER** Bill Cash • **TRAFFIC MANAGER** Dayva Savio

BRONZE

CATEGORY Direct Marketing-Collateral • **ADVERTISER/PRODUCT** Physicians for Human Rights • **TITLE** Shoebox • **ADVERTISING AGENCY** Euro RSCG Tatham McConnaughy, Chicago • **CREATIVE DIRECTOR** Jim Schmidt • **COPYWRITER** Jim Schmidt • **ART DIRECTOR** Jeff DeChausse

SILVER

CATEGORY Direct Marketing-Collateral • **ADVERTISER/PRODUCT** Bold Printing Group • **TITLE** Fjodor Dostojevskij • **ADVERTISING AGENCY** Schumacher, Jersild, Wessman & Enander, Stockholm • **ACCOUNT EXECUTIVE** Jan Selling • **COPYWRITER** Marten Knutsson • **ART DIRECTOR** Marita Kuntonen • **PRODUCTION MANAGER** Gith Kjellin

TRANSLATION OF HEADLINE: *Crime and Punishment* by Fyodor Dostoevsky, finally available in just 38 pages. **SUBHEAD:** If you have lots of space, you can do as you please.

CATEGORY Direct Marketing-Collateral • **ADVERTISER/PRODUCT** Bold Printing Group • **TITLE** Calendar 2001-2100 • **ADVERTISING AGENCY** Schumacher, Jersild, Wessman & Enander, Stockholm • **ACCOUNT EXECUTIVE** Jan Selling • **COPYWRITER** Hedvig Hagwall-Bruckner • **ART DIRECTOR** Marita Kuntonen • **PRODUCTION MANAGER** Yvonne Strömsäter

BRONZE

CATEGORY Direct Marketing-Collateral • **ADVERTISER/PRODUCT** Lexus • **TITLE** Bluebook • **ADVERTISING AGENCY** Team One Advertising, El Segundo • **ACCOUNT EXECUTIVE** Daphne Lee • **CREATIVE DIRECTOR** Tom Cordner • **COPYWRITER** Craig Crawford • **ART DIRECTOR** Betsy Nathane • **PRODUCTION MANAGER** Susanna Leighton

BRONZE

INSIDE TEXT: You'd never think about buying a new car without first doing your homework. But have you ever researched what it could be worth when you sell it? Lexus invites you to consider the resale value of your car brand against ours. And of course, then consider getting a Lexus.
THE RELENTLESS PURSUIT OF PERFECTION.
Have we piqued your interest? To learn even more, visit us at ValueLexus.com

CATEGORY Direct Marketing-Collateral • **ADVERTISER/PRODUCT** Humane Society of Canada • **TITLE** Dog Biting • **ADVERTISING AGENCY** TAXI Advertising & Design, Toronto • **ACCOUNT EXECUTIVE** Gary McGuire • **CREATIVE DIRECTOR** Zak Mroueh, Paul Lavoie • **COPYWRITER** Zak Mroueh • **ART DIRECTOR** Gordon Marshall • **PRODUCTION MANAGER** Beth MacKinnon

BRONZE

BRONZE

CATEGORY Trade: Product • **ADVERTISER/PRODUCT** Kärkimedia Nationwide Newspapers • **TITLE** Finns Are Really Into Their Newspapers (Fish) • **ADVERTISING AGENCY** Hasan & Partners Oy, Helsinki • **PHOTOGRAPHY STUDIO** Studio Timo Viljakainen, Helsinki • **ACCOUNT EXECUTIVE** Henrik Kylander, Tia Silván • **COPYWRITER** Jussi Turhala • **ART DIRECTOR** Ossi Piipponen • **PHOTOGRAPHER** Timo Viljakainen

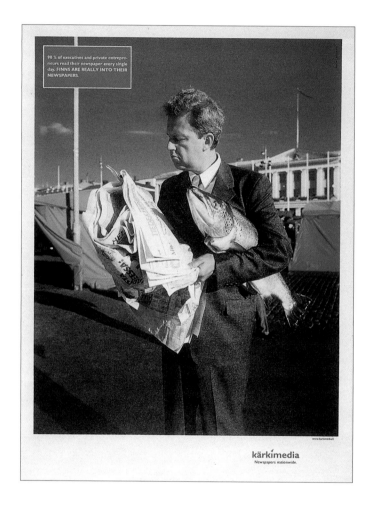

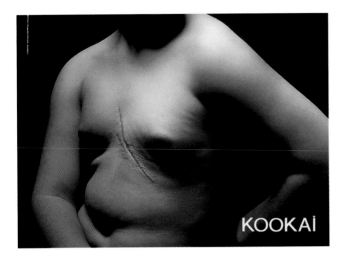

CATEGORY Photography • **ADVERTISER/PRODUCT** Kookai • **TITLE** Fat
• **ADVERTISING AGENCY** CLM/BBDO, Paris • **ACCOUNT EXECUTIVE**
Marie-Pierre Benitah • **CREATIVE DIRECTOR** Anne de Maupeou •
COPYWRITER Frederic Temin, Guillaume de la Croix •
PHOTOGRAPHER Vincent Peters

GOLD

CATEGORY Photography • **ADVERTISER/PRODUCT** Kookai • **TITLE**
White • **ADVERTISING AGENCY** CLM/BBDO, Paris • **ACCOUNT**
EXECUTIVE Marie-Pierre Benitah • **CREATIVE DIRECTOR** Anne de
Maupeou • **COPYWRITER** Frederic Temin, Guillaume de la Croix •
PHOTOGRAPHER Vincent Peters

SILVER

CATEGORY Photography • **ADVERTISER/PRODUCT** Peugeot 206 •
TITLE Motorcycle • **ADVERTISING AGENCY** CraveroLanis Euro RSCG,
Buenos Aires • **ACCOUNT EXECUTIVE** Fernando Vizcaino • **CLIENT**
SUPERVISOR Esteban Ochoa • **GENERAL CREATIVE DIRECTOR** Juan
Cravero, Dario Lanis • **COPYWRITER** Roberto Leston • **ART DIRECTOR**
Toto Marelli, Mercedes Tiagonce, Javier Lourenco • **PRODUCTION**
MANAGER Rolando Lambert

BRONZE

Poster & Billboard

CATEGORY Apparel/Fashion • **ADVERTISER/PRODUCT** Kansas Work Wear • **TITLE** Catwalk • **ADVERTISING AGENCY** Grey, Copenhagen • **ACCOUNT EXECUTIVE** Sune Bang • **COPYWRITER** Thomas Asbaek • **ART DIRECTOR** Tobias Rosenberg

BRONZE

CATEGORY Apparel/Fashion • **ADVERTISER/PRODUCT** Fiona Bennett's Hats • **TITLE** Beautiful Hats (V-neck) • **ADVERTISING AGENCY** Scholz & Friends Berlin, Berlin • **ACCOUNT EXECUTIVE** Sandra Landgraf • **CREATIVE DIRECTOR** Martin Pross, Joachim Schoepfer • **ART DIRECTOR** Marco Fusz, Meik Heindorf • **PHOTOGRAPHER** Matthias Kosslik

BRONZE

CATEGORY Automotive • **ADVERTISER/PRODUCT** Volkswagen Beetle • **TITLE** Fun Fur • **ADVERTISING AGENCY** BMP DDB, London • **ACCOUNT EXECUTIVE** Jon Busk • **CREATIVE DIRECTOR** Mike Hannett, Dave Buchanan • **COPYWRITER** Adam Tucker • **ART DIRECTOR** Justin Tindall • **PHOTOGRAPHER** James Day • **CLIENT SUPERVISOR** Catherine Fordham • **TYPOGRAPHER** Kevin Clarke

GOLD

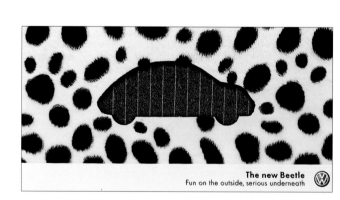

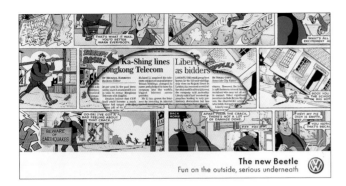

CATEGORY Automotive • ADVERTISER/PRODUCT Volkswagen Beetle • TITLE Desperate Dan • ADVERTISING AGENCY BMP DDB, London • ACCOUNT EXECUTIVE Jon Busk • CREATIVE DIRECTOR Mike Hannett, Dave Buchanan • COPYWRITER Adam Tucker • ART DIRECTOR Justin Tindall • PHOTOGRAPHER James Day • CLIENT SUPERVISOR Catherine Fordham • TYPOGRAPHER Kevin Clarke

SILVER

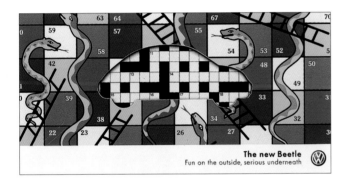

CATEGORY Automotive • ADVERTISER/PRODUCT Volkswagen Beetle • TITLE Snakes & Ladders • ADVERTISING AGENCY BMP DDB, London • ACCOUNT EXECUTIVE Jon Busk • CREATIVE DIRECTOR Mike Hannett, Dave Buchanan • COPYWRITER Adam Tucker • ART DIRECTOR Justin Tindall • PHOTOGRAPHER James Day • CLIENT SUPERVISOR Catherine Fordham • TYPOGRAPHER Kevin Clarke • ILLUSTRATOR Steve Dell

SILVER

CATEGORY Media Promotion • ADVERTISER/PRODUCT The Weather Network • TITLE As Seen On TV • ADVERTISING AGENCY Holmes & Lee Inc., Toronto • ACCOUNT EXECUTIVE John Lee • CREATIVE DIRECTOR Peter Holmes • COPYWRITER Chad Kabigting • ART DIRECTOR Peter Holmes

BRONZE

BRONZE

CATEGORY Media Promotion • **ADVERTISER/PRODUCT** The Weather Network • **TITLE** Ozone Layer • **ADVERTISING AGENCY** Holmes & Lee Inc., Toronto • **ACCOUNT EXECUTIVE** John Lee • **CREATIVE DIRECTOR** Peter Holmes • **COPYWRITER** Peter Holmes • **ART DIRECTOR** Peter Holmes

SILVER

CATEGORY Public Service • **ADVERTISER/PRODUCT** Gun Control • **TITLE** John Lennon • **ADVERTISING AGENCY** Goodby, Silverstein & Partners, San Francisco • **CREATIVE DIRECTOR** Jeffrey Goodby, Rich Silverstein • **COPYWRITER** Christy Chan • **ART DIRECTOR** Stefan Copiz, Matt Stein • **PRODUCTION MANAGER** Michael Stock

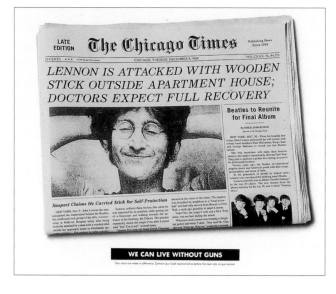

SILVER

CATEGORY Public Service • **ADVERTISER/PRODUCT** Gun Control • **TITLE** John F. Kennedy • **ADVERTISING AGENCY** Goodby, Silverstein & Partners, San Francisco • **CREATIVE DIRECTOR** Jeffrey Goodby, Rich Silverstein • **COPYWRITER** Christy Chan • **ART DIRECTOR** Stefan Copiz, Matt Stein • **PRODUCTION MANAGER** Michael Stock

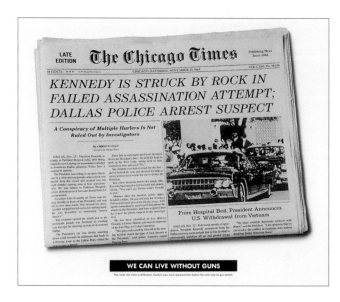

CATEGORY Public Service • ADVERTISER/PRODUCT Fundação SOS Mata Atlantica • TITLE Eye V • ADVERTISING AGENCY F/Nazca S&S, São Paulo • PHOTOGRAPHY STUDIO João Caetano, São Paulo • ACCOUNT EXECUTIVE Bob Romagnoli, Jean André Neto, Luciana Serra • CREATIVE DIRECTOR Fabio Fernandes, Eduardo Lima • COPYWRITER Eduardo Lima, Victor Sant'Anna • ART DIRECTOR Sidney Araujo • PRODUCTION MANAGER Ze Roberto, Armando Ferreira • PHOTOGRAPHER João Caetano

SILVER

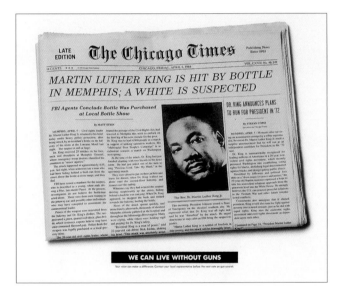

CATEGORY Public Service • ADVERTISER/PRODUCT Gun Control • TITLE Martin Luther King Jr. • ADVERTISING AGENCY Goodby, Silverstein & Partners, San Francisco • CREATIVE DIRECTOR Jeffrey Goodby, Rich Silverstein • COPYWRITER Christy Chan • ART DIRECTOR Stefan Copiz, Matt Stein • PRODUCTION MANAGER Michael Stock

BRONZE

BRONZE

CATEGORY Public Service • **ADVERTISER/PRODUCT** GAPA • **TITLE** Spider • **ADVERTISING AGENCY** J. Walter Thompson, São Paulo • **ACCOUNT EXECUTIVE** Saulo Sanches • **CREATIVE DIRECTOR** Andre Pinho, Darcy Fonseca • **COPYWRITER** Darcy Fonseca • **ART DIRECTOR** Darcy Fonseca • **PHOTOGRAPHER** Richard Kohut

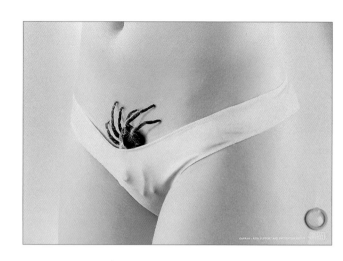

GOLD

CATEGORY Toiletries/Pharmaceuticals • **ADVERTISER/PRODUCT** Trojan • **TITLE** Bubble • **ADVERTISING AGENCY** Heymann/Bengoa/Berbari, Miami • **PHOTOGRAPHY STUDIO** Maestri-Rambo, Buenos Aires • **ACCOUNT EXECUTIVE** Hernán Bengoa, Matías Montero • **CREATIVE DIRECTOR** Jorge Heymann, Alejandro Berbari, Marcelo Burgos • **COPYWRITER** Jorge Heymann, Alejandro Berbari, Alejandro Egozcue • **ART DIRECTOR** Marcelo Burgos • **PRODUCTION MANAGER** Juán Insua • **PHOTOGRAPHER** Daniel Maestri

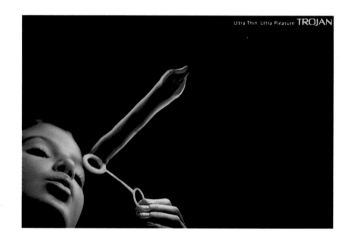

CATEGORY Local Campaign • ADVERTISER/PRODUCT Nike Shox • TITLE Trampoline • TITLE Hoop • TITLE Line-up • ADVERTISING AGENCY
The Jupiter Drawing Room (South Africa), Johannesburg • PHOTOGRAPHY STUDIO David Prior, Johannesburg • ACCOUNT EXECUTIVE
Michelle Young • CREATIVE DIRECTOR Graham Warsop • COPYWRITER Bernard Hunter, Leon Van Huysteen, Peter Callaghan • ART
DIRECTOR Michael Bond, Paul Anderson • PRODUCTION MANAGER Hilary Simpson • PHOTOGRAPHER David Prior

BRONZE

CATEGORY Local Campaign • ADVERTISER/PRODUCT Fiona Bennett's Hats • TITLE Beautiful Hats 1 • TITLE Beautiful Hats 2 • TITLE Beautiful Hats 3 •
ADVERTISING AGENCY Scholz & Friends Berlin, Berlin • ACCOUNT EXECUTIVE Sandra Landgraf • CREATIVE DIRECTOR Martin Pross, Joachim
Schoepfer • ART DIRECTOR Marco Fusz, Meik Heindorf • PHOTOGRAPHER Matthias Kosslik

BRONZE

BRONZE

CATEGORY Local Campaign • **ADVERTISER/PRODUCT** VBZ / World Literature • **TITLE** Death on the Nile • **TITLE** Romeo and Juliet • **TITLE** Around The World in 80 Days • **ADVERTISING AGENCY** Advico Young & Rubicam, Zurich-Gockhausen • **ACCOUNT EXECUTIVE** Manuela Gerosa • **CREATIVE DIRECTOR** Peter Broennimann • **COPYWRITER** Margrit Brunswick, Juerg Brechbuehl, Stefan Ehrler • **ART DIRECTOR** Dana Wirz • **PHOTOGRAPHER** Julien Vonier

GOLD

CATEGORY National Campaign • **ADVERTISER/PRODUCT** Kookai • **TITLE** Hairy • **TITLE** Old • **TITLE** Fat • **ADVERTISING AGENCY** CLM/BBDO, Paris • **ACCOUNT EXECUTIVE** Marie-Pierre Benitah • **CREATIVE DIRECTOR** Anne de Maupeou • **COPYWRITER** Frederic Temin, Guillaume de la Croix • **PHOTOGRAPHER** Vincent Peters

CATEGORY National Campaign • **ADVERTISER/PRODUCT** Gun Control • **TITLE** Martin Luther King Jr. • **TITLE** John F. Kennedy • **TITLE** John Lennon • **ADVERTISING AGENCY** Goodby, Silverstein & Partners, San Francisco • **CREATIVE DIRECTOR** Jeffrey Goodby, Rich Silverstein • **COPYWRITER** Christy Chan • **ART DIRECTOR** Stefan Copiz, Matt Stein • **PRODUCTION MANAGER** Michael Stock

SILVER

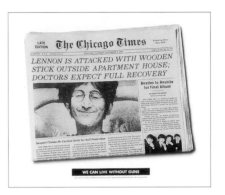

CATEGORY National Campaign • **ADVERTISER/PRODUCT** Fundação SOS Mata Atlantica • **TITLE** Eye I • **TITLE** Eye II • **TITLE** Eye III • **ADVERTISING AGENCY** F/Nazca S&S, São Paulo • **PHOTOGRAPHY STUDIO** João Caetano, São Paulo • **ACCOUNT EXECUTIVE** Bob Romagnoli, Jean André Neto, Luciana Serra • **CREATIVE DIRECTOR** Fabio Fernandes, Eduardo Lima • **COPYWRITER** Eduardo Lima, Victor Sant'Anna • **ART DIRECTOR** Sidney Araujo • **PRODUCTION MANAGER** Ze Roberto, Armando Ferreira • **PHOTOGRAPHER** João Caetano

SILVER

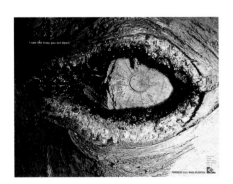
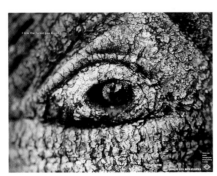

SILVER

CATEGORY National Campaign • **ADVERTISER/PRODUCT** The Economist • **TITLE** Long Headline • **TITLE** Chris • **TITLE** Lose the Ability • **ADVERTISING AGENCY** Abbott Mead Vickers BBDO, London • **ACCOUNT EXECUTIVE** Mark Peterson • **CREATIVE DIRECTOR** Peter Souter • **COPYWRITER** Tony Strong, Tim Riley, Sean Doyle • **ART DIRECTOR** Mike Duran, Rob Oliver, Dave Dye

A poster should contain no more than eight words, which is the maximum the average reader can take in at a single glance. This, however, is a poster for Economist readers.

"Can I phone an Economist reader please Chris?"

Lose the ability to slip out of meetings unnoticed.

The Economist

BRONZE

CATEGORY National Campaign • **ADVERTISER/PRODUCT** 77th Street • **TITLE** Freeway • **TITLE** Skyscrapers • **TITLE** Streetlamps • **ADVERTISING AGENCY** Lowe Lintas & Partners, Singapore • **PHOTOGRAPHY STUDIO** Alex Kai Keong Studio, Singapore • **CREATIVE DIRECTOR** Ng Khee Jin • **COPYWRITER** Jay Phua • **ART DIRECTOR** Thomas Yang • **PRODUCTION MANAGER** Douglas Wong • **IMAGING** Procolor, Singapore • **TYPOGRAPHER** Thomas Yang

CATEGORY National Campaign • **ADVERTISER/PRODUCT** Heinz Salad Cream • **TITLE** Sink • **TITLE** Mr. Potato Head • **TITLE** Sausage • **ADVERTISING AGENCY** Leo Burnett, London • **PHOTOGRAPHY STUDIO** Kelvin Murray, London • **ACCOUNT EXECUTIVE** Arianna Cefis, Katrina Ingham • **EXECUTIVE CREATIVE DIRECTOR** Mark Tutssel, Nick Bell • **CREATIVE DIRECTOR** Jack Stephens, Rob Nielsen • **COPYWRITER** Jack Stephens, Adam Griffin • **ART DIRECTOR** Rob Nielsen, Rob Spicer

BRONZE

CATEGORY National Campaign • **ADVERTISER/PRODUCT** Slimfast • **TITLE** Broken Cake • **TITLE** Split Dress • **TITLE** Sinking Into Cake • **ADVERTISING AGENCY** Grey Worldwide, Toronto • **PHOTOGRAPHY STUDIO** Instil Productions, Toronto • **ACCOUNT EXECUTIVE** Tracy Fogarty • **CREATIVE DIRECTOR** Marc Stoiber • **COPYWRITER** Shawn McClenny • **ART DIRECTOR** Shelley Weinreb • **PRODUCTION MANAGER** Joe Stevens • **PHOTOGRAPHER** Philip Rostron • **DESIGNER** Patty Groff

BRONZE

BRONZE

CATEGORY National Campaign • **ADVERTISER/PRODUCT** The Weather Network • **TITLE** Some Scenes May Be Disturbing to Viewers • **TITLE** As Seen on TV • **TITLE** Bitch And Complain Sooner • **ADVERTISING AGENCY** Holmes & Lee Inc., Toronto • **ACCOUNT EXECUTIVE** John Lee • **CREATIVE DIRECTOR** Peter Holmes • **COPYWRITER** Peter Holmes, Chad Kabigting • **ART DIRECTOR** Peter Holmes

BRONZE

CATEGORY National Campaign • **ADVERTISER/PRODUCT** Giro Sport Design • **TITLE** Beauty • **TITLE** Passion • **TITLE** Breathe • **ADVERTISING AGENCY** Crispin Porter + Bogusky, Miami • **ACCOUNT EXECUTIVE** Laura Bowles • **CREATIVE DIRECTOR** Alex Bogusky • **COPYWRITER** Rob Strasberg • **ART DIRECTOR** Tony Calcao

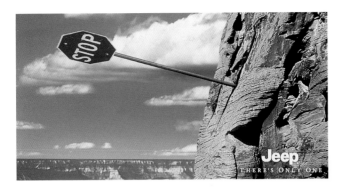

SILVER

CATEGORY Automotive • **ADVERTISER/PRODUCT** DaimlerChrysler Canada Inc. (Jeep) • **TITLE** Stop Sign (Horizontal) • **ADVERTISING AGENCY** BBDO Canada, Toronto • **ACCOUNT EXECUTIVE** Gary King, Brian Jamieson, Erin Iles • **CREATIVE DIRECTOR** Jack Neary, Michael McLaughlin, Mike Smith, Steve Denvir • **COPYWRITER** Michael Clowater • **ART DIRECTOR** John Terry • **PRODUCTION MANAGER** Frank Ninno, Barb LeClere, Gord Lawrason • **PHOTOGRAPHER** Bill Drummond • **TYPOGRAPHER** John Rodrigues • **DIGITAL RETOUCHER** ReBecca Nixon

BRONZE

CATEGORY Media Promotion • **ADVERTISER/PRODUCT** The Economist • **TITLE** Ignore Obstacles • **ADVERTISING AGENCY** Ogilvy & Mather, Hong Kong • **ACCOUNT EXECUTIVE** Jason Ayers • **CREATIVE DIRECTOR** Annie Wong, Troy Sullivan • **COPYWRITER** Simon Handford, Troy Sullivan • **ART DIRECTOR** Annie Wong • **PRODUCTION MANAGER** Candy Tam

BRONZE

CATEGORY National Campaign • **ADVERTISER/PRODUCT** Deutsche Bahm Medien Gmbh • **TITLE** Steering Wheel • **TITLE** Number Plates • **TITLE** SOS • **ADVERTISING AGENCY** Jung von Matt Werbeagentur GmbH, Hamburg • **PHOTOGRAPHY STUDIO** Hanseatisches Luftbild GmbH • **ACCOUNT EXECUTIVE** Bent Rosinski, Jens Peter Peuckert, Christian Frank • **CREATIVE DIRECTOR** Constantin Kaloff, Ove Gley • **COPYWRITER** Ove Gley, Michael Ohanian • **ART DIRECTOR** Katja Winterhalder, Toygar Bazarkaya • **PHOTOGRAPHER** Kai Uwe Gundlach, Stephan Foersterling

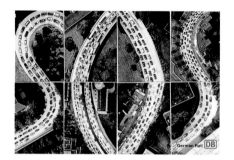

BRONZE

CATEGORY National Campaign • **ADVERTISER/PRODUCT** DaimlerChrysler Canada Inc. (Jeep) • **TITLE** Gas Pump (Sideways) • **TITLE** Parking Meter (Sideways) • **TITLE** Stop Sign (Sideways) • **ADVERTISING AGENCY** BBDO Canada, Toronto • **ACCOUNT EXECUTIVE** Gary King, Brian Jamieson, Erin Iles • **CREATIVE DIRECTOR** Jack Neary, Michael McLaughlin, Mike Smith, Steve Denvir • **COPYWRITER** Michael Clowater • **ART DIRECTOR** John Terry • **PHOTOGRAPHER** Bill Drummond • **PRINT PRODUCTION STUDIO** SGL Studio, Toronto • **TYPOGRAPHER** John Rodrigues • **DIGITAL RETOUCHER** ReBecca Nixon

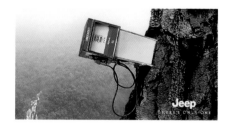
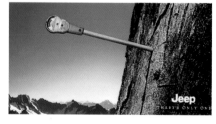
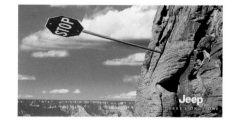

CATEGORY National Campaign • ADVERTISER/PRODUCT Kuoni Reisen AG / Travel Agency • TITLE Left/Right • TITLE This is a Tram • TITLE 1 + 1 = 2 • ADVERTISING AGENCY Advico Young & Rubicam, Zurich-Gockhausen • ACCOUNT EXECUTIVE Stefan Erhart, Anja Breter • CREATIVE DIRECTOR Martin Spillmann • COPYWRITER Peter Rettinghausen • ART DIRECTOR Hélène Forster

BRONZE

CATEGORY National Campaign • ADVERTISER/PRODUCT Terre des Hommes Children's Charity • TITLE Teaser—Barbaric • TITLE Teaser—AIDS • TITLE Teaser—Despair • ADVERTISING AGENCY Springer & Jacoby International, London • ACCOUNT EXECUTIVE Jan Hartzel • CREATIVE DIRECTOR Kurt Georg Dieckert, Stefan Schmidt • COPYWRITER Thomas Chudalla • ART DIRECTOR Tony Hector • ILLUSTRATOR Felix Reidenbach

BRONZE

Innovative Media

GOLD

ADVERTISER/PRODUCT Auckland Regional Council Drains (street media) • **TITLE** Crab • **TITLE** Gannet • **ADVERTISING AGENCY** Saatchi & Saatchi New Zealand, Auckland • **ACCOUNT EXECUTIVE** James Ward • **CREATIVE DIRECTOR** John McCabe • **COPYWRITER** Andy Blood, Andrew Tinning • **ART DIRECTOR** Andy Blood, Andrew Tinning • **ILLUSTRATOR** Ingrid Berzins, Ali Teo • **TYPOGRAPHER** Ingrid Berzins, Ali Teo

GOLD

ADVERTISER/PRODUCT KFM / S.A. Gun Alliance (display) • **TITLE** Gun Vending Machine • **ADVERTISING AGENCY** The Jupiter Drawing Room (South Africa), Cape Town • **ACCOUNT EXECUTIVE** Steyn Laubsher • **CREATIVE DIRECTOR** Ross Chowles • **COPYWRITER** Anton Visser • **ART DIRECTOR** Graham Lang • **PRODUCTION MANAGER** Vanessa Eyden • **PHOTOGRAPHER** Wayne Rochat • **ACCOUNT MANAGER** Charl Nel • **ART BUYER** Vanessa Eyden

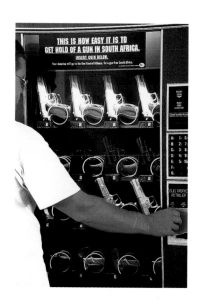

ADVERTISER/PRODUCT The Seattle Show (audio) • TITLE Bob Barrie • TITLE Tracy Wong • TITLE Communication Arts • ADVERTISING AGENCY FCB, Seattle • CREATIVE DIRECTOR Mike Roe, Fred Hammerquist • COPYWRITER Mike Roe • ART DIRECTOR Paul Stechschulte • PRODUCER Mike Roe • RECORDING STUDIO Clatter & Din, Seattle • STUDIO ENGINEER Vince Werner

SILVER

NOTE: A week before the Seattle Show, this voice mail was sent to unsuspecting creatives.

BOB: Good morning! This is Bob Barrie from Fallon. As you may or may not know, I'm the current president of the One Club in New York—the group responsible for the One Show. Anyway, to maintain the integrity of the show, each year we audit the entries. And that's why I'm calling. [RUFFLE PAPERS] I'm looking at your entry here from last year and I have a question about the publication you've listed. Frankly, I've never heard of it. I asked our media director here also and she's never heard of it either. Just so you know, the One Club has a "zero tolerance" for source forgery. And anyone caught falsifying a publication or run date is banned for life. I'm sure it's just an oversight. So please do me a favor. Call my assistant Pam at 206-628-3654 and let's get this thing straightened out. Thanks.

VO: You know, there's a better way to get his attention. It's called the Seattle Show and it's coming December 5th. For tickets, log on to seattleshow.org or call 275-4501.

NOTE: A week before the Seattle Show, this voice mail was sent to unsuspecting creatives.

WHITNEY: Hi. This is Whitney from Communication Arts. And I'm calling to…in regards to your entry for the 2000 Advertising Annual? And, according to our records, the notification confirming your acceptance was never sent. So first, I'd like to apologize. And second, I'd like to congratulate you for being one of the 253 entries selected for this year's Annual. If you give me a call, I'll fax your confirmation…[TO HERSELF] wait a minute? 6-0-2?…oh shit! I'm sorry, this is the wrong number. Please disregard this notification. [HANGS UP]

VO: Heads up, buck-a-roo. You still have a chance to win at this year's Seattle Show. But hurry, the big night is December 5. For tickets, call 275-4501 or log on to seattleshow.org.

NOTE: A week before the Seattle Show, this voice mail was sent to unsuspecting creatives.

TRACY: [THROUGH SPEAKERPHONE] Hey, this is Tracy Wong, I'm on a crappy speakerphone, so sorry about that. Forgive the blind call, but a friend of mine gave me your number. Anyway, we've got a buttload of work here and you come highly recommended. So, I was wondering if we could meet at my house. Say, next Tuesday? And talk about a job. My assistant can give you directions or you can call me direct. We can talk money then too, if you like. Oh, one other thing, I don't know if you bring your own tools or what, but I've got a beat-up Lawn Boy if you want to use it. The pull cord's a little sketchy but it cuts like a champ. By the way, you don't do gutters do you? Anyway, call me. I'm looking forward to meeting you. [HANGS UP]

VO: Here's an idea: attend this year's Seattle Show and get noticed for your other talents. For tickets, log on to seattleshow.org or call 275-4501.

ADVERTISER/PRODUCT Fiona Bennett's Hats (street media) • **TITLE** Beautiful Hats • **ADVERTISING AGENCY** Scholz & Friends Berlin, Berlin • **ACCOUNT EXECUTIVE** Sandra Landgraf • **CREATIVE DIRECTOR** Martin Pross, Joachim Schoepfer • **ART DIRECTOR** Marco Fusz, Meik Heindorf • **PHOTOGRAPHER** Matthias Kosslik

ADVERTISER/PRODUCT Nike (ambient) • **TITLE** Elevator • **TITLE** Railway • **TITLE** Stairs • **ADVERTISING AGENCY** J. Walter Thompson, Mexico City • **ACCOUNT EXECUTIVE** Ivonne Sotres • **CREATIVE DIRECTOR** Carlos Betancourt, Rigoberto Ginés, Alex Vázquez • **COPYWRITER** Rigoberto Ginés • **ART DIRECTOR** Alvaro Zunini • **PHOTOGRAPHER** Miguel Flores, Marco Esperón

ADVERTISER/PRODUCT Norteshopping Summer Sale (ambient) • **TITLE** Sliding Doors • **ADVERTISING AGENCY** Giovanni FCB, Rio de Janeiro • **ACCOUNT EXECUTIVE** Renata Habib • **CREATIVE DIRECTOR** Adilson Xavier, Cristina Amorim • **COPYWRITER** Bruno Pinaud • **ART DIRECTOR** Rodrigo Westin • **PRODUCTION MANAGER** Paulo Moraes • **PHOTOGRAPHER** Daniel Mattar

BRONZE

ADVERTISER/PRODUCT Samsonite Luggages (taxi top) • **TITLE** WorldProof Taxi • **ADVERTISING AGENCY** TBWA, Singapore • **ACCOUNT EXECUTIVE** Dinesh Sandhu • **CREATIVE DIRECTOR** Graham Kelly • **COPYWRITER** Robert Kleman • **ART DIRECTOR** Gregory Yeo • **PRODUCTION MANAGER** Daniel Tay

BRONZE

ADVERTISER/PRODUCT The Economist (ambient) • **TITLE** Know What's Round The Corner • **ADVERTISING AGENCY** Abbott Meads Vickers BBDO, London • **ACCOUNT EXECUTIVE** Vicky Zimmerman • **CREATIVE DIRECTOR** Peter Souter • **COPYWRITER** Mike Nicholson • **ART DIRECTOR** Daryl Corps

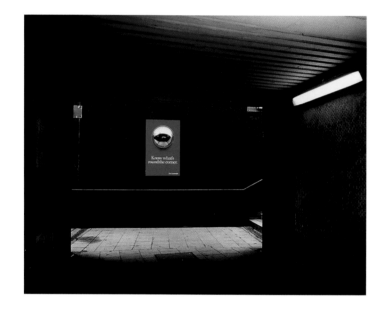

ADVERTISER/PRODUCT Diet Guarana (magazine spine) · **TITLE** Do What Top Models Do · **ADVERTISING AGENCY** DM9 DDB, São Paulo ·
ACCOUNT EXECUTIVE Sergio Brandao · **COPYWRITER** Manir Fadel · **ART DIRECTOR** Mariana Sa · **PRODUCTION MANAGER** Carla Lustosa

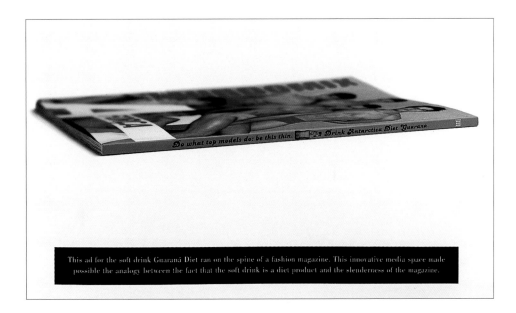

Do what top models do: be this thin. Drink Antarctica Diet Guaraná.

This ad for the soft drink Guaraná Diet ran on the spine of a fashion magazine. This innovative media space made possible the analogy between the fact that the soft drink is a diet product and the slenderness of the magazine.

Radio

BRONZE

CATEGORY Beverages/Alcoholic • **ADVERTISER/PRODUCT** Bud Light • **TITLE** Conversation Land Mine Detector • **ADVERTISING AGENCY** Palmer Jarvis DDB, Toronto • **PRODUCTION COMPANY** Pirate Radio & Television, Toronto • **MUSIC COMPANY** Pirate Radio & Television, Toronto • **SOUND DESIGN COMPANY** Pirate Radio & Television, Toronto • **ACCOUNT EXECUTIVE** Jeff Plowman, Tim Binkley • **CREATIVE DIRECTOR** David Chiavegato, Rich Pryce-Jones, Dan Pawych • **COPYWRITER** David Chiavegato, Rich Pryce-Jones • **MUSIC** Tom Eymundson

VO: It's no secret that the more time you spend in the doghouse with your spouse, the less time you spend with your buddies. And often, men get themselves into trouble without the slightest inclination of the potential consequences. That's why we've developed the Bud Light Conversational Land Mine Detector. At any sign of impending relationship danger, an alarm will sound.
WOMAN: Honey.
MAN: Yes, dear.
WOMAN: Did you miss me when I was gone?
[**SFX:** Warning buzzer.]
VO: Once you hear the alarm, you make an excuse and get out of the room as quickly as possible.
MAN: Damn, I think my kidney just imploded. I've got to go.
VO: Our programmers have spent months ensuring that the widest range of conversational landmines were covered.
WOMAN: Notice anything different?
[**SFX:** Warning buzzer.]

WOMAN: Don't you like my mother?
[**SFX:** Warning buzzer.]
WOMAN: Does this dress make me look fat?
[**SFX:** Warning buzzer.]
WOMAN: What color are my eyes?
[**SFX:** Warning buzzer.]
WOMAN: Do you find my sister attractive?
[**SFX:** Warning buzzer.]
WOMAN: You do know what day it is, don't you?
[**SFX:** Warning buzzer.]
WOMAN: Do you ever think of anyone else when we make love?
[**SFX:** Massive warning buzzer.]
VO: Remember. A healthy relationship leads to more trust, more understanding, and most important, more golf with your friends. Now this calls for a Bud Light.

BRONZE

CATEGORY Dot Com Advertising • **ADVERTISER/PRODUCT** OurHouse.com • **TITLE** Pet • **ADVERTISING AGENCY** Black Rocket, San Francisco • **PRODUCTION COMPANY** Crescendo Studios, San Francisco • **ACCOUNT EXECUTIVE** Joleen McKay • **CREATIVE DIRECTOR** Bob Kerstetter • **COPYWRITER** Stacy Yost

MAN: Hey, honey?
WOMAN: I'm in here, hon.
MAN: You'll never guess what I bought.
WOMAN: What?
MAN: What?
WOMAN: What?
MAN: A kangaroo.
WOMAN: A what?
[**SFX:** Metal door of a pet's cage squeaking open.]
MAN: Come on, it's okay, it's okay. This is your new home. This is my wife.
[**SFX:** House being destroyed: things crashing, breaking. The couple is groaning, falling down and struggling to catch the animal.]
WOMAN: That's my lamp! Put it on a leash! Get a leash.
MAN: No, no, down! Down!
WOMAN: What are you doing?!
MAN: Down boy. Down boy.

[**SFX:** Crashing sounds stop.]
WOMAN: What have you done?
MAN: Bad kangaroo! Bad! Heel!
VO: Tools. Advice. Housecalls. Sanity. Everything you need to fix up your house, or have it done for you. OurHouse.com. We're here to help.
VO 2: Partnered with Ace.

CATEGORY Entertainment Promotion • **ADVERTISER/PRODUCT** Toronto Symphony Orchestra • **TITLE** I'm Afraid of the TSO • **ADVERTISING AGENCY** Pirate Radio & Television, Toronto • **PRODUCTION COMPANY** Lonesome Pine Studios, Toronto • **MUSIC COMPANY** Pirate Radio & Television, Toronto • **SOUND DESIGN COMPANY** Pirate Radio & Television, Toronto • **CREATIVE DIRECTOR** Terry O'Reilly, Tom Eymundson, Kerry Crawford • **COPYWRITER** Terry O'Reilly

[MUSIC: Concerned, emotive.]

VO: Someone, in this city—right now—is facing a fear they can't seem to overcome. Fear…of the Toronto Symphony Orchestra. Take Louise M. of Etobicoke:

LOUISE: I'm afraid of clapping at the wrong time.

VO: A common fear. Does anybody really know when a piece of classical music ends? The answer is no—nobody really knows when a piece of classical music ends. So if in doubt, wait for the rest of the audience to applaud. That way if we're all wrong, we're all wrong together. Gary W. of Weston:

GARY: I once held up my lighter for an encore. I'm afraid that was wrong in hindsight.

VO: Next time, simply stand and applaud at your seat. This universal signal for an encore involves no combustible materials. Richard B. of Mimico:

RICHARD: I'm afraid of Jukka-Pekka Saraste's first name.

VO: You're not alone. Yes, Jukka-Pekka has four K's in his first name. But having Jukka-Pekka as our music director is envied the world over.

Remember, fear of the TSO can be overcome by calling the Roy Thompson Hall Box Office for tickets or log on at tso.on.ca.

The Toronto Symphony Orchestra. You should only be afraid you'll miss it.

SILVER

CATEGORY Entertainment Promotion • ADVERTISER/PRODUCT No. 1 Best Seller Book • TITLE Mark Ellis • ADVERTISING AGENCY Saatchi & Saatchi New Zealand, Auckland • PRODUCTION COMPANY Digital Post, Auckland • ACCOUNT EXECUTIVE Angela Watson • CREATIVE DIRECTOR John McCabe • COPYWRITER Eugen Ruane • PRODUCER Esther Watkins

MARK ELLIS: Listen, I was at a bookstore yesterday. I flicked through it and I'm sorry but I really think it's BLEEP.
If I endorse this, what are people's perceptions gonna be about me? Mark Ellis is dumb, that's what! It has no wit. It has no style. No ideas. It's dull. Not to put too fine a point on it mate, it's absolutely BLEEPING BLEEP.
Sorry, but if I go on radio and say this is a great book I'd be shafting myself. See you!
[SFX: Door slams.]
MALE VOICE: Well that doesn't give us much to work with. D'you reckon you can you do anything with it?
MALE VOICE 2: Well I'll give it a go but it won't be easy...now let's see...
...OK...can't do anything more, have a listen to this.
MARK ELLIS: I really think it's shi-fting people's perceptions. It has-wit, it has-style. It's absolutely fu-ll of-fine-ideas. Not to put too fine a point on it, I endorse this-I endorse this. I go on radio and say this is a great book. See you-at the bookstore.
VO: The Number One Best Seller by Mike Hutcheson. In bookshops now.

CATEGORY Public Service • ADVERTISER/PRODUCT United Way • TITLE 911 • ADVERTISING AGENCY The STAR Group, Cherry Hill • PRODUCTION COMPANY Mackenzie Cutler, New York • SOUND DESIGN COMPANY Bang, New York • CREATIVE DIRECTOR Rick Ender • COPYWRITER Rick Ender

KEVIN BACON: This is an actual 911 call.
[SFX: Phone ringing through filter.]
911 OPERATOR: Emergency.
LITTLE GIRL: My mommy and daddy are having a fight.
911 OPERATOR: Is he hitting her?
LITTLE GIRL: They always have this because he's always coming in he's always drinking and getting drunk. My daddy's a drunk.
911 OPERATOR: Does he have any weapons?
LITTLE GIRL: No, but he's hurting mommy.
911 OPERATOR: How is he hurting her?
LITTLE GIRL: He made some red marks on mommy's neck. He just slapped mommy! Stop it! Don't hurt the baby! Stop it! They're arguing! Ohhhhh! Oh my God!
911 OPERATOR: What's the matter?
LITTLE GIRL: Something happened. Just please send the police!
[SFX: Dial tone as phone goes dead.]
KEVIN BACON: Every year, 911 operators answer thousands of calls for help. And every day United Way agencies hear the same calls for help. And yet, we can't always answer. Now that you've heard the call, what are you going to do? Dial 215-665-GIVE or are you going to do what most people do and just look the other way?

CATEGORY Local Campaign • **ADVERTISER/PRODUCT** Sunday Tribune Newspaper • **TITLE** Mark Banks: FIFA • **TITLE** Mark Banks: Alfred Cache (Maradonna) • **TITLE** Mark Banks: Smoking • **TITLE** Mark Banks: Olympics • **TITLE** Mark Banks: Queen • **TITLE** Mark Banks: US Dept. of Justice • **ADVERTISING AGENCY** FCB Durban, Umhlanga Rocks • **PRODUCTION COMPANY** Sterling Sound, Johannesburg • **ACCOUNT EXECUTIVE** Ingrid Hall • **CREATIVE DIRECTOR** Lynton Heath, Michael Bond • **COPYWRITER** Lynton Heath • **PRODUCER** Hazel Bartlett

GOLD

[**SFX**: Phone rings.]
SETH BLATTER: Yes.
MARK BANKS: Mr Seth Blatter?
SETH BLATTER: Yes, that's me.
MARK BANKS: It's Mark Banks phoning from the Sunday Tribune in South Africa. How are you today?
SETH BLATTER: I'm fine and you?
MARK BANKS: Well we're all a bit miserable as you know. We still haven't got over not winning the World Cup bid, as I am sure millions and millions of people have written and told you. Our expectations were so high here in South Africa—we had all the balloons and the flags and the posters and the billboards and the buses and the outdoor hoardings and the television advertisements and all the catering awards had been awarded, airplane routes had been diverted for all the different games. Then came that fateful day when we heard the word "Deutchland." Do you think it should have gone to South Africa personally?
SETH BLATTER: Absolutely, absolutely. You know my support for this continent is still ongoing.
MARK BANKS: Do you think there was much bribery and corruption?
SETH BLATTER: No, I would put my hand into boiling oil or into a fire or all of that.
MARK BANKS: Boiling oil or fire?
SETH BLATTER: Or fire, ja.
MARK BANKS: So you think we will see it in 2010?
SETH BLATTER: I am sure. I can say I love you all.
MARK BANKS: Thank you very much Mr. Joseph Seth Blatter, President of Federation of International Football Association.
SETH BLATTER: Thank you, goodbye.
VO: The Sunday Tribune—We bring the news home.

SYNOPSIS: Mark Banks from the Sunday Tribune in Durban, South Africa, calls a representative of Diego Maradonna to inquire about his health. The dialogue is spoken in Spanish, and is left untranslated for the listener.
SWITCHBOARD: Buenos dias.
MARK BANKS: It's Mark Banks calling from the Sunday Tribune newspaper, Durban, South Africa. I wondered if it's possible to speak to Alfred Cache.
SWITCHBOARD/MARK BANKS: Spanish exchange…
VO: Sunday Tribune, we bring the news home.

[**SFX**: Phone rings.]
PROFESSOR DAYNARD: Hello.
MARK BANKS: Hello, is that Professor Daynard?
PROFESSOR DAYNARD: It is.
MARK BANKS: America's leading anti-tobacco activist?
PROFESSOR DAYNARD: Yes.
MARK BANKS: It's Mark Banks phoning from the Sunday Tribune newspaper, Durban, South Africa.
[**SFX**: Professor Daynard coughs.]
MARK BANKS: Was that a smoker's cough?
PROFESSOR DAYNARD: That was a cough, not a smoker's cough.
MARK BANKS: Oh, not a smoker's cough. Do you see the tobacco industry being completely outlawed in the United States?
PROFESSOR DAYNARD: Well, I think that is unlikely because we have 40 to 50 million Americans who are hooked on their product.
MARK BANKS: I don't know if you are aware but in South Africa we had draconian anti-smoking laws brought in by our erstwhile Minister of Health, Dr. Zuma—an African Madeleine Albright.
PROFESSOR DAYNARD: Draconian means effective.
MARK BANKS: Draconian means the only place you could smoke in South Africa would be Madagascar.
PROFESSOR DAYNARD: Ah, ha.
MARK BANKS: You see, here in this country we do nothing about drive-by shootings, for instance, but we have laws against smokers.
PROFESSOR DAYNARD: Yes.
MARK BANKS: And I think most of the people who are shot in drive-by shootings are people who have gone outside to have a cigarette.
PROFESSOR DAYNARD: I'd be interested to see the statistics for drive-by shootings of people who have gone out to have a cigarette.
[**SFX**: Professor Daynard coughs.]
MARK BANKS: Oh, so you are a complete nonsmoker?
PROFESSOR DAYNARD: Uh, yes, that's right, essentially yes.
MARK BANKS: Thank you very much Professor Daynard.
PROFESSOR DAYNARD: Sure, bye.
MARK BANKS: All the best, goodbye.
VO: The Sunday Tribune—We bring the news home.

MILTON COBORN: General Manager Media.

MARK BANKS: Hello, is that Milton Coborn?

MILTON COBORN: Yes.

MARK BANKS: My name is Mark Banks. I am phoning from the Sunday Tribune, Durban, South Africa. I believe you are spokesperson for the sharks in Sydney Harbour.

MILTON COBORN: Amongst other things I am.

MARK BANKS: Apparently the triathletes for the Olympics will be swimming in Sydney Harbour.

MILTON COBORN: OK, as a precaution we will have divers in the water with electronic shark pods which are designed to repel sharks.

MARK BANKS: Right, and one of the things we are told here to avoid shark attacks is to not swim like a seal. So I think anyone who does swim like a seal should be eaten by a shark, quite honestly.

MILTON COBORN: Exactly, yes.

MARK BANKS: And this is the biggest media contingency ever in the history of the Olympics.

MILTON COBORN: Yes, around about 17,000—1.7 media representatives for every athlete.

MARK BANKS: And which country's media do you find the worst, the absolute dog pigs of media?

MILTON COBORN: That's easy, the Australians.

MARK BANKS: Wonderful, thank you very much for your time, Milton.

MILTON COBORN: Pleasure, bye.

VO: The Sunday Tribune—We bring the news home.

SWITCHBOARD: Good morning, Hardy Ames.

MARK BANKS: It's Mark Banks calling from the Sunday Tribune newspaper, Durban, South Africa. I wondered if it's possible to speak to Mr. Hardy Ames.

SWITCHBOARD: I can possibly put you through to his PR man.

STEVEN LUMLY: Steven Lumly.

MARK BANKS: It's Mark Banks calling from the Sunday Tribune. We've just had the news here about the queen having won the world's worst-dressed woman.

STEVEN LUMLY: Yes—Sir Hardy will not comment about any kind, whether it's the Queen or anybody else—far too common and vulgar.

MARK BANKS: So you don't think we will be seeing the way the queen dresses changing.

STEVEN LUMLY: Not from remarks from some qualified idiot. People want to make remarks like that are just ill-mannered. So you can tell Mr. Blackwell to xxx himself. That's from me, not from Mr. Hardy.

MARK BANKS: Thank you very much. Thank you for your time.

STEVEN LUMLY: Goodbye.

VO: The Sunday Tribune—We bring the news home.

SWITCHBOARD: Good morning, Department of Justice, Operator 51, how may I direct your call?

MARK BANKS: May I speak to a spokesperson for Janet Reno?

SWITCHBOARD: Hold on one second.

MARK BANKS: Thank you very much.

SPOKESPERSON: Hi, this is Carol.

MARK BANKS: It's Mark Banks calling from the Sunday Tribune, Durban, South Africa.

SPOKESPERSON: Yes.

MARK BANKS: Speaking on behalf of the U.S. Justice Department, what is the current situation in the Elian Gonzalez case?

SPOKESPERSON: We feel that it is proper for the child to be with his father, that both from an international law perspective and common sense about the deep bonds between a child and a parent.

MARK BANKS: And of course emotionally it's got all the elements there with the child and the parents, the dead mother—the only thing missing is a bicycle and Steven Spielberg to turn it into a new Paramount Pictures blockbuster.

MARK BANKS: Thank you very much, Carol.

SPOKESPERSON: You're very welcome. Bye.

VO: The Sunday Tribune—We bring the news home.

CATEGORY Local Campaign • **ADVERTISER/PRODUCT** Toronto Symphony Orchestra • **TITLE** I'm Afraid Of The TSO • **TITLE** Monetary Fine • **TITLE** Go Gownless • **ADVERTISING AGENCY** Pirate Radio & Television, Toronto • **PRODUCTION COMPANY** Lonesome Pine Studios, Toronto • **MUSIC COMPANY** Pirate Radio & Television, Toronto • **SOUND DESIGN COMPANY** Pirate Radio & Television, Toronto • **CREATIVE DIRECTOR** Terry O'Reilly, Tom Eymundson, Kerry Crawford • **COPYWRITER** Terry O'Reilly

[MUSIC: Concerned, emotive.]

VO: Someone, in this city—right now—is facing a fear they can't seem to overcome. Fear…of the Toronto Symphony Orchestra. Take Louise M. of Etobicoke…

LOUISE: I'm afraid of clapping at the wrong time.

VO: A common fear. Does anybody really know when a piece of classical music ends? The answer is no—nobody really knows when a piece of classical music ends. So if in doubt, wait for the rest of the audience to applaud. That way if we're all wrong, we're all wrong together. Gary W. of Weston…

GARY: I once held up my lighter for an encore. I'm afraid that was wrong in hindsight.

VO: Next time, simply stand and applaud at your seat. This universal signal for an encore involves no combustible materials. Richard B. of Mimico…

RICHARD: I'm afraid of Jukka-Pekka Saraste's first name.

VO: You're not alone. Yes, Jukka-Pekka has four K's in his first name. But having Jukka-Pekka as our music director is envied the world over.

Remember, fear of the TSO can be overcome, by calling the Roy Thompson Hall Box Office for tickets or log on at tso.on.ca.

The Toronto Symphony Orchestra. You should only be afraid you'll miss it.

[MUSIC: Concerned, emotive.]

VO: Someone, in this city—right now—is facing a fear they can't seem to overcome. Fear…of the Toronto Symphony Orchestra. Take Mrs. Sylvia H. of Mineola…

SYLVIA: I don't own a $500 strapless evening gown.

VO: I do. But I don't feel compelled to wear it, because formal attire is not required at the TSO. Wear whatever you feel comfortable in. For tickets, call the Roy Thompson Hall Box Office or log on at tso.on.ca.

The Toronto Symphony Orchestra. You should only be afraid you'll miss it.

[MUSIC: Concerned, emotive.]

VO: Someone, in this city—right now—is facing a fear they can't seem to overcome. Fear…of the Toronto Symphony Orchestra. Take Walter S. of Toronto…

WALTER: I'm afraid I'll mispronounce Wagner. Or Shostakovich.

VO: Shostakovich.

WALTER: Him, too!

VO: Don't let this stop you from seeing the TSO. And if you do mispronounce a composer's name, you'll only have to pay a small monetary fine. We're kidding. We don't do that. Anymore.

Call the Roy Thompson Box Office for tickets.

The Toronto Symphony Orchestra. You should only be afraid you'll miss it.

CATEGORY National Campaign • **ADVERTISER/PRODUCT** Jiffy Lube • **TITLE** Nutcracker • **TITLE** William Tell • **TITLE** Blue Danube • **ADVERTISING AGENCY** The Richards Group, Dallas • **PRODUCTION COMPANY** charlieuniformtango, Dallas • **CREATIVE DIRECTOR** Ron Henderson • **COPYWRITER** Ron Henderson • **AUDIO ENGINEER** Russel Smith

[MUSIC: Symphony performance of the Nutcracker's "Dance of the Reed Flutes." After a few stanzas, an average guy begins to talk/sing made-up lyrics to the music.]
GUY: I wish I had gone to Jiffy Lube, 'cuz I don't like hitching rides with motley dudes.
Now I'm in a pasture, freezing off my keester.
Looking at my engine that is smoking and convulsing while I'm talking on my cell phone with my shoes in cow manure and oh…
I wish I had gone to Jiffy Lube—then I wouldn't feel like a gigantic boob.
It's not like the others, run by deadbeat brothers.
They have trained technicians with diplomas on the wall.
Signature Service at Jiffy Lube, oils and lubes most everything except your hair.
Complete care for your auto, the whole enchilada.
Wish I'd gone each three thousand miles.
VO: Jiffy Lube Signature Service. Does your car get it?

[MUSIC: Symphony performance of "Blue Danube." After a few stanzas, an average guy begins to talk/sing made-up lyrics to music.]
GUY: I'm in my car…with no AC.
I'm sweating like…a pig in heat.
I wish I'd gone…to Jiffy Lube.
They don't just do oil, they do air…with leak checks, charge, and refrigerant.
Getting hotter, where's a doctor?
Now my belt buckle's branded me just below my navel.
Give me…iced tea…Jiffy…
VO: Get your AC checked and serviced at Jiffy Lube. Does your car get it?

[MUSIC: Symphony performance of the "William Tell Overture." After a few stanzas, an average guy begins to talk/sing made-up lyrics to the music.]
GUY: I need some oil…and a wiper blade.
It's raining dogs, and I can't see straight.
To Jiffy Lube…I should have gone.
I have the IQ of a prawn.
There's mud on my windshield.
I think I'm in a field.
My legs feel like rubber.
Tell my wife I love her.
Jiffy Lube…Jiffy Lube.
What a dope, what a dope…I am.
What a drag, what a drag…this is.
I did not get their Signature Service.
They change your oil…and wipers too.
They just won't trim…your Fu Manchu.
VO: Jiffy Lube Signature Service. Does your car get it?

BRONZE

CATEGORY National Campaign • **ADVERTISER/PRODUCT** American Legacy Foundation • **TITLE** Rip it Out—This Is For • **TITLE** Rip It Out—Sound • **ADVERTISING AGENCY** ARNOLD Worldwide, Boston • **MUSIC COMPANY** Bart Better Radio • **ACCOUNT EXECUTIVE** Libby Cesarz, Azurae • **CHIEF CREATIVE OFFICER** Ron Lawner • **GROUP CREATIVE DIRECTOR** Pete Favat, Alex Bogusky • **CREATIVE DIRECTOR** Roger Baldacci • **COPYWRITER** Chris Edwards • **AGENCY PRODUCER** Brian Sweeney

[SFX: Sounds of pages being ripped out of magazines throughout.]
ETHAN: This is for putting stuff in cigarettes that make them more addictive.
D'ANNE: This is for making a product that kills 1,200 people a day.
RYAN: This is for sticking me with a habit that costs me 40 bucks a week.
KARA: This is for hooking my little brother.
RANDY: This is for taking 7 years off my life.
ALEX: This is for actually creating the need for a nicotine patch.
RYAN: I don't know, I just like ripping stuff.
JOEL: This is for the 7 people who'll die from your product by the time this commercial is over.
LEVON: This is for saying, "Today's teenager is tomorrow's potential regular customer."
WHITNEY: This is for the billions of dollars you make off smoking each year.
ETHAN: This is for the 430,000 people who die from smoking each year.
IAN: This…is for my mother.
[MUSIC: Hip beat.]
ALEX: Next time you see a cigarette ad, rip it out. Who knows, maybe if there were fewer cigarette ads, there'd be fewer cigarette deaths. For more about "Rip It Out," check out thetruth.com.
JOEL: This has been a "rip it out" reminder from truth.
ALEX: Please practice safe ripping. Only rip out ads from magazines that are yours. Thank you.

[SFX: Ripping noise.]
JOEL: That's the sound of a cigarette ad being ripped out of a magazine.
[SFX: Ripping noise.]
KARA: That's the sound of a tobacco executive screaming because $50,000 worth of his advertising just got wasted.
[SFX: Ripping noise.]
LARRY: That's the sound of a tobacco executive stressing out because fewer people are taking up smoking.
[SFX: Ripping noise.]
GARETH: That's the sound of a tobacco executive getting reamed because profits are way down.
[SFX: Ripping noise.]
D'ANNE: That's the sound of a tobacco executive putting a "For Sale" sign in front of his house.
[SFX: Ripping noise.]
KARA: That's the sound of a tobacco executive finding a new job.
[SFX: Ripping noise.]
RANDY: That's the sound of a life being saved.
[MUSIC: Hip beat.]
ALEX: Rip out the next tobacco ad you see. Because maybe fewer cigarette ads will lead to fewer cigarette deaths. For more about "Rip It Out," check out thetruth.com.
JOEL: This has been a "rip it out" reminder from truth.
ALEX: Please practice safe ripping. Only rip out ads from magazines that are yours. Thank you.

CATEGORY National Campaign • **ADVERTISER/PRODUCT** Wideyes • **TITLE** Pilot—Meteorologist • **TITLE** Customer Services—Radio DJ • **TITLE** Rock Star—Psychiatrist • **ADVERTISING AGENCY** Sexton 87 Ogilvy, Stockholm • **PRODUCTION COMPANY** Pettersson Åkerlund, Stockholm • **ACCOUNT EXECUTIVE** Louice Alvarson • **CREATIVE DIRECTOR** Lars Arrid Boisen • **COPYWRITER** Per Grarenius • **ACCOUNT DIRECTOR** Aje Stenbeck • **ART DIRECTOR** Martin Osterqren • **PRODUCER** Nils Jorgen Kittelsen • **DIRECTOR** Mats Stenberg

BRONZE

CAPTAIN: Good afternoon, this is Captain Torstensson speaking. Welcome on board Flight 737 to London, Heathrow. Right now, we are cruising at an altitude of 30,000 feet and the temperature outside is—49 degrees. The wind is westerly and will strengthen during the day, causing gusts along the coast, while conditions will clear inland later in the day and temperatures will drop to between 50 and 60 degrees Fahrenheit. Not exactly summer weather, I'm afraid.
VO: Do you have a hidden talent? Wideyes is a recruitment company that matches people's need for challenges with companies' need of talent. Visit us at wideyes.se.

ROCK STAR: Thank you! It's great being back in Tulsaaaaaa! All right…Do you feel good? I can't hear you! Do you feel good? Are you sure? Everything's all right, there's no worries, nothing you want to talk about, nothing to get out in the open, nothing that's niggling away? We'll take you, you there, how are you doing? That thing about your mother, it doesn't bother you? Just lie down on the couch…try to relax…and think about the first time…you saw your father…naked…
VO: Do you have a hidden talent? Wideyes is a recruitment company that matches people's need for challenges with companies' need of talent. Visit us at wideyes.se.

CUSTOMER SERVICE REP: A message from customer services. Could the parents of Elin Gustavsson, four years old, please come and collect their daughter, Elin Gustavsson, at the reception desk. Elin? Do you want to say something to your mummy and daddy? Okay…moving on to question number two. What is oval and runs by itself? Do we have a caller on the line? Not yet…we'll play a song in the meantime. A real fall ballad for all of you out there.
VO: Do you have a hidden talent? Wideyes is a recruitment company that matches people's need for challenges with companies' need of talent. Visit us at wideyes.se.

Integrated Media

ADVERTISER/PRODUCT Diesel S.P.A Jeans & Workwear • **TV/CINEMA TITLE** It's Real—Joanna • **PRINT TITLE** It's Real—Shoes Off • **PRINT TITLE** It's Real—Improved Body • **PRINT TITLE** It's Real—Toilet • **PRINT TITLE** It's Real—Dirty Country Girl • **ADVERTISING AGENCY** Paradiset DDB, Stockholm • **PRODUCTION COMPANY** Milkyway, Stockholm; Trigger Happy Productions, Berlin • **PHOTOGRAPHY STUDIO** Peter Gehrke, Stockholm; Magnus Klackenstam, Stockholm • **ACCOUNT EXECUTIVE** Stefan Öström • **CREATIVE DIRECTOR** Joakim Jonason • **COPYWRITER** Björn Rietz • **ART DIRECTOR** Tove Langseth • **DIRECTOR** Jhoan Camitz • **PHOTOGRAPHER** Peter Gehrke • **ACCOUNT MANAGER** Anna Magnusson • **ART WORK** Patrik Andersson, Camilla Brindfors • **FILM PRODUCTION MANAGER** Martin Persson • **PRINT PRODUCTION MANAGER** Sanna Wallenstierna

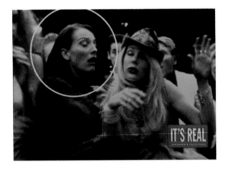

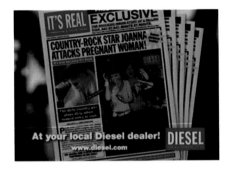

REPORTER VO: Country-rock star Joanna's terror outside nightclub.
VISUAL: Joanna walks down crowded red carpet to club entrance.
BOUNCER: I can't let you in with these clothes.
JOANNA: What, this?
VISUAL: Bouncer pushes Joanna into woman behind her.
REPORTER VO: Attacking a pregnant woman!
SUPER: Country-rock star Joanna attacks pregnant woman!
PREGNANT WOMAN: She just attacked me!
BOUNCER: She was wearing dirty clothes.
REPORTER VO: Join us as we find out more about Joanna's dirty past.
VISUAL: Reporter stands in city square.
REPORTER: Joanna's homeland.
VISUAL: Reporter stands among pigs on a farm.
REPORTER: This...could be where Joanna was brought up.
VISUAL: Reporter inteviews a few men outside pub.
SUPER: Joanna's Father.

REPORTER: Isn't Joanna a disgrace to your family?
VISUAL: Reporter hands the father a beer.
JOANNA'S FATHER: Tak!
REPORTER: And "tak" means yes.
VISUAL: Reporter at Joanna's ex-boyfriend's house.
REPORTER: Is your son home?
EX-BOYFRIEND'S MOTHER: Come in! Come in!
SUPER: Joanna's Ex-Boyfriend.
EX-BOYFRIEND: She seemed like a dog…
REPORTER: Filthy?
EX-BOYFRIEND: Yes, yes.
VISUAL: Reporter and assistants searching a room in the dark.
SUPER: Joanna's Childhood Home.
REPORTER: We are searching for her diary.
VISUAL: Reporter points his flashlight on Joanna's sleeping mother.
REPORTER: This is Joanna's mother.
ASSISTANT: I found it!

VISUAL: Mother wakes up and screams. The men sneak out the window.
SUPER: It's Real. Tomorrow's Truth Today. London.
VISUAL: Reporter chases Joanna down the street.
SUPER: St. Tropez.
VISUAL: Reporter hanging on fence outside Joanna's home. His assistants take pictures of the scantily-clad Joanna in her backyard.
SUPER: Paris.
VISUAL: Joanna opens door to her hotel room. The reporter shows her the pictures he took at St. Tropez.
REPORTER: And this woman here…
VISUAL: Joanna slaps reporter.
JOANNA: Get out! Why don't you just leave me alone!
REPORTER VO: The shocking story of a falling star, only in It's Real magazine!
SUPER: At your local Diesel dealer. Diesel. www.diesel.com.

ADVERTISER/PRODUCT NADACE—Foundation for Bone Marrow Transplantation • **TV/CINEMA TITLE** House • **TV/CINEMA TITLE** Dog • **TV/CINEMA TITLE** Cat • **PRINT TITLE** Wanted—someone to care for my home and family • **PRINT TITLE** Free—husband in excellent condition • **PRINT TITLE** Kitten—good with children, needs loving home • **RADIO TITLE** Piano • **ADVERTISING AGENCY** Leo Burnett Advertising, Prague • **PRODUCTION COMPANY** Still King, Prague • **EDITING COMPANY** Avid Edit S.R.O., Prague • **SOUND DESIGN COMPANY** Cinema Sound, Prague • **PHOTOGRAPHY STUDIO** Petr Skvrne, Prague • **ACCOUNT EXECUTIVE** Mila Knepr • **CREATIVE DIRECTOR** Bill Stone • **COPYWRITER** Martin Charvat • **ART DIRECTOR** Jiri Langpaul • **DIRECTOR:** Ivan Zacharias • **PRODUCER** Premysl Grepl • **PRODUCTION STUDIO** Leo Burnett, Prague

SILVER

OFFSCREEN VOICE: This is the house, solid brick, new roof, has a big garden and a side entrance through the porch. This is the hallway. Upstairs there's a study, downstairs is the bedroom, kitchen, and finally the living room. With fireplace.
You can have it all for free. If I can't find a bone marrow donor.

OFFSCREEN VOICE: So this is Sarah, our German shepherd, she's five months old. She eats pretty much everything, but pig ears are her favourite. Sarah will get used to you, I'm sure. If I can't find a bone marrow donor.

OFFSCREEN VOICE: This is my Micka. She is not a very good mouse catcher, but she is very friendly. She loves our porch, but she'll get used to yours. If I can't find a bone marrow donor.

[MUSIC: Melancholic preludizing on the piano.]
FEMALE VO: This piano you are hearing, I got it from my grandfather when I was five.
So, it's been mine…well…for the past twenty-four years.
I spent a lot of hours on it, but I never became a concert pianist.
[MUSIC: One tone sounds a little flat.]
FEMALE VO: Hmm…it needs a little tuning.
I don't need it anymore, so, if you are interested… it's yours. For free.
[MUSIC: Silence.]
FEMALE VO: They have not found a bone marrow donor for me yet.
MALE VO: If you want to help, call 02/510 20 510.

ADVERTISER/PRODUCT Courtyard by Marriott • TV/CINEMA TITLE Lunch • TV/CINEMA TITLE Ticket • TV/CINEMA TITLE Thespian • PRINT TITLE Women's Bathroom • RADIO TITLE Captain • ADVERTISING AGENCY Lowe Lintas & Partners, New York • PRODUCTION COMPANY @radical.media, New York; McHale Barone, New York • EDITING COMPANY Mackenzie Cutler, New York • ACCOUNT EXECUTIVE Peter Hempel, EVP/General Manager, Account Management • CREATIVE DIRECTOR Lee Garfinkel, Chairman/CEO/CCO; Gary Goldsmith, Chairman/CCO; Dean Hacohen, EVP/CD; Steven Hanratty, VP/Creative Group Head; Ralph Yznaga, VP/Creative Group Head • COPYWRITER Steven Hanratty, VP/Creative Group Head; Michael Polovsky; Leo Shin • ART DIRECTOR Ralph Yznaga, VP/Creative Group Head; Leo Shin • DIRECTOR Lenard Dorfman • EDITOR Gavin Cutler • CINEMATOGRAPHER Tony Wolberg • AUDIO ENGINEER Tim Leitner • SENIOR AGENCY PRODUCER Rikki Furman • AGENCY PRINT PRODUCER Linda Pino

BRONZE

VISUAL: A typical American diner at lunchtime. A businessman gazes blankly at his lunch. He picks up a fry and absent-mindedly examines it. He decides that this limp platter of fries needs ketchup. He picks up the bottle and shakes it, unknowingly spraying the shirt of the woman sitting behind him. Before he puts the ketchup on his fries, he notices that the cap is off. He shrugs and carries on.
Everyone is oblivious to the mess on the back of the woman's shirt, including the woman herself.
SUPER: Never underestimate the importance of getting enough rest.
Courtyard by Marriott. The hotel designed by business travelers.

VISUAL: The passenger cabin of an airplane. The plane has not taken off yet. The passengers are getting settled in their seats.
[SFX: Intercom bell sounds.]
CAPTAIN: Good morning, everybody. This is your captain speaking. We'll soon be flying non-stop to Tampa. So just sit back, relax, and enjoy the flight.
VISUAL: A passenger looks at his ticket. He realizes he's on the wrong flight. He gathers his things and runs down the aisle to get off the plane.
SUPER: Never underestimate the importance of getting enough rest.
Courtyard by Marriott. The hotel designed by business travelers.

VISUAL: An actor is delivering a moving speech to an audience in a theater. However, the spotlight is aimed on a different part of the stage.
ACTOR: And all our yesterdays have lighted fools the way to dusty death.
Out, out brief candle! Life is but a walking shadow, a poor player that struts and frets his hour upon the stage and then is heard no more.
It is a tale told by…
VISUAL: The spotlight operator suddenly realizes his mistake and swings the spotlight on the actor, causing him to stutter momentarily.
ACTOR: …An idiot!
Full of sound and fury, signifying nothing.
SUPER: Never underestimate the importance of getting enough rest.
Courtyard by Marriott. The hotel designed by business travelers.

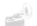

CAPTAIN: Good morning, everybody. This is your captain speaking. We're flying from New York to Tampa today. We'll soon be climbing to 3,000 feet. So just sit back, relax and enjoy the flight.
[SFX: Intercom bell sounds.]
CAPTAIN: It's not 3,000 feet we'll be climbing to, but 30,000. Sorry for the mix-up.
[SFX: Intercom bell sounds.]
CAPTAIN: Uh, captain again. Did I mention that we're going to Chicago, not Tampa?
[SFX: Intercom bell sounds.]
CAPTAIN: I said Chicago, right?
CAVETT: Never underestimate the importance of getting enough rest. That's why when you stay at a Courtyard by Marriott, you'll have an entire range of amenities, everything you could need to relax and prepare for the day ahead. Courtyard by Marriott. The hotel designed by business travelers. For reservations, call your travel agent or visit courtyard.com.

Interactive Advertising

BRONZE

CATEGORY Banner Ads 15K and Under • **ADVERTISER/PRODUCT** Hewlett-Packard • **NAME OF SITE** Invent Campaign • **ADVERTISING AGENCY** Freestyle Interactive, San Francisco, in partnership with Goodby, Silverstein & Partners, San Francisco • **CREATIVE DIRECTOR** Mike Yapp, Steve Simpson • **COPYWRITER** John Matejczyk • **ART DIRECTOR** Regan Honda, Rick Casteel, Jeff Benjamin • **PRODUCER** Danaa Zellers • **EXECUTIVE PRODUCER** Kim Askew • **ACCOUNT MANAGER** John Glander, Christina Blosser • **ENGINEERING LEAD** Keith Neil • **ENGINEER** Mike Jones

A branding campaign created to promote the HP tagline: INVENT. The banners allow users to create and discover interactively within the context of two separate banner spaces: One simulating the revisable flight pattern of a paper airplane; the other depicting a mathematical equation with changing variables.

CATEGORY Brand Building • ADVERTISER/PRODUCT Siemens SL45 Mobile Phone • NAME OF SITE Siemens SL45 • WEB DEVELOPER
Deepend, Sydney • ADVERTISING AGENCY J. Walter Thompson, Sydney • ACCOUNT EXECUTIVE Kate Theakston • CREATIVE DIRECTOR
Ashleigh Bolland • DESIGNER Ashleigh Bolland • PROGRAMMER Silas Rowe, Ashleigh Bolland • SOUND DESIGNER Robert St. Clair •
ILLUSTRATOR Leon Rosenburg • GAMES DEVELOPER Silas Rowe

GOLD

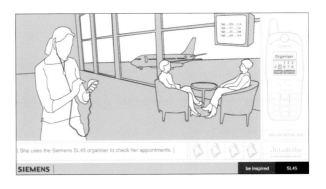

A product design microsite conceived to reposition the Siemens brand as a technology innovator through the launching of its SL45 mobile phone.

GOLD

CATEGORY Brand Building • ADVERTISER/PRODUCT Aamer Taher Design Studio • NAME OF SITE Narrative Spaces • WEB DEVELOPER Kinetic Interactive, Singapore • ADVERTISING AGENCY Kinetic Interactive, Singapore • ACCOUNT EXECUTIVE Elaine Tay • CREATIVE DIRECTOR Benjy Choo • COPYWRITER Benjy Choo, Aamer Taher • ART DIRECTOR Benjy Choo • DESIGNER Benjy Choo • PROGRAMMER Benjy Choo

A site that communicates the Aamer Taher Design Studio's belief that architecture evokes emotion, by inviting visitors to view areas that illustrate how the usage of space can convey an understanding of one's habitat.

GOLD

CATEGORY Brand Building • ADVERTISER/PRODUCT Nike • NAME OF SITE The World Body • WEB DEVELOPER Blast Radius, Vancouver • CREATIVE DIRECTOR Jon Maltby • DESIGNER Francis Chan, Skilla • SENIOR PRODUCER Emily Brew • PRODUCER Ean Lensch, Barry Locke, Chris Rowell • CHIEF CREATIVE OFFICER Lee Feldman • SENIOR PROJECT MANAGER Rani MacInnes • LEAD DESIGNER Matthew Willis, Arnaud Mercier • TECHNICAL ARCHITECT Terrance Yu • PRODUCTION ASSISTANT Curt Ahlschlager, Dan Manuszak • SENIOR WRITER Neil Webster • ASSISTANT PRODUCER Mary Milstead • WEB MISTRESS Kristen Boden-Mackay • DESIGN & PRODUCTION Svea Sjober, Graeme Dimmick, Cory Christians, Kelly Hale, SoYoun Kim, Mikki Oyama, Kemp Attwood, Dana Brouesseau, Jade McClure, Brent Hopkins • USER EXPERIENCE TEAM Jen Hanson, Karla Kosowan • PRODUCTION COORDINATOR Arch Archbold • SYSTEM ANALYST Erin Cooper, Anne Yeo • SENIOR ADVISOR Michael Dingle • IT SUPPORT Shad Stafford, Tracey Snoyer • DEVELOPER Alexei Potiagalov, Sang Park, Richard Tang, Ryan Klak, Nathan Paziuk, Gord Webster, Ryan Lai, Mike Lee, Chad Lascelles, Darren Pirang, Bart Millar, Shaun Krislock, Sunder Rajan, Taz • DIRECTOR, CONTENT DEVELOPMENT AND STRATEGIC COMMUNICATIONS Keith Peters

This site announces Nike's presence at the Sydney Olympics. The World Body speaks about the athletes as people as opposed to super-humans. The site defines special Olympic moments of forty-four athletes, and refers to the Nike products those individuals used during competition.

CATEGORY Brand Building • ADVERTISER/PRODUCT Volkswagen of America Inc. • NAME OF SITE vw.com/autoshow2001 • ADVERTISING AGENCY ARNOLD Worldwide, Boston • ACCOUNT EXECUTIVE Cindy Lovell, Emily D'Entremont • CREATIVE DIRECTOR Tim Brunelle, Chris Bradley • COPYWRITER Tim Brunelle, Alex Russell • ART DIRECTOR Chris Bradley, Adele Ellis • DESIGNER Nicole McDonald, Rick Webb, Joe Cartman, Heavy Industries • PROGRAMMER Rick Webb, Seranova Inc. • PRODUCER Jennifer Bruns, Ken Kingdon • CHIEF CREATIVE OFFICER Ron Lawner • GROUP CREATIVE DIRECTOR Alan Pafenbach • TECHNICAL DIRECTOR Jonathan Groves • SENIOR PRODUCER Jennifer Iwanicki • ASSISTANT PRODUCER Erica Lohnes • PRODUCTION ARTIST Rick Webb, Redtree Interactive, Mark Kraus, Matt Murphy, Jody Rayfield • ASSISTANT DESIGNER Mark Kraus • MECHANICAL ARTIST Claudine Kaprielain, Mike Shafran • ANIMATOR (PHOTO) Bill Cash • CINEMATOGRAPHER Martin Albert • MUSIC Peter Ducharme

SILVER

Capturing the spirit of what happens at the Detroit and Los Angeles auto shows, this site gives Volkswagen the opportunity to interact with the public and deliver on the line "Drivers Wanted."

CATEGORY Brand Building • ADVERTISER/PRODUCT Montblanc International • NAME OF SITE www.montblanc.com • WEB DEVELOPER Elephant Seven, Hamburg • ADVERTISING AGENCY Elephant Seven, Hamburg • ACCOUNT EXECUTIVE Mirelle Janne, Dirk Kedrowitsch • CREATIVE DIRECTOR Barbara Schmidt • COPYWRITER Nicole Staehr • ART DIRECTOR Yvonne Lange • PROGRAMMER Oliver Kutter

SILVER

A sleek and elegant site that showcases the diverse line of Mont Blanc products for the fashionable and discriminating businesswoman.

SILVER

CATEGORY Brand Building • ADVERTISER/PRODUCT Wallpaper • NAME OF SITE Wallpaper.com • WEB DEVELOPER I-D Media Limited, London • ADVERTISING AGENCY I-D Media Limited, London • ACCOUNT EXECUTIVE Merle Busch • ART DIRECTOR Maurus Fraser • DESIGNER Shalini Bharadwaj • PROGRAMMER Rainer Jon Kraft, Conor Boyd • PRODUCTION MANAGER Amanda Hall • INTERACTIVE DEVELOPER/ANIMATOR Kevin Dowd, Jan Fex, Nathalie Ducard

Wallpaper.com is an online magazine that maintains the same exemplary design standards as the print version, while at the same time introducing a new level of interactivity for its Internet audience.

SILVER

CATEGORY Brand Building • ADVERTISER/PRODUCT eMarker by Sony • NAME OF SITE Sony eMarker • WEB DEVELOPER Resource Marketing, Columbus • ADVERTISING AGENCY Resource Marketing, Columbus • ACCOUNT EXECUTIVE Molly Metzger, Patty Resatka • COPYWRITER Jessica Hagy • ART DIRECTOR Jeff Fischer, Pete Durfee • DESIGNER Jeff Fischer • PROGRAMMER Joel Stanley

The Sony eMarker is a tiny musical tool that allows the user to access information about specific songs, such as title and artist. The site is a place where music can be downloaded, information can be discovered, and visitors can chat with others in the interest of trading music-related data.

CATEGORY Brand Building • **ADVERTISER/PRODUCT** Volkswagen of America Inc. • **NAME OF SITE** vw.com/microbus • **ADVERTISING AGENCY** ARNOLD Worldwide, Boston • **ACCOUNT EXECUTIVE** Emily D'Entremont, Ben Muldrew, Jon Castle, Beth Doty, Colleen McGee • **CREATIVE DIRECTOR** Tim Brunelle, Chris Bradley • **COPYWRITER** Tim Brunelle • **ART DIRECTOR** Chris Bradley • **DESIGNER** Keith Butters, Mark Kraus, Redtree Productions • **PRODUCER** Ken Kingdon • **CHIEF CREATIVE OFFICER** Ron Lawner • **GROUP CREATIVE DIRECTOR** Alan Pafenbach • **INTERACTIVE PRODUCER** Jennifer Iwanicki • **BROADCAST PRODUCER** Chris Jennings • **TECHNICAL DIRECTOR** Jonathan Groves, Rick Webb • **DHTML PROGRAMMER** Stefka Hristova • **FLASH PROGRAMMER** Keith Butters • **CINEMATOGRAPHER/PHOTOGRAPHER** Martin Albert • **ILLUSTRATOR** Nicole McDonald • **COMPOSER** John Dragonetti (Jack Drag) • **MECHANICAL ARTIST** Joe Cartman • **FLASH DESIGNER** Keith Butters

BRONZE

Promoting a concept car introduced at the Detroit auto show, this site also acts as a virtual focus group in its effort to gauge enthusiasm for this new product. It also re-establishes Volkswagen as a design leader in its field.

CATEGORY Consumer-Targeted Site • **ADVERTISER/PRODUCT** Ericsson T20 • **NAME OF SITE** Ericsson T20 • **ADVERTISING AGENCY** Impiric, London • **CREATIVE DIRECTOR** Louise Perry • **COPYWRITER** Richard Johnson • **DESIGNER** Anthony Lelliot, David Alcock • **PROGRAMMER** Richard Smith • **PRODUCER** Rachael Clein • **INFORMATION ARCHITECT** Darren Glenister • **ILLUSTRATOR** Nicola Cunningham

BRONZE

The Ericsson T20 cellular phone is introduced in a fun and offbeat manner. Games, color/design variations, related accessories, and a virtual demonstration of the phone are among the features found within the site.

BRONZE

CATEGORY Consumer-Targeted Site • **ADVERTISER/PRODUCT** Charity Golf Tournament • **NAME OF SITE** Dayton's Challenge • **WEB DEVELOPER** Periscope, Minneapolis • **ADVERTISING AGENCY** Periscope, Minneapolis • **ACCOUNT EXECUTIVE** John Warren • **CREATIVE DIRECTOR** Chris Cortilet • **COPYWRITER** Katerina Martchouk • **ART DIRECTOR** Chris Courtilet • **DESIGNER** Andy Gugel, T Scott Major • **PROGRAMMER** Steve Killingbelk • **PRODUCTION MANAGER** Matt Hattenberger • **FLASH ARCHITECT** Andy Gugel • **DESIGNER** Andy Gugel, T. Scott Major • **PROGRAMMER** Steve Killingbeck

Dayton's Challenge is a charity golf tournament that raises a considerable amount of money for the Children's Cancer Research Fund. The site promotes the event while securing corporate and private donations, as well as driving ticket sales to the tournament itself.

BRONZE

CATEGORY Consumer-Targeted Site • **ADVERTISER/PRODUCT** Wallpaper • **NAME OF SITE** Wallpaper.com • **WEB DEVELOPER** I-D MEDIA Limited, London • **ADVERTISING AGENCY** I-D MEDIA Limited, London • **ACCOUNT EXECUTIVE** Merle Busch • **ART DIRECTOR** Maurus Fraser • **DESIGNER** Shalini Bharadwaj • **PROGRAMMER** Rainer Jon Kraft, Conor Boyd • **PRODUCER** Amanda Hall • **INTERACTIVE DEVELOPMENT/ANIMATION** Kevin Dowd, Jan Fex, Nathalie Ducard

Wallpaper.com is a graphically exciting and technically flexible site that exploits the full potential of electronic media. All of the features of its printed version remain, but are intensified by the enhancements made available within the context of the Internet.

CATEGORY Direct Response • ADVERTISER/PRODUCT Women's Secret • NAME OF SITE Women's Secret • WEB DEVELOPER DoubleYou, Barcelona • ADVERTISING AGENCY DoubleYou, Barcelona • ACCOUNT EXECUTIVE Daniel Córdoba • CREATIVE DIRECTOR Frédéric Sanz • COPYWRITER Esther Pino, Eduard Pou • ART DIRECTOR Blanca Piera • DESIGNER Anna Coll, Oriol Quin, Monterrat Torras • PROGRAMMER Joakim Borgström, Jordi Martínez, Xavi Caparrós • INTERACTIVE DIRECTOR Joakim Borgström • APPLICATIONS Beatriz Martín • PRODUCER Paula Ohlin • ASSOCIATE PRODUCER Jordi Pont

SILVER

Womensecret.com is a virtual lingerie store, equipped with banners and a superstitial, and which is targeted at men. These features transfer users to a microsite where they view alluring images in the Womensecret catalogue, and are invited to e-mail their female friends, informing them of a free gift offer.

CATEGORY Direct Response • ADVERTISER/PRODUCT Banco Itaú • NAME OF SITE Rudi • ADVERTISING AGENCY AgenciaClick, São Paulo • ACCOUNT EXECUTIVE Ana Amria Nubie, Ana Carolina Escorel • CREATIVE DIRECTOR PJ Pereira • COPYWRITER Suzana Apelbaum, Mauro Alencar • ART DIRECTOR Thiago Zanato • DESIGNER Thiago Zanato, Miguel Castarde • PROGRAMMER Marcelo Siqueira, Jefferson Russo, Miguel Castarde • PRODUCER Carolina Escorel • PRODUCTION MANAGER Anna Carolina Escorel • TECHNICAL DIRECTOR Abei Reis • MULTIMEDIA Doca Cobert, Prodigo • PHOTOGRAPHER Adriano Zagottis • COPYWRITER Suzana Apelbaum, Amuro Alencar • SOUND EFFECTS Arthur Guidi

BRONZE

The Banco Itau site promotes investing in today's children for a better tomorrow via health, education, and civic programs. It links to the Web sites of other socially aware organizations.

GOLD

CATEGORY Fresh Approach • ADVERTISER/PRODUCT Laramara Foundation • NAME OF SITE Laramara • WEB DEVELOPER Zentropy Partners/Thunder House Brazil, São Paulo • ADVERTISING AGENCY Zentropy Partners/Thunder House Brazil, São Paulo • ACCOUNT EXECUTIVE Clóvis La Pastina, Lucas Góis • CREATIVE DIRECTOR Bob Gebara, André Matarazzo, Clóvis La Pastina • COPYWRITER Clóvis La Pastina • ART DIRECTOR André Matarazzo • DESIGNER André Matarazzo • PROGRAMMER Thiago Avancini • PRODUCTION MANAGER Juliano Tosetto

The Laramara Foundation diagnoses and assists visually impaired children who live with partial or full blindness, with the goal of integrating them into society at large. To illustrate the challenges that the visually impaired face on a daily basis, the site places the user in the position of one without sight, and who then must navigate in darkness. The site is intended to be both playful and educational.

SILVER

CATEGORY Fresh Approach • ADVERTISER/PRODUCT Hewlett-Packard • NAME OF SITE Invent Campaign • ADVERTISING AGENCY Freestyle Interactive, San Francisco, in partnership with Goodby, Silverstein & Partners, San Francisco • CREATIVE DIRECTOR Mike Yapp, Steve Simpson • COPYWRITER John Matejczyk • ART DIRECTOR Regan Honda, Rick Casteel, Jeff Benjamin • PRODUCER Danaa Zellers • EXECUTIVE PRODUCER Kim Askew • ACCOUNT MANAGER John Glander, Christina Blosser • ENGINEERING LEAD Keith Neil • ENGINEER Mike Jones

A branding campaign created to promote the HP tagline: INVENT. The banners allow users to create and discover interactively within the context of two separate banner spaces: one simulating the revisable flight pattern of a paper airplane; the other depicting a mathematical equation with changing variables.

CATEGORY Fresh Approach • **ADVERTISER/PRODUCT** Nerd Olympics, Job Recruitment • **NAME OF SITE** Nerd Olympics • **WEB DEVELOPER** Starlet Deluxe, Stockholm • **ADVERTISING AGENCY** Starlet Deluxe, Stockholm • **CREATIVE DIRECTOR** Martin Cedergren • **ART DIRECTOR** Martin Cedergren • **DESIGNER** eBoy, Per Holmquist • **PROGRAMMER** Tim Sajdak, Kim Nordstrom, Icon • **PRODUCTION MANAGER** Martin Cedergren

BRONZE

The Nerd Olympics is a job search site that integrates a light-hearted attitude, via virtual games, to the competitive reality of seeking and securing employment.

CATEGORY Internet Rich Media Advertising • **ADVERTISER/PRODUCT** Hewlett-Packard • **NAME OF SITE** Invent Campaign • **ADVERTISING AGENCY** Freestyle Interactive, San Francisco, in partnership with Goodby, Silverstein & Partners, San Francisco • **CREATIVE DIRECTOR** Mike Yapp, Steve Simpson • **COPYWRITER** John Matejczyk • **ART DIRECTOR** Regan Honda, Rick Casteel, Jeff Benjamin • **PRODUCER** Danaa Zellers • **EXECUTIVE PRODUCER** Kim Askew • **ACCOUNT MANAGER** John Glander, Christina Blosser • **ENGINEERING LEAD** Keith Neil • **ENGINEER** Mike Jones

SILVER

A branding campaign created to promote the HP tagline: INVENT. The banners allow users to create and discover interactively within the context of two separate banner spaces: one simulating the revisable flight pattern of a paper airplane; the other depicting a mathematical equation with changing variables.

SILVER

CATEGORY Internet Rich Media Advertising • **ADVERTISER/PRODUCT** Braille • **NAME OF SITE** Braille Site • **WEB DEVELOPER** AgenciaClick, Sao Paulo • **ADVERTISING AGENCY** AgenciaClick, São Paulo • **ACCOUNT EXECUTIVE** Ana Maria Nubie, Debora Salles • **CREATIVE DIRECTOR** PJ Pereira, Eduardo Martins • **COPYWRITER** Mauro Alencar • **ART DIRECTOR** Edwin Veelo • **DESIGNER** Marcelo Siqueira • **PRODUCTION MANAGER** Claudia Obata

The braille site promotes the need for cornea donations so that operations can be performed on the visually impaired. A banner of braille symbols reveals alphabet letters of the sighted as the curser grazes over it, to ultimately proclaim its message: Donate Cornea.

BRONZE

CATEGORY Internet Rich Media Advertising • **ADVERTISER/PRODUCT** Popwire.com • **NAME OF SITE** Do You Have What it Takes to Become a Popstar? • **WEB DEVELOPER** Starlet Deluxe, Stockholm • **ADVERTISING AGENCY** Starlet Deluxe, Stockholm • **CREATIVE DIRECTOR** Martin Cedergren • **ART DIRECTOR** Martin Cedergren • **DESIGNER** Per Holmqvist, Cristian Pencheff • **PROGRAMMER** Tony Sajdak, Rafael Hedman • **PRODUCTION MANAGER** Martin Cedergren

A campaign to tempt visitors to the music portal Popwire.com. Aspiring composers can create their own tunes directly within the banner using an online drum machine and synth, and then save them within the site for future visitors to download and play.

CATEGORY Internet Rich Media Advertising • **ADVERTISER/PRODUCT** Nerd Olympics, Job Recruitment • **NAME OF SITE** Nerd Olympics •
WEB DEVELOPER Starlet Deluxe, Stockholm • **ADVERTISING AGENCY** Starlet Deluxe, Stockholm • **CREATIVE DIRECTOR** Martin Cedergren •
ART DIRECTOR Martin Cedergren • **DESIGNER** eBoy, Per Holmqvist • **PROGRAMMER** Tim Sajdak, Kim Nordstrom, Icon • **PRODUCTION**
MANAGER Martin Cedergren

BRONZE

The Nerd Olympics is a job search site that integrates a light-hearted attitude - via virtual games - to the competitive reality of seeking and securing employ-
ment. Shockwave is utilized throughout the site.

CATEGORY Self-Promotion • **ADVERTISER/PRODUCT** Rui Camilo • **NAME OF SITE** www.rui-camilo.de • **WEB DEVELOPER** Scholz & Volkmer,
Wiesbaden • **ADVERTISING AGENCY** Scholz & Volkmer, Wiesbaden • **ACCOUNT EXECUTIVE** Mathias Schaab, Heike Brockmann • **CREATIVE**
DIRECTOR Michael Volkmer • **COPYWRITER** Annika Koehler, Rui Camilo • **ART DIRECTOR** Heike Brockmann • **DESIGNER** Melanie Lent, Angela
Hoos • **PROGRAMMER** Mathias Schaab, Peter Reichard • **FLASH PROGRAMMING** Mathias Schaab • **PROGRAMMING** Mathias Schaab, Peter
Reichard • **PROJECT MANAGER** Mathias Schaab, Heike Brockmann • **SCREEN DESIGN** Melanie Lenz, Angela Hoos • **CLIENT** Rui Camilo
Photography

SILVER

This Web site features the work of German photographer Rui Camilo. Visitors can obtain a full overview of the artist's portfolio, as well as establish direct
contact with the artist himself.

CATEGORY Self-Promotion • **ADVERTISER/PRODUCT** Vir2L Web Site • **NAME OF SITE** Vir2L • **WEB DEVELOPER** Vir2l Team, Rockville • **CREATIVE DIRECTOR** Vir2l Team • **COPYWRITER** Vir2l Team • **ART DIRECTOR** Vir2l Team • **DESIGNER** Vir2l Team • **PROGRAMMER** Vir2l Team

A promotional site for design company Vir2L Studios, which includes a "virtual forum"—an area where creative artists can explore new Web productions and interactive graphics.

CATEGORY Self-Promotion • **ADVERTISER/PRODUCT** Fusebox Holiday Fusespot • **NAME OF SITE** Hungry? • **WEB DEVELOPER** Fusebox, New York • **CREATIVE DIRECTOR** Laura Michaels • **COPYWRITER** Sharoz Makarechi, Harris Silver • **ART DIRECTOR** Alexis Idone • **DESIGNER** Dan McGorry • **PROGRAMMER** Rob Hudack • **PHOTOGRAPHER** Dayon Daumont

"Hungry?" was created as a holiday e-greeting sent out by Fusebox to their friends and clients. The message contrasts the hunger of ambitious New Yorkers with the 300,000 truly physically hungry people of that city, as a plea for donating time, food, and money to those who are less fortunate.

CATEGORY Self-Promotion • **ADVERTISER/PRODUCT** Ego Media • **NAME OF SITE** Ego Media Corporate Web Site • **WEB DEVELOPER** Ego Media, New York • **ACCOUNT EXECUTIVE** Raymond Roubeni • **CREATIVE DIRECTOR** David Weil • **COPYWRITER** Joseph Calderone, Raymond Roubeni • **ART DIRECTOR** Jenya Spektor • **DESIGNER** Meredith Bacheller, Rob Carin, Dimitry Leokumovich, Mat Ranauro • **PROGRAMMER** Vitaly Leokumovich • **PRODUCTION MANAGER** Joey Roubeni, Dirk Winkler • **PROJECT LEAD** Christine Walder

BRONZE

Ego Media is an interactive brand development company whose site is a mixture of design and entertainment. Visitors may personalize sections of the site as they navigate through it.

Design

GOLD

CATEGORY Annual Reports •
ADVERTISER/PRODUCT Maxygen 1999 Annual
Report • **DESIGN COMPANY** Cahan and
Associates, San Francisco • **ACCOUNT**
EXECUTIVE Liza Thomson • **CREATIVE**
DIRECTOR Bill Cahan • **COPYWRITER**
Maxygen • **ART DIRECTOR** Bill Cahan, Sharrie
Brooks • **DESIGNER** Sharrie Brooks •
PHOTOGRAPHER Ken Probst, Isabelle
Francais

SILVER

CATEGORY Annual Reports •
ADVERTISER/PRODUCT Collateral
Therapeutics 1999 Annual Report • **DESIGN**
COMPANY Cahan and Associates, San
Francisco • **ACCOUNT EXECUTIVE** Katie
Kniestedt • **CREATIVE DIRECTOR** Bill Cahan •
COPYWRITER Thom Elkjer, Kevin Roberson •
ART DIRECTOR Bill Cahan, Kevin Roberson •
DESIGNER Kevin Roberson • **PHOTOGRAPHER**
Robert Schlatter

BRONZE

CATEGORY Annual Reports •
ADVERTISER/PRODUCT Yahoo! • **DESIGN**
COMPANY Turner & Associates, San Francisco •
MANUFACTURER Anderson Lithograph, Los
Angeles • **CREATIVE DIRECTOR** Steve Turner •
DESIGNER Laurie Carrigan •
COMMUNICATIONS DIRECTOR Phil Hamlett •
DESIGN DIRECTOR Laurie Carrigan

CATEGORY Brochures-Product/Service • **ADVERTISER/PRODUCT** Retail Store Takashimaya Volume 8 • **ADVERTISING AGENCY** Design M/W, New York • **DESIGN COMPANY** Design M/W, New York • **MANUFACTURER** Lithographix, Los Angeles • **CREATIVE DIRECTOR** Allison Williams, JP Williams • **COPYWRITER** Laura Silverman • **ART DIRECTOR** Allison Williams • **DESIGNER** Allison Williams, Yael Eisele • **PHOTOGRAPHER** Gentl & Hyers

GOLD

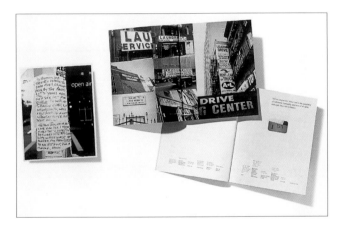

CATEGORY Brochures-Product/Service • **ADVERTISER/PRODUCT** Open Air Catalogue • **DESIGN COMPANY** Elmwood, London/Leeds • **MANUFACTURER** Typographic Circle, London • **ACCOUNT EXECUTIVE** Jayne Workman • **DESIGNER** Alan Ainsley

GOLD

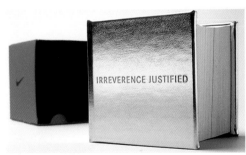

CATEGORY Brochures-Product/Service • **ADVERTISER/PRODUCT** Nike Gold Book • **ADVERTISING AGENCY** Wieden & Kennedy, Amsterdam • **ACCOUNT EXECUTIVE** Philippe Horeau, Enrico Balleri • **CREATIVE DIRECTOR** Robert Nakata, Glenn Cole • **COPYWRITER** Glenn Cole • **ART DIRECTOR** Robert Nakata

SILVER

SILVER

CATEGORY Brochures-Product/Service • **ADVERTISER/PRODUCT** Burberry Global Brochure Autumn/Winter 2000 • **DESIGN COMPANY** Four IV Design Consultants, London • **CREATIVE DIRECTOR** Andy Bone • **ART DIRECTOR** Kim Hartley • **PRODUCTION MANAGER** Mickey Davies • **DESIGNER** Kim Hartley • **PHOTOGRAPHER** Craig Fordham, Richard Foster

BRONZE

CATEGORY Brochures-Product/Service • **ADVERTISER/PRODUCT** GF Smith/Strathmore Papers Promotion • **DESIGN COMPANY** Navy Blue Design Consultants, Edinburgh • **CREATIVE DIRECTOR** Jonathan Evans • **COPYWRITER** J. Evans, P. Evans • **ART DIRECTOR** J. Evans, J. Reid • **DESIGNER** J. Reid, I. Valentine • **UK DISTRIBUTOR** GF Smith • **PRINTER** H. MacDonald, Vancouver

BRONZE

CATEGORY Brochures-Product/Service • **ADVERTISER/PRODUCT** Pylonia • **ADVERTISING AGENCY** Schumacher, Jersild, Wessman & Enander, Stockholm • **DESIGN COMPANY** Greger Ulf Nilson AB, Stockholm • **MANUFACTURER** Gylden Dahl/Journal/Øresunds- Konsortiet, Copenhagen/ Stockholm • **ACCOUNT EXECUTIVE** Ajs Dam, Gösta Flemming • **CREATIVE DIRECTOR** Greger Ulf Nilson • **COPYWRITER** Klaus Rifbjerg, Gösta Flemming • **ART DIRECTOR** Greger Ulf Nilson • **DESIGNER** Greger Ulf Nilson • **PHOTOGRAPHER** Henrik Saxgren

BRONZE

CATEGORY Brochures-Product/Service •
ADVERTISER/PRODUCT Diesel S.P.A.—It´s
Real Magazine • **ADVERTISING AGENCY**
Paradiset DDB, Stockholm • **ACCOUNT**
EXECUTIVE Stefan Öström • **CREATIVE**
DIRECTOR Joakim Jonason • **COPYWRITER**
Björn Rietz • **ART DIRECTOR** Tove Langseth •
PRODUCTION MANAGER Anna Magnusson •
PHOTOGRAPHER Peter Gherke • **ART WORK**
Patrik Andersson

BRONZE

CATEGORY Brochures-Product/Service •
ADVERTISER/PRODUCT Exhibition Catalog
Nordic Design • **ADVERTISING AGENCY**
Forsman & Bodenfors Design, Gothenburg •
MANUFACTURER Röhsska Museet,
Gothenburg • **ACCOUNT EXECUTIVE** Katarina
Wredmark • **ART DIRECTOR** Anders
Kornestedt, Louise Lindgren • **DESIGNER**
Louise Lindgren • **ILLUSTRATOR** Fredrik
Persson

BRONZE

CATEGORY Brochures-Product/Service •
ADVERTISER/PRODUCT Graphic Arts Center
Brochure • **DESIGN COMPANY** Sandstrom
Design, Portland • **ACCOUNT EXECUTIVE**
Kathy Middleton • **CREATIVE DIRECTOR** Steve
Sandstrom • **COPYWRITER** Steve Sandoz •
ART DIRECTOR Steve Sandstrom •
PRODUCTION MANAGER Kathy Middleton •
DESIGNER Steve Sandstrom • **PRODUCTION**
DESIGNER Andre Burgoyne

GOLD

CATEGORY Corporate Identity •
ADVERTISER/PRODUCT H&R Block •
ADVERTISING AGENCY Landor Associates,
San Francisco • DESIGN COMPANY Landor
Associates, San Francisco • CREATIVE
DIRECTOR Margaret Youngblood • DESIGNER
Kisitina Wong, Cameron Imani, Tina
Schoepflin, Irena Blok, David Rockwell, Mary
Hayano • SENIOR DESIGN DIRECTOR Eric
Scott • WRITER Daniel Meyerovich, Susan
Manning • ACCOUNT DIRECTORS Russ
Meyer, Liz Magnusson • PROJECT
MANAGEMENT Bill Larsen, Stephen Lapaz •
PRODUCTION Tom Venegas

SILVER

CATEGORY Corporate Identity • ADVERTISER/
PRODUCT BP Amoco Identity System •
ADVERTISING AGENCY Landor Associates, San
Francisco • DESIGN COMPANY Landor
Associates, San Francisco • CREATIVE
DIRECTOR Margaret Youngblood, Nancy
Hoefig, Courtney Reeser • DESIGNER Cynthia
Murnane, Todd True, Frank Mueller, Michele
Berry, Ivan Thelin, Ladd Woodland, Maria
Wenzel • SENIOR BRAND STRATEGIST Peter
Harleman • ENVIRONMENTS DESIGN DIRECTOR
David Zapata • INTERACTIVE DESIGN
DIRECTOR Brad Scott • WRITER Jane Bailey,
Susan Manning • INTERACTIVE ACCOUNT
DIRECTOR Wendy Gold • PROJECT
MANAGEMENT Greg Barnell, Stephen Lapaz,
Bryan Vincent • REALIZATION Russell DeHaven

BRONZE

CATEGORY Corporate Identity •
ADVERTISER/PRODUCT 800.com Logo •
DESIGN COMPANY Sandstrom Design,
Portland • ACCOUNT EXECUTIVE Kirsten
Cassidy • CREATIVE DIRECTOR Steve
Sandstrom • ART DIRECTOR Dan Richards •
PRODUCTION MANAGER Kirsten Cassidy •
DESIGNER Dan Richards • PRODUCTION
DESIGNER John Bohls

BRONZE

www.kidmachine.com

CATEGORY Corporate Identity •
ADVERTISER/PRODUCT Kidmachine •
ADVERTISING AGENCY
Heymann/Bengoa/Berbari, Buenos Aires •
DESIGN COMPANY Heymann/Bengoa/Berbari /
Design, Buenos Aires • **ART DIRECTOR** Jorge
Heymann, Marcelo Burgos • **PRODUCTION**
MANAGER Juán Insua • **DESIGNER** Marcelo
Burgos

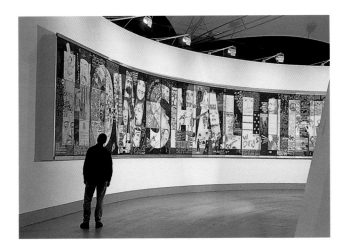

SILVER

CATEGORY Environmental Design •
ADVERTISER/PRODUCT How Shall I Live? Dome
Wall in Faith Zone • **DESIGN COMPANY** The
Chase Manchester, Manchester • **CREATIVE**
DIRECTOR Ben Casey, Alan Herron • **DESIGNER**
Alan Herron, Billy Harkcom • **ILLUSTRATOR**
Peter Till, Ruth Rowland, Ian Saxton, Phil Disley,
Jovan Djordjevic, Jayne Morris, Rob Ball, David
Hughes, Olly Gaiger, Andrew Griffin, Shane
McGowan, Sarah Young, Jonathan Gibbs, Tony
Forster, Tony Williams, Mark Ross, James
Graham, Ivan Rowles, Tom Shaughnessy, Alan
Herron, Billy Harkcom, Grant Mitchell, John
Paul Sykes, Annie McCormack, Armand Terruli,
Darrel Rees, Aude Van Ryn, Ian Wright, Brent
Harvey-Smith, Steve Bland, DC Thompson

BRONZE

CATEGORY Environmental Design •
ADVERTISER/PRODUCT ESPN Trade Show •
DESIGN COMPANY Sandstrom Design,
Portland • **ACCOUNT EXECUTIVE** Kathy
Middleton • **CREATIVE DIRECTOR** Steve
Sandstrom • **COPYWRITER** Neil Webster •
ART DIRECTOR Dan Richards • **PRODUCTION**
MANAGER Kathy Middleton • **DESIGNER** Dan
Richards • **PRODUCTION DESIGNER** John
Bohls

CATEGORY Environmental Design •
ADVERTISER/PRODUCT Nordstrom In House
Cafe • **ADVERTISING AGENCY** Duffy
Minneapolis, Minneapolis • **DESIGN COMPANY**
Duffy Minneapolis, Minneapolis • **ACCOUNT**
EXECUTIVE Robin Beddor • **CREATIVE**
DIRECTOR Alan Colvin • **ART DIRECTOR** Alan
Colvin • **PRODUCTION MANAGER** Bridget
Duffy • **DESIGNER** Ken Sakurai, Craig Duffney •
PHOTOGRAPHER Richard Klein • **ART**
PRODUCTION Tracy Hogenson

BRONZE

CATEGORY Package Design •
ADVERTISER/PRODUCT Tazo Full Leaf Tea Kits
with Infusers • **DESIGN COMPANY** Steve
Sandstrom, Portland • **ACCOUNT EXECUTIVE**
Carole Johnson • **CREATIVE DIRECTOR** Steve
Sandstrom • **COPYWRITER** Steve Sandoz •
ART DIRECTOR Steve Sandstrom •
PRODUCTION MANAGER Carole Johnson •
DESIGNER Steve Sandstrom • **PRODUCTION**
DESIGNER Andrew Randall

GOLD

CATEGORY Package Design •
ADVERTISER/PRODUCT Tazo Holiday Gift Box
and Infuser Tins • **DESIGN COMPANY**
Sandstrom Design, Portland • **ACCOUNT**
EXECUTIVE Ann Riedl • **CREATIVE DIRECTOR**
Steve Sandstrom • **COPYWRITER** Steve
Sandoz • **ART DIRECTOR** Steve Sandstrom •
PRODUCTION MANAGER Ann Riedl •
DESIGNER Steve Sandstrom • **PRODUCTION**
DESIGNER Starlee Matz

GOLD

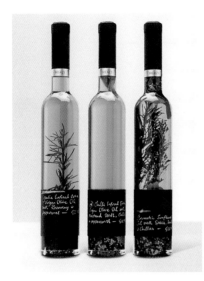

CATEGORY Package Design •
ADVERTISER/PRODUCT Heals Oils • **DESIGN**
COMPANY Williams Murray Hamm, London •
MANUFACTURER Heals Department Stores,
London • **ACCOUNT EXECUTIVE** Kellie
Chapple • **CREATIVE DIRECTOR** Garrick
Hamm • **COPYWRITER** Kellie Chapple, Fiona
Curran • **ART DIRECTOR** Garrick Hamm •
PRODUCTION MANAGER Kellie Chapple •
DESIGNER Fiona Curran

GOLD

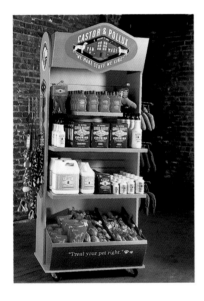

CATEGORY Package Design •
ADVERTISER/PRODUCT Castor & Pollux Pet
Products • **DESIGN COMPANY** Sandstrom
Design, Portland • **ACCOUNT EXECUTIVE**
Kelly Culp • **CREATIVE DIRECTOR** Steve
Sandstrom • **COPYWRITER** Leslee Dillon •
ART DIRECTOR Jon Olsen • **DESIGNER** Jon
Olsen • **ILLUSTRATOR** Larry Jost •
PRODUCTION DESIGNER Starlee Matz

GOLD

CATEGORY Package Design •
ADVERTISER/PRODUCT Plant Aid •
ADVERTISING AGENCY Grey Worldwide,
Kuala Lumpur • **MANUFACTURER** CDA
Malaysia, Kuala Lumpur • **ACCOUNT**
EXECUTIVE Neal Estavillo • **CREATIVE**
DIRECTOR Edwin Leong, Jeff Orr •
COPYWRITER Edwin Leong • **ART DIRECTOR**
Edwin Leong, Andy Soong • **PRODUCTION**
MANAGER Sharon Yap • **DESIGNER** Richard
Chin, Edwin Leong, Andy Soong •
PHOTOGRAPHER Jack Shea

SILVER

SILVER

CATEGORY Package Design •
ADVERTISER/PRODUCT Tazo Infuser Tins •
DESIGN COMPANY Sandstrom Design,
Portland • **ACCOUNT EXECUTIVE** Carole
Johnson • **CREATIVE DIRECTOR** Steve
Sandstrom • **COPYWRITER** Steve Sandoz •
ART DIRECTOR Steve Sandstrom • **DESIGNER**
Steve Sandstrom • **PRODUCTION DESIGNER**
Andrew Randall

SILVER

CATEGORY Package Design •
ADVERTISER/PRODUCT Belazu •
ADVERTISING AGENCY Turner Duckworth,
London • **DESIGN COMPANY** Turner
Duckworth, London • **MANUFACTURER** The
Fresh Olive Company, London • **ACCOUNT**
EXECUTIVE Justine Stringer • **CREATIVE**
DIRECTOR Bruce Duckworth, David Turner •
ART DIRECTOR Bruce Duckworth, David
Turner • **DESIGNER** Janice Davison

BRONZE

CATEGORY Package Design •
ADVERTISER/PRODUCT Diva • **DESIGN**
COMPANY Lewis Moberly, London •
MANUFACTURER Waitrose Limited, Bracknell •
ACCOUNT EXECUTIVE Ann Marshall • **ART**
DIRECTOR Mary Lewis • **DESIGNER** Suse
Klingholz, Ann Marshall • **BUYER**
(WHITEROSE LTD.) Catherine Taylor •
GRAPHIC DESIGN MANAGER (WHITEROSE
LTD.) Maggie Hodgetts

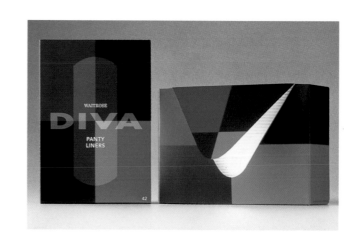

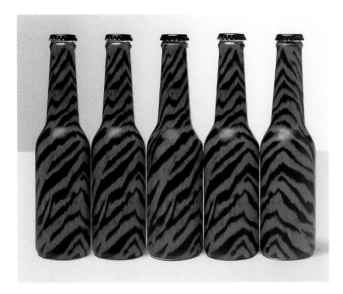

CATEGORY Package Design •
ADVERTISER/PRODUCT Wild Brew • DESIGN
COMPANY Williams Murray Hamm, London •
MANUFACTURER Interbrew Uk Ltd., Luton,
Bedfordshire • ACCOUNT EXECUTIVE Kellie
Chapple • CREATIVE DIRECTOR Garrick
Hamm • ART DIRECTOR Garrick Hamm •
PRODUCTION MANAGER Kellie Chapple •
DESIGNER Ruth Waddingham, Simon
Porteous • PHOTOGRAPHER National History
Museum

BRONZE

CATEGORY Package Design •
ADVERTISER/PRODUCT Muu-milk •
ADVERTISING AGENCY Forsman & Bodenfors
Design, Gothenburg • MANUFACTURER Arla
Foods • ART DIRECTOR Anders Kornestedt •
DESIGNER Anders Kornestedt • ILLUSTRATOR
Moses Voight

BRONZE

SAY SO LONG TO HAIR
YOU'D RATHER NOT HAVE
WITH NO NEED TO HEAT WAX STRIPS,
THERE'S NO FINER WAY TO TURN YOUR
PEACH INTO A NECTARINE THAN WITH A DELICATELY
SCENTED AROMATHERAPY FORMULA, DEVELOPED WITH
NATURAL, SKIN-FRIENDLY INGREDIENTS FOR USE ON FACE, LEGS,
UNDERARM AND BIKINI LINE. FOLLOW THESE SIMPLE STEPS FOR

GOODBYE TO
ANY TRACE OF BRISTLE,
HELLO TO THE LOVELIEST LEGS
WITH A HAIR REMOVING CREAM

WAVE CHEERIO
WITH BARE-FACED
CHEEK TO FACIAL HAIR,
WITH THE NEATEST LITTLE

CATEGORY Package Design •
ADVERTISER/PRODUCT Superdrug Hair
Products • DESIGN COMPANY Williams
Murray Hamm, London • MANUFACTURER
Superdrug, Croydon, Surrey • ACCOUNT
EXECUTIVE Kellie Chapple • CREATIVE
DIRECTOR Garrick Hamm • COPYWRITER
Martin Ferrell • ART DIRECTOR Garrick Hamm
• PRODUCTION MANAGER Kellie Chapple •
DESIGNER Ruth Waddingham • TYPOGRAPHY
Ruth Waddingham

BRONZE

SILVER

CATEGORY Point of Purchase •

ADVERTISER/PRODUCT Paul's Bait and Tackle

• **ADVERTISING AGENCY** D'Arcy, St. Louis •

CREATIVE DIRECTOR Ron Crooks, Michael

Smith, Dave Swaine • **COPYWRITER** Dave

Swaine • **ART DIRECTOR** Michael Smith •

PRODUCTION MANAGER Dave Christoff •

PHOTOGRAPHER Ferguson & Katzman

Photography

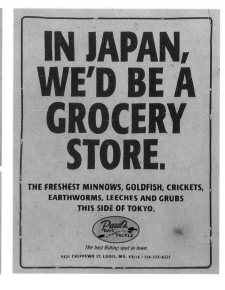

GOLD

CATEGORY Self-Promotion •

ADVERTISER/PRODUCT Mark Hooper

Photography • **DESIGN COMPANY** Sandstrom

Design, Portland • **ACCOUNT EXECUTIVE**

Kathy Middleton • **CREATIVE DIRECTOR**

Steve Sandstrom • **ART DIRECTOR** Steve

Sandstrom • **PRODUCTION MANAGER** Kathy

Middleton • **DESIGNER** Steve Sandstrom •

PHOTOGRAPHER Mark Hooper •

PRODUCTION DESIGNER Andrew Randall

GOLD

CATEGORY Self-Promotion • **ADVERTISER/
PRODUCT** Cahan and Associates—I Am Almost
Always Hungry (book) • **DESIGN COMPANY**
Cahan and Associates, San Francisco •

ACCOUNT EXECUTIVE Sharon Lichtenfeld •

CREATIVE DIRECTOR Bill Cahan • **COPYWRITER**
Bob Dinetz, Kevin Roberson, Sharon
Lichtenfeld, Bill Cahan, Thom Elkjer, Ken
Coupland, Chris Harges, JoAnna di Paolo,
Marty Neumeier, Glen Helfand, Tom Vanderbilt
• **ART DIRECTOR** Bill Cahan, Bob Dinetz •

DESIGNER Bob Dinetz • **PHOTOGRAPHER** Tony
Stromberg, William Mercer McLeod, Robert
Schlatter, William Howard, Bob Dinet

258

CATEGORY Self-Promotion •
ADVERTISER/PRODUCT East Champ Optics - Sewing Kit • **ADVERTISING AGENCY** Lowe Lintas & Partners, Singapore • **CREATIVE DIRECTOR** Ng Khee Jin • **COPYWRITER** Eddie Wong • **ART DIRECTOR** Eddie Wong • **PRODUCTION MANAGER** Douglas Wong • **TYPOGRAPHER** Eddie Wong

BRONZE

CATEGORY Self-Promotion •
ADVERTISER/PRODUCT Third Eye Design •
DESIGN COMPANY Third Eye Design, Glasgow • **DESIGNER** Mark Noë, Kenny Allan •
PHOTOGRAPHER Emme Biberstein

BRONZE

Student

Television, Print & Design

GOLD

CATEGORY Student • **ADVERTISER/PRODUCT** Nike • **TITLE** Beatboxer • **CREATIVE DIRECTOR** Tony Garcia • **COPYWRITER** Lisa Plettinck • **DIRECTOR** Tony Garcia • **PRODUCER** Tony Garcia • **DIRECTOR OF PHOTOGRAPHY** Tony Garcia • **SCHOOL** Art Center College of Design, Pasadena

VISUAL: A man on a basketball court. He beatboxes for the camera.
SUPER: What can you do with AIR?

SILVER

CATEGORY Student • **ADVERTISER/PRODUCT** Samsonite Luggage • **TITLE** Bomb Squad • **PRODUCTION COMPANY** Christian Sebaldt, Glendale • **EDITING COMPANY** Joe Shugart, Studio City • **MUSIC COMPANY** Jeffrey Alan Jones, Lakewood • **SOUND DESIGN COMPANY** Jeffrey Alan Jones, Lakewood • **CREATIVE DIRECTOR** Geoff McGann • **COPYWRITER** Dave Matli • **ART DIRECTOR** Dave Matli • **DIRECTOR** Phil Boston • **PRODUCER** Brandon Menschen • **EDITOR** Joe Shugart • **CINEMATOGRAPHER** Christian Sebaldt • **SCHOOL** Art Center College of Design, Pasadena

VISUAL: A SWAT team runs through the halls of an evacuated building.
BASE: We have a green light.
VISUAL: The team bursts through a locked door.
DELTA COMMANDER: Nobody move! Nobody move! Everybody down! Down, down, down, down!
VISUAL: The only thing in the room is a suitcase bomb with a timer set for 30 seconds.
BASE: What have you got?

DELTA COMMANDER: Everybody out! Everybody out!
VISUAL: The rest of the team runs out.
DELTA COMMANDER: We got a package, base. It's in a case.
VISUAL: The commander inspects the bomb.
DELTA COMMANDER: Swiss K-4 detonator, four switch override. I'm going for the primary.
BASE: Delta Command, do not cut!
VISUAL: Delta Commander cuts a wire, but the counter

continues to tick.
DELTA COMMANDER: Clear the building, Base!
VISUAL: In a last desperate attempt to find a way of stopping the counter, he feels along the outside of the briefcase and discovers the Samsonite logo.
DELTA COMMANDER: Wait…
VISUAL: Relaxing, he simply closes the case.
[**SFX:** Muffled explosion.]
SUPER: Samsonite.

CATEGORY Student • **ADVERTISER/PRODUCT** Ascrum Amsterdam • **TITLE** Tooth • **COPYWRITER** Miguel Hernandez • **ART DIRECTOR** Isabela Ferreira • **SCHOOL** Miami Ad School, Miami Beach

VISUAL: A man in his bathroom stretches in front of the mirror. He picks up his toothbrush, adds the toothpaste and then brushes the only tooth in his mouth. After cleaning, he spits out the toothpaste and smiles.

SUPER: Rugby season is here again.
Ascrum Amsterdam.
VISUAL: Man flosses only tooth.

CATEGORY Student • **ADVERTISER/PRODUCT** ecampus.com • **TITLE** Jelly • **ART DIRECTOR** Nicoletta Nelson • **DIRECTOR** Nicoletta Nelson • **PRODUCER** Nicoletta Nelson • **DIRECTOR OF PHOTOGRAPHY** Nathan Hill • **SCHOOL** Academy of Art College, San Francisco

SUPER: Paid Fall Tuition.
[**MUSIC:** Burt Bacharach's "What the World Needs Now Is Love"]
VISUAL: The bottom half of a sandwich. The bread is covered with peanut butter. A hand reaches in and places a slice of bread on top, completing sandwich.
SUPER: Dinner.
[**SFX:** Squishing sound.]
SUPER: Paid Minimum Balance on Credit Cards.

VISUAL: The bottom half of a sandwich. The bread is covered with peanut butter. A hand reaches in and places a slice of bread on top, completing sandwich.
SUPER: Dinner.
[**SFX:** Squishing sound.]
SUPER: Bought book @ecampus.com.
[**SFX:** Needle scratching across record]
[**MUSIC:** Changes to upbeat section of song.]
VISUAL: The bottom half of a sandwich. The bread is

covered with peanut butter. A hand reaches in and drops a spoonful of jelly on the bread. Hand places a slice of bread on top, completing sandwich.
SUPER: Dinner.
[**SFX:** Plop of jelly, squishing sound.]
SUPER: Ecampus.com.
Textbooks for cheap. Hey, every penny counts.

CATEGORY Student • **ADVERTISER/PRODUCT** Staples Office Supplies • **TITLE** Gotcha • **CREATIVE DIRECTOR** Tony Garcia • **COPYWRITER** Lisa Plettinck • **DIRECTOR** Tony Garcia • **PRODUCER** Armando Sanchez • **MUSIC** Jill Wisoff • **DIRECTOR OF PHOTOGRAPHY** Tony Garcia • **EDITOR** Lisa Plettinck, Tony Garcia • **SCHOOL** Art Center College of Design, Pasadena

VISUAL: A car coasts into the driveway with both lights and engine off. A mother sits at a desk carefully packing her knick-knacks in bubble wrap. Meanwhile, her son is cautiously sneaking his girlfriend up to his room. He's done this before, so he has the route to his room planned. He takes her through the laundry room and up the creaky staircase. As the amorous teens pass by the son's first communion picture, they know they've made it to the home stretch. Just as they turn the corner—POP!…POP!…CRACK!… POP! The further they walk into the trap, the louder it gets.

A wry smile creeps across the mother's face as she gets up from her desk. She caught the couple via bubble wrap!

SUPER: STAPLES. Think beyond home office supplies.

CATEGORY Student • **ADVERTISER/PRODUCT** Francis Bacon Exhibit at the Minneapolis Institute of Arts • **TITLE** Yellow • **TITLE** Red • **TITLE** Green • **COPYWRITER** Erik Kvålseth • **ART DIRECTOR** Jen Neis • **SCHOOL** Brainco - The Minneapolis School of Advertising, Minneapolis

GOLD

CATEGORY Student • **ADVERTISER/PRODUCT** Dramamine • **TITLE** Moby Dick • **TITLE** On The Road • **TITLE** Around The World In 80 Days • **CREATIVE DIRECTOR** Constantine Cotzias • **COPYWRITER** Pat McKay • **ART DIRECTOR** Jill Keeler • **SCHOOL** VCU Adcenter, Richmond

GOLD

CATEGORY Student • **ADVERTISER/PRODUCT** Poland Spring Water • **TITLE** Banana Minus Water • **TITLE** Fig Minus Water • **TITLE** Pineapple Minus Water • **COPYWRITER** Andre Perri • **ART DIRECTOR** Andre Perri • **SCHOOL** Parsons School of Design, New York

BRONZE

BRONZE

CATEGORY Student • ADVERTISER/PRODUCT Amtrak • TITLE The Journey Is The Destination (Postcard) • TITLE The Journey Is The Destination (Film) • TITLE The Journey Is The Destination (Photo Corners) • PHOTOGRAPHY STUDIO Rafael Dagul • CREATIVE DIRECTOR John Butler • COPYWRITER Mark Day, Niraj Zaveri, Daniel Elmslie • ART DIRECTOR Niraj Zaveri • SCHOOL Academy of Art College, San Francisco

BRONZE

CATEGORY Student • ADVERTISER/PRODUCT Salvation Army • TITLE Palm Pilot • TITLE 85% • TITLE 4% • CREATIVE DIRECTOR Constantine Cotzias • COPYWRITER Jon Runkle • ART DIRECTOR Trevor Blake • SCHOOL VCU Adcenter, Richmond

CATEGORY Student • **ADVERTISER/PRODUCT** Vantage Press Inc. • **TITLE** Like To Write? (Menu) • **TITLE** Like To Write? (Check) • **TITLE** Like To Write? (Cake) • **COPYWRITER** Suzanna Pareja • **ART DIRECTOR** Matt Parsons • **SCHOOL** Miami Ad School, Miami Beach

BRONZE

CATEGORY Student • **ADVERTISER/PRODUCT** Target • **TITLE** Ritz • **TITLE** Spider • **TITLE** Fly Swatter • **TITLE** Shoelace • **TITLE** Hammer • **COPYWRITER** Lina Hitomi, Nick Tamburri • **ART DIRECTOR** Lina Hitomi, Nick Tamburri • **SCHOOL** Art Center College of Design, Pasadena • **PHOTOGRAPHER** Zachary Scott • **CLIENT** Target

BRONZE

BRONZE

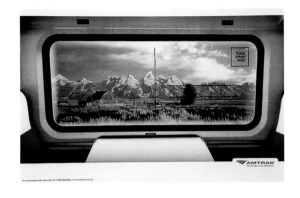

CATEGORY Student • ADVERTISER/PRODUCT Amtrak • TITLE The Journey Is The Destination (Postcard) • CREATIVE DIRECTOR John Butler • COPYWRITER Niraj Zaveri, Mark Day, Daniel Elmslie • ART DIRECTOR Niraj Zaveri • SCHOOL Academy of Art College, San Francisco

BRONZE

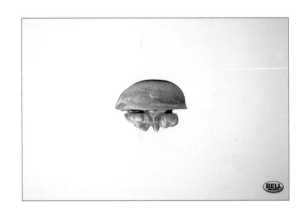

CATEGORY Student • ADVERTISER/PRODUCT Bell Helmets • TITLE Walnut • ART DIRECTOR Andre Perri • SCHOOL Parsons School of Design, New York

BRONZE

CATEGORY Student • ADVERTISER/PRODUCT Oxydol Detergent • TITLE For Whatever Your Clothes Smell Like. (Skunk) • PHOTOGRAPHY STUDIO Chuck Rogers, Minneapolis • COPYWRITER Jon Yasgur • ART DIRECTOR Chuck Matzker • PHOTOGRAPHER Chuck Matzker • SCHOOL Brainco - The Minneapolis School of Advertising, Minneapolis

CATEGORY Student • **ADVERTISER/PRODUCT** Moskva Vodka • **DESIGNER** Hee Jung Moon • **INSTRUCTOR** Michael Osborne • **DIRECTOR OF GRAPHIC DESIGN** Mary Scott • **SCHOOL** Academy of Art College, San Francisco

GOLD

CATEGORY Student • **ADVERTISER/PRODUCT** Blueprint Magazine—Brochure • **DESIGNER** Abigail Planas • **INSTRUCTOR** Jaime Calderon • **DIRECTOR OF GRAPHIC DESIGN** Mary Scott • **SCHOOL** Academy of Art College, San Francisco

GOLD

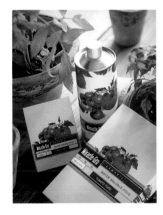

CATEGORY Student • **ADVERTISER/PRODUCT** Miracle Gro • **DESIGNER** Melanie Halim • **INSTRUCTOR** Michael Osborne • **DIRECTOR OF GRAPHIC DESIGN** Mary Scott • **SCHOOL** Academy of Art College, San Francisco

SILVER

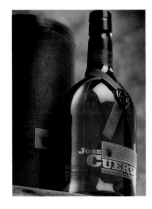

CATEGORY Student • **ADVERTISER/PRODUCT** Cuervo Tequila • **DESIGNER** Abigail Planas • **INSTRUCTOR** Michael Osborne • **DIRECTOR OF GRAPHIC DESIGN** Mary Scott • **SCHOOL** Academy of Art College, San Francisco

SILVER

SILVER

CATEGORY Student • **ADVERTISER/PRODUCT** Dickel Whisky • **DESIGNER** Katja Ebert • **INSTRUCTOR** Michael Osborne • **DIRECTOR OF GRAPHIC DESIGN** Mary Scott • **SCHOOL** Academy of Art College, San Francisco

SILVER

CATEGORY Student • **ADVERTISER/PRODUCT** Lego—Corporate ID • **DESIGNER** Abigail Planas • **DIRECTOR OF GRAPHIC DESIGN** Mary Scott • **INSTRUCTOR** Gregoir Vion • **SCHOOL** Academy of Art College, San Francisco

BRONZE

CATEGORY Student • **ADVERTISER/PRODUCT** Hush Puppies Shoe Cleaning Accessories • **DESIGNER** Abigail Planas • **INSTRUCTOR** Chris Lehmann • **DIRECTOR OF GRAPHIC DESIGN** Mary Scott • **SCHOOL** Academy of Art College, San Francisco

BRONZE

CATEGORY Student • **ADVERTISER/PRODUCT** Body Shop Annual Report • **DESIGNER** Melanie Halim • **INSTRUCTOR** Jennifer Bostic Olsen • **DIRECTOR OF GRAPHIC DESIGN** Mary Scott • **SCHOOL** Academy of Art College, San Francisco

Clio Representatives

ARGENTINA
Carlos Acosta
Reporte Publicidad
Buenos Aires

AUSTRALIA
Kim Shaw
Campaign Brief
Subiaco

AUSTRIA
Chrigel Ott
Creative Club of Austria
Vienna

BELGIUM
Siglinda Paquay
Creative Club of Belgium
Brussels

BRAZIL
Enrique Lipszyc
Escola Panamericana de Arte
Sao Paulo

CANADA
Mike Lewis
The Advertising & Design Club of Canada
Toronto

CHINA
Margaret Wong
The Association of Accredited
Advertising Agents of Hong Kong
Hong Kong

Mao Li Feng
ASTDC/Clio China
Shanghai

COLOMBIA
Christian Toro
Publicidad Toro/DMB&B
Bogota

COSTA RICA
Dennis Aguiluz Milla
Asociacion Costarricense de Agencias
de Publicidad (ASCAP)
San Jose

CZECH REPUBLIC
Jiri Mikes
Asociace Reklamnich Agentur (ARA)
Prague

DENMARK
Carl Gyllenhoff
Art & Copy
Espergaerde

ECUADOR
Jose Antonio Moreno
Asociacion Equatoriana de Agencias
de Publicidad
Quito

EL SALVADOR
Arturo Hirlemann
ANAES (National Association of
Advertisers)
San Salvador

FINLAND
Sinikka Virkkunen
Finnish Association of Advertising
Agencies
Helsinki

FRANCE
Anne Saint-Dreux
Maison de la Pub
Paris

GERMANY
Werner Bitz
GWA Service
Frankfurt/Main

GREECE
Maro Cambouris
EDEE (Hellenic Advertising Agencies
Association)
Athens

GUATEMELA
Luisa Maria Mata Arias
Corporacion Mariposa S.A.
Guatemala City

HUNGARY
Gabor Ergi
MaRS (Magyarorszagi
Rehlamugynoksegek
Szovelsege)
Budapest

INDIA
Bipin Pandit
The Advertising Club of Bombay
Mumbai

INDONESIA
J. Daniel Rembeth
Cakram Magazine
Jakarta

ITALY
Milka Pogliani
Art Directors Club Italiano
Milan

JAPAN
Kenji Kashima
ACC (All Japan Commercial Confederation)
Tokyo

KOREA
Won Seok Hee
Korea Commercial Film Maker's Union
Seoul

MALAYSIA
J. Matthews
Macomm Management Services Sdn Bhd
Petalying Jaya

MEXICO
Antonio Delius
El Publicista
Mexico City

NEW ZEALAND
Lynne Clifton
CAANZ (Communication Agencies
Association of New Zealand)
Auckland

NORWAY
Sol M. Olving
Reklamebyråforeningen
Oslo

PHILIPPINES
Oli Laperal
R.S. Video & Film Production
Manilla

POLAND
Leslaw Wilk
Crackfilm Agency
Kraków

PORTUGAL
Rui Cupido
Meios Publicidade/Work Media
Lisbon

SINGAPORE
Florence Oh
Association of Accredited Advertising
Agents of Singapore
Mandarin Singapore

SWEDEN
Anna Serner
The Advertising Association of Sweden
Stockholm

SWITZERLAND
Walter Merz
Association of Swiss Advertising
Agencies BSW/USC
Zurich

TAIWAN
Helen Wang
Brain Magazine
Taipei

THAILAND
Niwat Wongprompreeda
The Advertising Association of Thailand
Bangkok

TURKEY
Arsun Akün
Reklamcilar Dernegi
Istanbul

URUGUAY
Carlos Ricagni
McCann-Erickson
Montevideo

VENEZUELA
Raul Lotitto
Grupo Editorial Producto
Caracas

Credits

CLIO STAFF

ANDREW JAFFE
Executive Director

TONY GULISANO
Managing Director

KATHY BAKER
General Manager

JOEL GOODMAN
Project Manager/Judging Director

XOCHITL GONZALEZ
Director of Special Events

WAYNE YOUKHANA
Video Editor/Producer

BARBARA SANT'ANA
Project Coordinator

JUSTIN HOLT
Assistant Project Coordinator

REBECCA BLAKE
Controller

WALLY LAWRENCE
Director of Special Services

JOHN MACDONALD
Systems Analyst/Programmer

PUBLIC RELATIONS

DEF P.R. INC.
New York

MALISSA PIAZZA
Director of Public Relations, Clio Awards

LEGAL COUNCIL

JOHN M. ANDERSON, ESQ.
Heller Ehrman White & McAuliffe
San Francisco & New York

DESIGN FIRM

HATMAKER
Watertown, Massachusetts

ROCKPORT PUBLISHERS
Gloucester, Massachusetts